A Complete Guide to Character Rigging for Games Using Blender

This book is a comprehensive guide to using Blender to create character rigs for games, breaking down the technicalities of rigging tools and techniques into easily digestible chunks. It provides all the tools needed to go from a static character model to an animation-ready, high-quality, and fast-performing game rig.

Written to be accessible and easy to follow, the book covers character rigging theory that is supported by industry standard examples of how to apply that theory to character rigs for video games. It demonstrates the reasoning behind rigging decisions followed by instructions and examples on how to apply that knowledge to rig creation. It includes chapters that focus on the character deformation techniques that raise the visual quality of the model and subsequently of the animation and game it will be used in.

This book will be vital reading to those studying games animation as well as early-career rigging artists, character animators, modeling artists, technical animators, and technical artists.

About the Author

Armin Halač is a video game technical and character animator originally from Sarajevo, Bosnia, and Herzegovina, currently living and working in Berlin, Germany. With over a decade of experience, Armin is a principal animator in a genre leading, story-driven game studio. His previous work includes creating rigs and animation for games, short films, and ads.

When Armin isn't working on his next project, he can be found cycling, creating music, and taking long walks with his two dogs, Mitzi, and Pablo.

You can find him on Twitter at @ArminHalac or visit his website at www.arminhalac.com.

A Complete Guide to Character Rigging for Games Using Blender

Armin Halač

CRC Press

Taylor & Francis Group
Boca Raton London New York

CRC Press is an imprint of the
Taylor & Francis Group, an **informa** business

Designed cover image: Armin Halač

First edition published 2024
by CRC Press
2385 NW Executive Center Drive, Suite 320, Boca Raton FL 33431

and by CRC Press
4 Park Square, Milton Park, Abingdon, Oxon, OX14 4RN

CRC Press is an imprint of Taylor & Francis Group, LLC

© 2024 Armin Halač

Library of Congress Cataloging-in-Publication Data
Names: Halač, Armin, author.
Title: A complete guide to character rigging for games using Blender / Armin Halač.
Description: First edition. | Boca Raton : CRC Press, [2024] |
Includes bibliographical references and index.
Identifiers: LCCN 2023010708 (print) | LCCN 2023010709 (ebook) |
ISBN 9781032203119 (hbk) | ISBN 9781032203003 (pbk) | ISBN 9781003263166 (ebk)
Subjects: LCSH: Rigging (Computer animation) | Blender (Computer file) | Video games–Programming.
Classification: LCC TR897.72.B55 H35 2024 (print) | LCC TR897.72.B55 (ebook) |
DDC 777/.7–dc23/eng/20230331
LC record available at https://lccn.loc.gov/2023010708
LC ebook record available at https://lccn.loc.gov/2023010709

ISBN: 9781032203119 (hbk)
ISBN: 9781032203003 (pbk)
ISBN: 9781003263166 (ebk)

DOI: 10.1201/9781003263166

Typeset in Times
by codeMantra

For Maja

Contents

Acknowledgments

Special thanks to Charles Wardlaw and Brad Clark for their continuous support, knowledge sharing, and feedback. A thank you to these folks for sharing their experience and tips: Christian Corsica, Perry Leijten, and Josh Burton. And to everyone who has been unselfishly sharing their knowledge on various blogs, forums and videos and helped me learn to create rigs. Thanks to Will Bateman, Sherry Thomas, and Simran Kaur for their support on this project.

1

Introduction

What Is Rigging?

I split rigging into three sections: functionality, user experience, and deformation. The rig needs to work as expected, be easy to use, and produce good-looking poses.

Rig functionality is the first barrier people encounter when they learn to rig. You need to learn how to use the software you're working with (in this case, Blender) and how to assemble different parts of the rig. The good news is that there are actually not that many things that you need to learn. Just this book will provide most of the knowledge. Once you've learned these skills and gained some experience, you'll be able to use the same basic ideas for most rigs you will ever make. While other areas of game development are constantly changing, rigging remains relatively stable. They have developed some tools to make rigging easier, but the underlying concepts are the same. Most existing rigging resources are still relevant.

The next aspect of rigging to consider is the user experience. Animators might spend hundreds of hours using your rigs, so it is important to make sure it matches the animator's needs. Deciding how to structure a rig should be a collaborative process where you listen to their preferences and find a solution that works for everyone. The goal is to create a rig that the entire production team is happy with, and that is both efficient and functional in the game. It ultimately comes down to understanding the animators who will use the rig and the game you will use it in.

Deformation and visual design are something that many don't take into consideration when they think about what rigging is. The rig is a sculpting tool. It allows an animator to sculpt a model into different poses. And these poses have to be designed well. Meaning the rigger needs to understand visual design and create a rig that makes the character look appealing when posed and animated. Good deformation goes way beyond making some smooth bone weights. It's important to consider anatomy and character design when creating a rig.

I have attempted to break down the rigging process into a logical sequence, but the process is rarely sequential like that. When I rig I am working on multiple things in parallel and making multiple iterations on the same tasks. It would actually be quite counterproductive to do everything linearly. As you, for example, add bones and then move on to paint the weights, it is likely that you will start seeing possible improvements to bone placement. So I encourage you to not chase perfection, but go two steps forward and one back. Check how the previous work holds up with what you added on top.

This book gives you one approach to rigging, and I encourage you to experiment and try out different ways of solving problems. Debugging and reverse engineering rigs is an important part in learning to rig. One is that someone might ask you to deal with this when you work in a studio. Some other rigger might have created the entire pipeline already and you will need to figure out how the rigs are set up and how to continue expanding that pipeline. And if a rig breaks, you will need to figure out why it broke and how to fix it.

DOI: 10.1201/9781003263166-1

Additional Resources

Please find the supplemental material for the book here: www.arminhalac.com/rig_book. There you will find additional resources and updates that will help you better understand the concepts explained in this book as well as any potential changes that come with newer versions of Blender.

2

The Big Picture

It is important to consider other stages of a character's life cycle, such as design and modeling, because a successful rig depends on the work of the entire team. The quality of the rig directly affects the quality of the animation and other subsequent works. Therefore, it is essential for all disciplines to collaborate and sometimes compromise toward a shared goal.

Character Design and Modeling

There are no limits to what we can design for a character, but some designs may be easier to rig and animate than others. For example, a character with a simple T-shirt may be straightforward to rig, whereas a character with multiple layers of loose clothing may be difficult to rig. The rigging team should be involved in the early stages of design to ensure that the character can be effectively rigged and animated within budget.

Modelers may provide early block-out models to riggers to create a quick rig for testing the model's functionality. For example, if a character has large shoulder armor plates that move into the head when the arm is raised, model adjustments may be necessary to prevent this.

Rigging

You might ask why I have rigging in a list of things that we should consider when rigging. Unless you are working on a game that has only one rigged character, approach rigging holistically. We should not treat every rig as a completely isolated task. This is beneficial even for personal projects and skill development. Instead of reinventing your approach to rigging every time, use what you have learned and established on previous rigs and build. When working in a studio or on a project with multiple characters, keep the following in mind:

Standardize

Standardizing your rigs is essential for streamlining the process. Create a base skeleton structure and use it across similar characters with the same naming and orientation scheme, and adopt a consistent visual language in control shapes and colors. This benefits animators and improves rigging, animation sharing, re-targeting, and exporting.

Define Specifications

Define technical budgets and specifications early in production. Create quick prototypes to determine bone count and vertex influences for each character. Decide on facial animation and cloth techniques based on character and game requirements. Analyzing these factors will help plan and implement the rig, saving time and effort later.

DOI: 10.1201/9781003263166-2

Character Animation

Rigs should be designed to serve as an animation tool, taking into account the animators' needs and preferences. Although certain features are essential, such as IK/FK limbs, it's also important to consider the animators' preferences when designing the rig. Ultimately, the goal is to create the best rigs possible for the animators, taking into account technical limitations and compatibility with the pipeline.

If you think you've made a great rig but the animators don't like it, then you're not doing your job properly. Unless there are technical limitations that don't make certain options viable, as the rig must be functional and compatible with the rest of the pipeline.

Export

After creating a rig in a DCC tool like Blender, it must be exported to the game engine. During the export process, we only keep the deformation and helper bones necessary for the character to function, and we bake the animation onto the deformation bones. A well-organized rig ensures easy export to the game engine without the need for custom export tools. In a later chapter, we'll cover the export process in more detail.

Game Engines

The way we make game rigs is in many ways dictated by the limitations and requirements that come from the export process and game engine. It is crucial to know these limitations and the impact they make on the way you can design your game rigs. Modifiers, constraints and other tools that we use for rigging in Blender do not translate to game engines. We will use them in rigs, but the exported product will not contain those. In a later chapter, we'll cover these topics in more detail.

3

What Is a Game Rig

Definition

To qualify as a game rig, the bones, mesh deformations and animation created in the DCC (such as Blender) must be reproducible in the game engine. It is better to rig with these limitations in mind from the outset rather than adding things blindly and hoping they will work in the game engine. If you don't follow these requirements, you may need to go back and make adjustments to the rig before it is usable in the game. Before creating a rig, it is important to keep the following requirements in mind in order to avoid unnecessary work and potential issues.

Export Limitations

When rigging for games, the rigs must contain nothing that either can't be exported or that the game engine does not support. So we should start rigs knowing what these unsupported things are.

The most common export file format for game characters, including bones and animation, is FBX. gLTF 2.0 is on the rise and might take over in the future. The same format is used to export the character model, bones, and animation. Everything discussed here is supported by both formats.

With meshes, besides data like UV maps and normals, for game rigging, the export format needs to support the export of:

- Skin weights
- Blendshapes (shape keys) and their animated values
- Parenting information

The following is a list of tools commonly used in non-game rigs, which are not supported by FBX and game engines. These are the things that you can't export and, for that reason, can't use in making game rigs:

- Mesh modifiers. Lattice, corrective smooth, mesh deform, mirror, etc.
- Object constraints

The most important takeaway here is that we can only use shape keys and skin weights to deform the meshes. No other modifiers such as lattice, mirror, mesh deform, etc. are exportable out of Blender. This is a big deal because we will have to make the most out of these tools to get our characters to deform well.

For armatures and bones, the only data we can export are these types:

- Armature object, which gets converted into a single empty transform
- Bones
- Bone transformation information (location, rotation, scale)
- Parenting information
- Animation data

DOI: 10.1201/9781003263166-3

FIGURE 3.1 FBX export settings, where the Only Deform Bones option is found.

The *Only Deform Bones* export option (see Figure 3.1) tells the exporter to delete all bones that don't have their *Deform* attribute enabled. We use this to our advantage and leave it enabled only on bones that we don't want to be deleted. A thing to note is that bones that have *Deform* disabled, but have child bones that have it enabled, will also be exported.

Base Skeleton

To create a clear separation between the entire rig and the bones that will be exported, we will refer to the exported bones as the "base skeleton." The base skeleton will consist of the root bone, deformation bones, and prop bones, and will be in a separate bone hierarchy from the rest of the rig. This means that as we rig the character, the base skeleton bones will never be parented to mechanics or control bones, and other bones will not be parented to the base skeleton. This will ensure that the base hierarchy is never broken and can be exported with no superfluous bones that are not needed in the game. We will connect the base skeleton to the rest of the rig using constraints and drivers.

Bone Scaling Animation

A common requirement for rigs is that parts squash and stretch, which can be achieved by non-uniformly scaling bones. We can use an arm rig as an example. The desired behavior would be that when the animator moves the hand control beyond the length of the arm, the arm will become longer. This, in rigging terms, means the upper and lower arm needs to be scaled up to reach the hand. The hand would stay the same size and length.

When the baked behavior is applied to the deformation bones during export, things become more complex. As the hand bone is parented to the lower arm, it inherits the transformation from its parent. However, the rig is designed so that the hand counteracts that scale to maintain a consistent visual size. Game engines handle transformations differently from Blender, which means that this scale and counter-scale do not translate well. As a result, the animation will look different in Unreal Engine, as shown in Figure 3.2.

There are ways to fix this in Unreal Engine, for example, by using animation blueprints and copying the scale from the root to the hand. This adds complexity to the rig and is not perfect, but gets the job done if squash and stretch are required for the game.

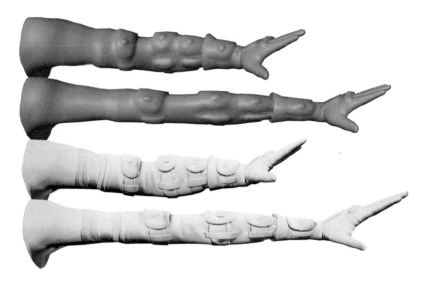

FIGURE 3.2 Two frames of the same animation played back in Blender (top), and Unreal Engine (bottom). Hand has a different size due to different ways scaling is handled.

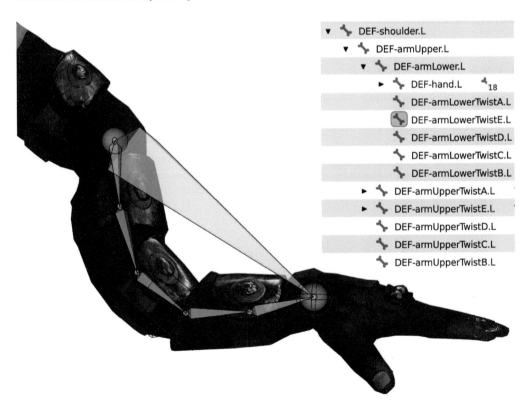

FIGURE 3.3 A flat bone hierarchy of twist bones removes scaling issues while the main hierarchy provides good animation blending.

Flattening the hierarchy in the section that needs to scale can avoid scale issues. In the example given, this means the hand, lower arm, and upper arm are all parented to the shoulder. However, this can make animation blending look worse as the motion will be linear and disjointed. This technique is quite useful in areas in which animation blending is less noticeable. For example, the arm can be in a proper

FIGURE 3.4 Arm stretching and bending is achieved by moving and rotating bones to prevent any scaling from happening.

hierarchy and not scale, and we can layer additional bones on top to create something like a bendy limb effect (Figure 3.3).

A second approach to squash and stretch would be to move bones instead of scaling them. Not having volume preservation is the downside of this approach, but it is a great technique for completely scale-free stretching and compressing (see Figure 3.4).

Max Number of Influences

In rigging, "influence" refers to a bone that a mesh is weighted to. The maximum number of influences is the highest number of bones that are affecting a single vertex in a mesh. Even if most vertices have single influences, if eight bones influence one vertex, the entire mesh will be considered as having eight influences.

To optimize performance, we often limit the number of bones that can influence each vertex. For low-end mobile games, this number can be as low as two influences per vertex, and rarely higher than four. For AAA games, this limit is most commonly four or eight influences.

4

Blender Tools and Concepts

Prerequisites

This is not a complete guide to using Blender, and fundamental Blender knowledge is a prerequisite. There are more than enough resources for learning general Blender concepts, and I strongly recommend you go through a Blender Fundamentals series on *www.youtube.com/@BlenderOfficial*, or anything similar to that. To get the most out of this book, you should be at a level where you can navigate the 3D view, change editors, locate the Preferences view, and know the names of different areas of Blender.

About Blender

Rigging in Blender is much more stable and less linear compared to something like Autodesk Maya. You can delete, separate, merge, etc. parts of a rigged mesh, and nothing will go wrong. You can do the same with the rig. This is an enormous benefit to rigging, as it doesn't discourage experimentation and an iterative workflow. Blender rigs are enclosed within armature objects and animation in action objects, which makes things like duplications, moves between files and exports straightforward. Then we have the separation into Edit and Pose mode, which allows us to compartmentalize rigging into two different processes and makes rigging more organized. Since animators get access to only the Pose mode, rigs are harder to break. There are many other features, for example B-bones, which you will get to learn as you make progress through this book.

Blender Version

This book uses Blender version **3.5**, which was the most recent version at the time of writing. While you can use a different version of Blender, keep in mind that there may be some compatibility issues between the version you are using and version 3.5. If that is the case, you might need to adjust the instructions to accommodate for the differences between versions.

Installing Blender is straightforward. In your web browser, open *www.blender.org/download/* and follow the download and installation instructions. You also have the option to download a portable version. Which downloads a zipped file and does not require any installation. Just unzip and run the Blender executable from the unzipped folder.

Initial Settings

The first time you start Blender, it will show the splash screen and the quick setup options. These options also exist in Blender preferences and you can adjust them at any point from the Preferences window. Which you can find in the main Blender menu under *Edit > Preferences*.

I prefer to set these settings to what used to be the Blender default, which I still believe is the better way of working with Blender. But this is subjective. In the end, they change the way you interact with Blender, so only your personal preferences matter. I recommend you use the same settings as I do while

DOI: 10.1201/9781003263166-4

making your way through the book. That way, you can apply the instructions as I present them here. If your settings are different, you will need to adjust for different settings.

I tailored all key shortcuts and inputs from int book to work with these initial settings:

- Language: *English*
- Shortcuts: *Blender*
- Select With: *Right*
- Spacebar: *Search*

Theme only changes the user interface colors, so pick the one you prefer. I am a big fan of the dark theme but will use Print Friendly throughout this book to make everything more readable.

Since we will use the right click for selection, the options menu (*Context* menu in Blender) that usually shows up when the right click is pressed in most applications can be invoked by pressing **W**.

Load Previous Version Settings

As you can see on the Splash Screen in Figure 4.1, Blender detects if a preferences folder from a previously installed Blender version exists on your system and shows a *Load #.# Settings* button. This is very useful as it copies everything, including preferences, shortcuts, default layouts and add-ons, which means you need to set up your Blender once and can carry everything over to all new versions.

This button shows up only the first time you start a new Blender version. In order to get the first startup splash screen to show up again, you can delete all preferences for the Blender version you want this to happen in. On Windows, we can delete Blender preferences by navigating to *C:\Users\[Your*

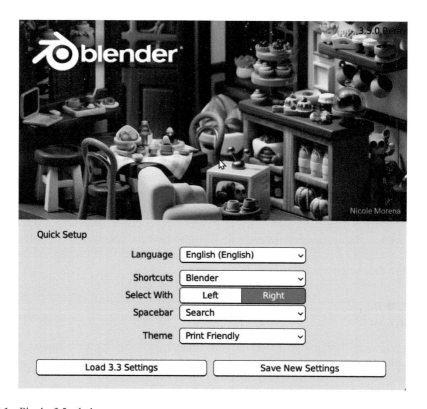

FIGURE 4.1 Blender 3.5 splash screen.

Username Here]\AppData\Roaming\Blender Foundation\Blender in the file explorer and deleting the folder labeled with the version number. Keep in mind that deleting this folder means you will lose all custom settings.

Context Sensitivity

Blender keeps track of various aspects of the current session (e.g. what objects are selected, the mode the scene is in, the area under the mouse cursor, etc.) in what is called context. When working with Blender, it's important to ensure that you are in the correct context when performing actions or using shortcuts. For example, if you want to move a bone, you need to be in the correct mode and have your cursor hovering over the 3D view.

Selection

Whereas in most software you can select and deselect items, Blender has a third option, which is the active state. This is usually the last selected item and is displayed by a brighter outline. Any tool that has a target will operate on the active object and fail if no object is active. Keep that in mind as only the single item selection performed by right-clicking marks the selection as active. If you use select all, marque select or anything else, these selection operations will mark none of the selected items as active.

Select All

Pressing the **A** key will toggle between selecting all objects and clearing the selection. It will not change the active object assignment.

Select Linked

Pressing **L** will select the object under the mouse cursor together with all other objects of the same type which are connected to it. To give a couple of examples, if the object under the cursor is a bone, then it will also select its connected parents and children, or if it is a mesh face, it will select all faces connected to it. There is a second mode to selecting linked, which selects what is linked to the current selection instead of what is under the mouse cursor.

Parent, Child, Siblings

It is possible to select the parent using [and child using]. We can extend the selection by holding **Shift** in combination with the bracket keys.

 Shift + G opens the Select Similar menu that offers additional options for selecting siblings, all immediate children, bones with the same prefix/suffix, etc.

Select Under Cursor

If **Alt + Right Click** is pressed with multiple objects stacked under the cursor, a pop-up menu will appear which contains a list of all the objects under the cursor. Clicking on a name in this list will select the object. To extend the current selection, invoke the same menu with **Shift + Alt + Right Click** (Figure 4.2).

Draw Selection

These are the selection modes which involve left click dragging, which are Box, Circle and Lasso. We can find them in the Toolbar (also known as the T panel). Box and Circle modes have shortcuts, which

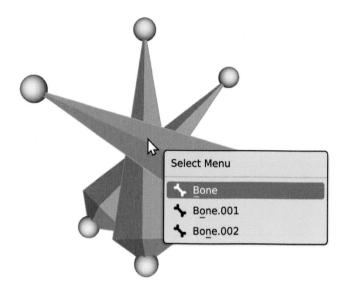

FIGURE 4.2 **Alt + Right Click** selection menu listing all bones under the cursor.

are **B** and **C**, respectively. For Circle select, using the shortcut is the preferred method because after we press C, the mouse wheel can change the circle size and middle click to deselect items.

Transformation

The T panel hosts the Move, Rotate, Scale and a Transform tool that is made from the previous three joined. These tools perform transformations on the object when we click and drag on their gizmos in the 3D view. Moving and scaling on two axes is done by clicking on the squares locates between the gizmo arrows.

We find the transformation options in the 3D viewport header (see Figure 4.3). It is important to note that these settings only affect how transformation is executed. They do not change any settings on objects.

Transform Orientation

By default, transformations are aligned to the world, meaning that the transformation gizmo axes will point in the same directions as the grid lines. There are several other transform orientations we can choose from, for example *Local,* which aligns the transformations with the object itself. We can change the orientation from the header by clicking on the button that says *Global*. We can also do this through a pie menu that is activated by the , (**comma**) key.

Here are all the transform orientations and what they represent:

- *Global*: Transformations are aligned with the Blender world.
- *Local*: The tools are aligned with the object
- *Normal*: The normal is what Blender considers being the front of the object. The tool will be aligned to that. Useful for moving a mesh face in the direction it is facing or orthogonal to it. Since bones don't have a local space in Edit mode, use *Normal* to align transforms with the bone.
- *Gimbal*: Similar to *Local* but the axes are aligned with the object's rotation axes. This will become clearer later when we talk about rotations in 3D space.
- *View*: The Z-axis is perpendicular to the view angle and the other two are parallel to the screen.

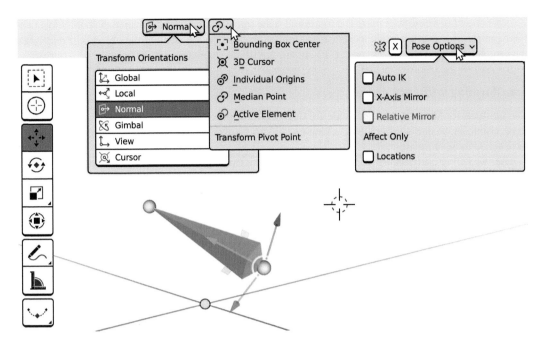

FIGURE 4.3 Transformation tool-related menus. From left to right: T panel, transform orientations, transform pivot point, and options.

- *Cursor*: Gizmo is aligned with the 3D cursor's rotation.
- The + icon in the top right corner of the menu can save the current orientation for use with different objects.

Transformation Pivot

We can change the transformation pivot or the point around which the transformations are happening. The location of the *Transform Pivot Point* menu can be seen in Figure 4.3. We can also do this through a pie menu that is activated by pressing the . (**period**) key.

This is what each pivot point option means:

- *Bounding Box Center*: Imagine drawing a cube that encloses the selected objects and then finding the center point of that box. This is the point around which the objects will transform.
- *3D Cursor*: The 3D Cursor will be used as the pivot point. More on this in the 3D Cursor section.
- *Individual Origins*: Every selected object will use its own origin as the pivot.
- *Median Point*: The pivot is placed at the center of the selected objects.
- *Active Element*: All selected objects will transform around the origin of the active object.

Options

The contents of this menu change based on what we have selected and the mode of the scene. An important option that is available in Edit and Pose mode is *X-Axis Mirror*, which reflects the transformations between the left and right sides. This is name dependent and the bones must have a side designator in their names (e.g. L and R).

Affect Only Locations will make the rotate and scale transformations only change the bone's location. For example, if we set the pivot to *3D Cursor* and enable this option, scaling the object will only scale the distance between the object and the 3D cursor. It will not change the object's size.

Transforming without Gizmos

The shortcuts for Move, Rotate and Scale are **G**, **R** and **S,** respectively. For these to work, no gizmo needs to be visible so we can disable it by clicking on something else in the T panel, e.g. *Select Box* is what I have active most of the time.

After we activate a transformation using **G**, **R** or **S**, we can trigger additional modifiers:

- *Cursor Motion*: There is no need for clicking. Move the mouse to adjust the transformation.
- **Shift** + *Cursor Motion*: Slows down the amount of transformation that is applied, enabling more precise control.
- *X, Y, Z*: Constrains the transformation to a single axis using the set transformation orientation. By pressing the axis key again, we switch the orientation to *Global*. If *Global* was already active, the mode is switched to *Local*.
- **Shift** + **X**, **Shift** + **Y**, **Shift** + **Z**: Similar to above, but we constrain the transformation to the other two axes. For example, **Shift** + **X** constrains the motion to the Y and Z axes.
- *Numerical inputs*: By typing in a number while a transform tool is active and pressing **Return** the object will transform by the amount. Mouse movement will be ignored.
- *Middle Click*: Axes can also choose the axis by using the middle mouse button.
- *Ctrl*: Holding this key temporarily toggles snapping.
- *Left Click*: Applies the current transformation.
- *Right Click*: Cancels the transformation.

Reset Transforms

Rotation, location and scale of all selected objects can quickly be reset to their default values by using the **Alt** + **R**, **Alt** + **G** and **Alt** + **S** shortcuts.

Hide and Unhide

The universal shortcuts for hiding and unhiding that work in different modes and on different object types are:

- *H*: Hides the selected items
- *Alt* + *H*: Unhides all hidden items
- *Shift* + *H*: Hides the unselected items

Hiding objects that are in the way can help reduce visual clutter and allow for easier selection. Keep in mind that hiding bones in Edit and Pose mode is separated so they can be hidden in one and visible in the other.

Data Objects

An object in Blender is a scene element that we can select and transform. Every object also has a data object attached to it. The data object is where the actual data, like bones of an armature or faces of a mesh, is stored. The object and the data are two completely independent entities and a data object can be

linked to many objects. This is essentially how instancing works where a single data object is displayed multiple times in a scene by attaching it to multiple objects.

When we delete an object, it will not delete the linked data object. This can lead to confusion when new objects are created or linked to a scene as name clashing might occur. You can test this by deleting the default cube and adding a new cube to the scene. The new cube will be named "Cube", while its data object will be called "Cube.001" because the "Cube" data object still exists in the scene.

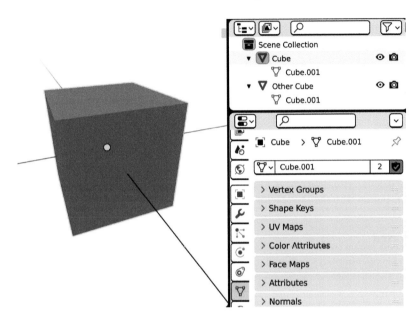

FIGURE 4.4 Display locations of a mesh (Cube.001) data object in the outliner and mesh object properties.

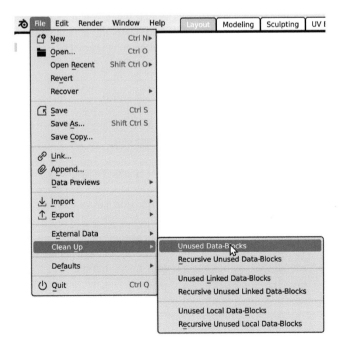

FIGURE 4.5 Clean up menu with data object removal operators.

Users

When data is linked to an object, which is done automatically whenever you create a new object, this tells Blender that this data object has a user. Data objects can have multiple users. For example, you can create a material and assign that material to multiple objects. This means the objects will share the data and changes done to it will be reflected on all users.

The number of users is displayed next to the data object's name in the object data properties (Check Figure 4.4. for reference). The number 2 next to "Cube.001" tells us it has two users. Which we can see in the Outliner as this data object is linked to both cube objects in the scene.

Auto Cleanup

Data objects that don't have any users will not be saved with the Blender file. They live in the currently open session and are deleted when the file is reloaded. Reloading a file is a convenient way of making sure the unused data objects get deleted.

Fake User

To prevent the deletion of a data object with no users, they can enable the *Fake User* option. We do this by enabling the button with the shield icon found next to the number of users (see Figure 4.5).

Remove Unused

Use the Clean Up operators to remove all unused data objects from the scene. The *Recursive* options are more thorough and they remove entire hierarchies of data objects.

Default Scene

Every time you save a Blender file, the user interface, including workspaces, is saved together with the file contents. This is how the default scene, that is loaded when you start Blender, is stored as well. It is just a regular Blender file. We can save the current scene as the default startup file by navigating to *File > Defaults > Save Startup File* from Blender's main menu (Figure 4.6).

3D Viewport Regions

We will spend most of our time in the 3D viewport, so I want to make sure we are familiar with it what the regions are called. Here is a description of its main sections:

- The main region of this view that displays the 3D space and scene objects. I will refer to this zone as the 3D view throughout this book.
- At the top is the header, which hosts the menus, transformation settings, viewport display settings and viewport rendering settings.
- On the left is the *Toolbar* which is often referred to as the T panel because the shortcut for toggling the visibility of this panel is **T**. If a button in this panel has a small arrow in the lower right corner, access additional tools by holding left click on the button.
- On the right we have the *Sidebar* or the N panel, which is also named for its shortcut **N** (Figure 4.7).

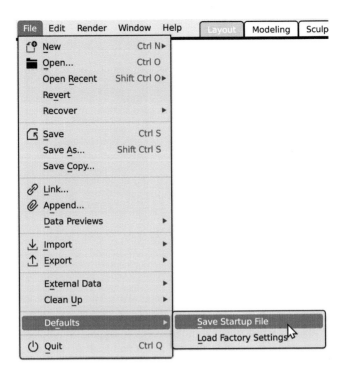

FIGURE 4.6 The save startup file operator location, which saves the current scene as the default scene.

FIGURE 4.7 The 3D viewport.

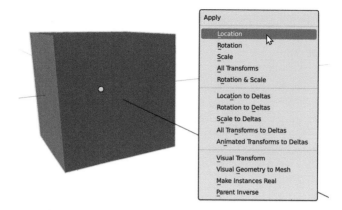

FIGURE 4.8 Object origin represented with a yellow dot and the apply transforms menu.

Object Origin

Every object has an origin point. It is displayed as a yellow dot when an object is selected. This point is used to determine the object's transformation in the world. In rigging, we prefer so-called clean transforms. This means location and rotation values are at 0.0 and scale at 1.0. All actual transformation happens in an armature via bones.

Apply Transforms

We can apply the current transformation of an object to be its default state. Meaning visually the object will not change, but we will clean transformation channels up by setting the current state as the default transformation and moving the origin to the world origin. We do this through the **Object > Apply** menu in the 3D view, or by pressing **Ctrl + A** (see Figure 4.8).

Snapping

In some cases manual aligning of objects to targets is not optimal and we can use instead automatic snapping to ensure an exact alignment.

Snap During Transform

We can snap during transformations and many snap target options are available. You can find the *Snap To* options in the 3D viewport's header, as shown in Figure 4.9. A hidden feature is to use the *Vertex* option to snap to a bone's head or tail, and *Edge* to snap along the body of a bone. The *Volume* option can snap to the center of a mesh.

Toggle snapping by clicking on the magnet icon in the 3D view header. A temporary toggle can be activated by holding the **Ctrl** key after a transformation is started.

Snap

There is an alternative way to align object which is based on selections. Find these options in the 3D viewport menu. The exact location varies based on the current mode:

- Object mode: *Object > Snap*.
- Mesh Edit mode: *Mesh > Snap*.

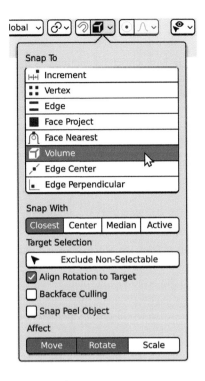

FIGURE 4.9 Snap to menu, found in the 3D view header.

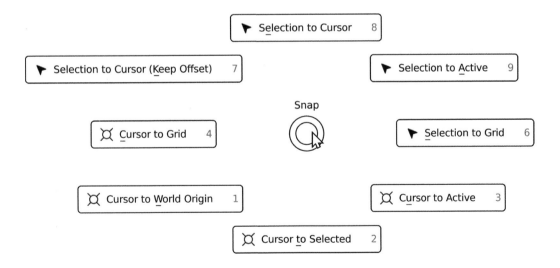

FIGURE 4.10 Snapping pie menu activated with Shift+S.

- Armature Pose mode: *Pose > Snap.*
- Armature Edit mode: *Armature > Snap.*

A faster way to get to the snap operator is to use the **Shift + S** shortcut which invokes the *Snap* pie menu from which the desired snap mode can be selected (Figure 4.10).

3D Cursor

If you are new to Blender, you might have noticed something in the 3D view that looks like a reticle. This is the 3D cursor. It is a point that lives in your Blender scene, which has a location and rotation. On the surface, it doesn't look like there is much to it but it is a very useful feature. Think of it as the thing you can rotate around, scale to, snap to, etc. For example, to place a bone in the middle of a mesh section (e.g. center of an eyeball, middle of a finger joint). You can select that section and snap the cursor to the selection, which will put it exactly at the center of that mesh selection. When you create a bone, or any other object, it will be automatically placed at the 3D cursor's location. Existing bones can be snapped to it, or just their head or tail.

There are four ways to position the cursor:

- *Left Click*: Enable the 3D Cursor tool in the 3D View, from the T panel and left click anywhere in the 3D View to place the cursor.
- *Snap To*: Easiest way to do this is from the Shift+S snap to pie menu.
- Type in values: Navigate to the *View* tab in the 3D view's N panel and find the 3D Cursor transformation fields there. Type in the position and rotation values to set the exact transformations for the 3D Cursor.
- The Cursor's position can be reset to world zero by pressing **Shift+C**.

Once the cursor is placed, you can snap objects to it, or you can be it as the transformation pivot, as discussed in the "Snapping" and "Transformation" sections from this chapter. Refer to those for more information.

Since I love the 3D Cursor so much, here are a few more examples of things you can do with it which would be very hard to do otherwise:

- If you want to change the length of a bone but keep the tail where it is, snap the cursor to the tail, set the transformation pivot to *3D Cursor*, select the bone and scale it. The bone's head should move closer to or further away from the tail.
- We can do the same to rotate the bone around its tail. Bones in Edit mode rotate unusually and rotating around the cursor can give more predictable results, especially when rotating multiple bones at once.
- To find the exact middle of a bone, select it in Edit mode and snap the cursor to it.
- If you want to orient a bone so one of its axes points in a certain direction, place the 3D Cursor there and use the Set Roll tool (Shift+N in Edit mode) with the *3D Cursor* target option.
- You can scale the entire rig in Edit mode from the world zero by resetting the cursor to world zero using **Shift+C**, setting it as the transformation pivot and then scaling the selection.

Symmetry

Many tools are built around the idea that anything that is on the positive side of the world's X-axis is considered being the left side, and everything on the negative side is considered as the right side. This dictates how we should orient the characters and rigs to ensure all tools work as expected. We followed the same convention in the naming of bones. Each side gets a side identifier in its name, e.g. L/R.

Any time I refer to the character's or rig's left or right side in this book, it will always be in relation to this convention, as opposed to when I talk about menus where we are looking at the screen left or right (Figure 4.11).

FIGURE 4.11 The character and rig left and right sides in relation to the world axes.

Outliner

The Outliner displays various types of information about the current Blender file. By default, it is in the *View Layer* mode which handles different object visibility states. This mode is the most useful one for rigging, as it provides an overview of parent/child relationships, visibility, names, and more. I encourage you to explore different modes and learn about what kind of information and functionality they provide (Figure 4.12).

Collections

Collections are virtual folders. They are displayed in the Outliner's hierarchy of objects, but they don't actually adjust object relationships as parenting does. Instead, objects are linked to collections and an object can be linked to multiple collections.

Link objects to collections by using drag and drop in the Outliner, or by using the **M** shortcut in either the Outliner or 3D view. The box with the plus icon in the top right corner of the Outliner is where we create new collections. We can also find this option in Outliner right-click menu.

Collections are very important for rigging, as they provide the means for bundling all components of a character for easy linking into animation files.

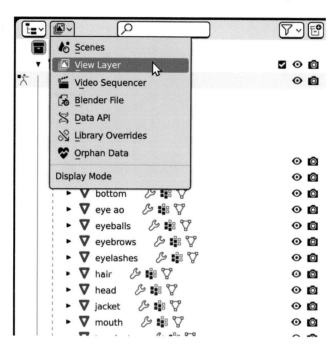

FIGURE 4.12 Outliner display modes.

Properties

The properties view contains many tabs, each dedicated to hosting properties and tools dedicated to different aspects of the current file and active object. See Figure 4.13 for a list of all tab names, including those displayed when the active object is an armature or a mesh.

Modifiers

A modifier is a tool that applies different operations to the mesh in a nondestructive fashion. Nondestructive meaning that the original mesh is preserved and if the modifier is removed, the mesh goes back to its original form. We can make adjustments to the mesh while modifiers are present and they will always operate on the current state of the mesh. We use the Armature modifier for rigging.

Modifier Stack

Modifiers are executed from top to bottom and each subsequent modifier will perform its operation on the results of the previous modifier. The modifier stack, as well as options to add modifiers to an object, can be found in the Properties view under the Modifiers tab, as shown in Figure 4.14.

To add a new modifier, click on *Add Modifier* and choose a modifier from the list that pops up. Reorder modifiers by clicking and dragging their headers, and remove them by clicking on the X icon in the header. There are four additional toggles in the header. The second button toggles the visibility of the modifier's effect in Edit mode, and the first button additionally aligns the mesh to the results. The last two buttons toggle the modifier's effects in the 3D view and in rendering. Finally, there is the chevron button, which hides additional operations like applying the modifier.

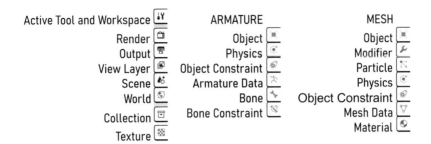

FIGURE 4.13 Names of all properties view tabs. Left are the global sections, middle tabs are displayed when an armature object is active and right when a mesh object is active.

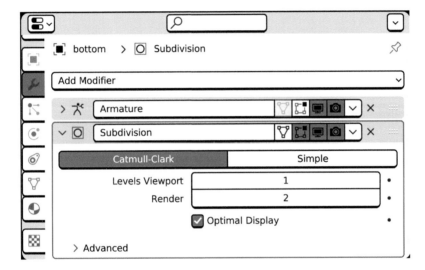

FIGURE 4.14 A mesh object's modifier stack, in the properties view, with an armature and subdivision surface modifier present.

Units

All Units settings, which we find in the Scene Properties view, are a matter of preference and only change how the numbers are displayed. Except one, which is *Unit Scale*. *Unit Scale* does what it says, it scales units, and it does this by multiplying them by the *Unit Scale* value. Which changes the perception of object scale where the other settings only convert the units between different conventions.

Both Unreal Engine and Unity have a unit system that is 100 times larger than the one in Blender. Meaning that if we export a box from Blender that is 1 m tall, which equals to 1 Blender unit, it will be 1 cm tall in those engines. And both automatically see this as too small and give the imported object a scale of 100.

So we have a choice: ignore this and accept that all our rigs will have a scale of 100 in a game, or change the *Unit Scale* so that units we see in Blender are the same as those in the game engines. The former can work but could cause issues in the game, and the latter means that all the measures are now multiplied by 0.01 so we have to scale all objects by 100 to compensate. Meaning that all objects will be gigantic in Blender terms, which is what I choose to do and have a clean scale value in the game. We should apply scale values using **Ctrl + A** and choosing the *Scale* option.

FIGURE 4.15 Unit settings found in the Scene properties view.

If you notice that objects or parts of them are disappearing after changing *Unit Scale* and scaling all objects by 100, this is probably due to view clipping values. View clipping is the distance from the camera that Blender considers visible, and we can change it from the *View* tab in the N panel. A *Clip Start* value of 1 cm and *Clip End* of 10,000 cm usually works well (Figure 4.15).

Import, Link, Append

Import

To add an external file (e.g. image or mesh) to the scene, use *File > Import*. If a character mesh is not delivered in a Blender file, chances are that it will come as a ".obj" or ".fbx" file which we can import using the *Import* menu and the corresponding importer. Blender cannot import formats native to other DCCs, e.g. Maya's ".ma" or ".mb". These have to be exported from those DCC's to one of the universal formats which Blender can import.

Link

We use Link and Append for object transferring across Blender files. The Link option will not add a copy of the object to the current file. Instead, it references the object from the original file. The purpose of this is to enable users to split work between files so we can work on them independently and link them to different scenes for animation. When the object is changed in the original file, the referenced object will get updated automatically. We can make some properties of a linked object adjustable by creating a library override. We do this through the 3D view's menu by navigating to *Object > Relations > Make Library Override* with the target object active.

Append

Append adds a copy of an object from a different Blender file. Meaning that any changes made to an appended object will not be propagated to the different files. There are no editing restrictions on appended objects as they are essentially the same as objects created in the scene.

Animation

There are five animation-related views in Blender. Is that too much? It absolutely is. There are many features that they share, but each has a unique purpose and we use them for specific types of tasks, so we have to at least mention all of them (Figure 4.16).

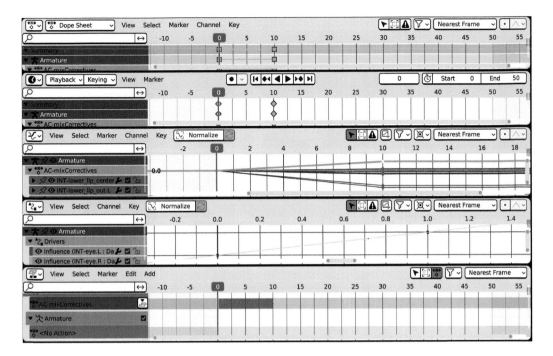

FIGURE 4.16 Blender's animation views, from top to bottom: Dope sheet, timeline, graph editor, drivers, nonlinear animation (NLA).

Actions

All animation information is stored in objects called actions. Just like meshes are created in mesh objects, keyframes are in actions. Whenever a keyframe is created, if there is no action assigned to the object already, a new action will be added and assigned to the object. Only one action can be linked to the object and edited, but multiple actions can be played back together through the use of the Nonlinear Animation editor.

Warning, actions that don't have users will be deleted when the file is closed. Set the *Fake User* flag to be enabled on all actions you want to be saved.

When working with armatures, keying them in Object mode sets a keyframe on the object itself and not on the data inside. Keyframing of the data happens in Pose mode. The recommended workflow is to always animate characters in pose mode. Hence why we add a world control that transforms the entire characters, instead of transforming the armature in Object mode.

We manipulate actions through the Dope Sheet's *Action Editor* mode (see Figure 4.17). This menu displays the active object's linked action and gives the options for naming, duplicating, un-linking and toggling the *Fake User* option. It is not possible to delete actions through this menu. Instead, change the Outliner to *Blender File* mode and delete actions from there. Actions and animation are further explained in the "Animation" chapter.

Dope Sheet

If you are hearing about the dope sheet for the first time, as funny as it sounds, this is its real name. It has several modes, but the only ones relevant for us are the default *Dope Sheet* mode and the *Action Editor* mode. We chose the mode from the drop down menu in the Dope Sheet's header.

The default and *Action Editor* modes are almost exactly the same. The only difference is that the latter adds options for manipulating actions. See Figure 4.18 for reference.

Timeline

Besides the playback controls, the Timeline is where we can adjust viewport playback and keying settings. An important feature to keep in mind is *Auto Keying*, which is represented by the record button

FIGURE 4.17 Dope sheet in action editor mode, with the expanded list of actions. Non I have edited relevant options out of the image for clarity.

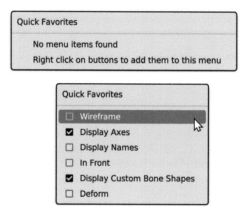

FIGURE 4.18 Quick favorites menu, empty and with items added in armature edit mode.

next to the playback controls. When enabled, this feature will add a keyframe for any change that is made to the scene. Timeline also allows for keyframe manipulation. We can perform various operations on the keyframes e.g. changing time, duplicating, deleting.

Graph Editor

The Graph Editor is used to adjust keyframe values and the way these values are interpolated between keyframes. There is a lot of depth to this and it is mainly oriented towards animators.

Drivers

On the surface, this editor looks very similar to the Graph Editor, but it serves a very different purpose and is important for rigging. I cover everything related to drivers in the "Drivers" chapter.

Nonlinear Animation

We can chain together or layer multiple actions through the use of the Nonlinear Animation editor. It is not very relevant for rigging, besides the fact that it can create a selection of actions to be exported out of Blender. More on this in the "Export" chapter.

FIGURE 4.19 The adjust last operation menu that appears after a move transformation is done.

Quick Favorites

The Quick Favorites is a pop-up menu we can populate with frequently used properties and operators. These menus are unique to different views and different modes within them. To display the Quick Favorites menu, press **Q**. To add an item to the menu, right click on it and select *Add to Quick Favorites*. If the item is already in the menu, this option will be replaced with *Remove from Quick Favorites*.

Preferences

We can make adjustments to how Blender functions and what it looks like from the Preferences menu. Which is accessed by clicking on *Edit > Preferences* in the main menu. These settings apply to the entire application. There are two options I like to change which slightly improve the rigging experience.

To make it easier to see bones and custom shapes, under the *Interface* preferences, change *Line Width* to *Thick*. In the *Navigation* section, enable *Orbit Around Selection*. Since we will be working with loads of bones, this option makes it easier to keep the selected bone in focus.

Operators

Operators are functions that are executed when we click on buttons and menus or press shortcut keys. Pretty much whenever we are performing actions in Blender e.g. move an object, add a mesh, we are running Operators.

After we execute an operator, we can further adjust its input values through the *Adjust Last Operation* menu that will appear in the lower left corner of the 3D view (see Figure 4.19).

Blender Python API

Most, if not all, manual steps required to assemble a rig can be automated using Python code. Scripts and add-ons for Blender are created using the Python language and the Blender Python API (Application Programming Interface). The API is provides a way to access Blender's internal data and commands.

Add-ons

Blender comes packed with add-ons, some enabled by default and others that you can enable by navigating to *Edit > Preferences* and switching to the *Add-ons* tab in the Preferences window.

5

3D World and Transformation

To fully understand rig mechanics and the reasons behind their behaviors, it is necessary to grasp the principles governing the 3D space in which they operate. A thorough understanding of these rules and principles is crucial as much of rigging involves manipulating these rules to achieve a specific behavior.

World Space

Imagine an empty, dark void on the screen. To create a 3D world within it, we need to define three axes for objects to move in: the X-axis for left and right, the Y-axis for front and back, and the Z-axis for up and down. Blender displays these axes in red, green, and blue, respectively, and they intersect at a point called the world origin or world zero.

To measure the distance of an object from the origin, we divide each axis into equally long segments, creating a 3D Cartesian coordinate system, which is like placing three rulers perpendicular to each other. Once we have the origin, axes, and units, we can place objects in the world by defining their location as the distance from the origin, their rotation as the angular difference to the world axes, and their scale as a multiplier of their distance.

We call this "world space transformation," and it involves using the world origin as the reference point for object transformations. We later see that there are other types of spaces that can be used, including spaces that can be nested within each other (Figure 5.1).

From this point forward, we will use the word "transform" both as a verb and as a noun. As a verb, it means to change an object's location, rotation, and/or scale. As a noun, a transform refers to the current

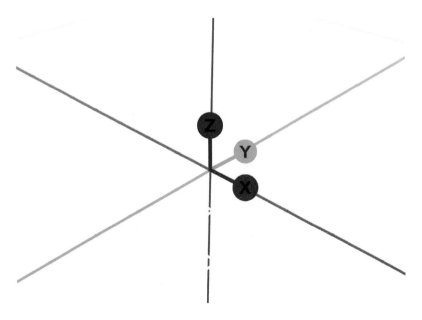

FIGURE 5.1 The world axes.

DOI: 10.1201/9781003263166-5

combined state of an object's location, rotation, and scale. When we say that we are transforming an object along a world axis, it means that the transformation is occurring in a direction that aligns with one or more of the world axes.

Vectors and Translation

In 3D space, the distance from the world center (i.e. the object's location) can be described using X, Y, and Z coordinates. This is like giving someone street directions, where X corresponds to the street, Y corresponds to the avenue, and Z corresponds to the building floor.

Instead of having to specify each coordinate separately, we can use a vector to represent the coordinates as a single set of numbers, such as (2, 3, 5). Vectors are useful for a variety of tasks, including calculating the rotational difference between objects, finding the distance between objects, and identifying orthogonal directions to objects. While it is not necessary to understand all the math behind vectors, it is important to know how to use the tools in Blender that perform these calculations for us. Essentially, we can think of a vector as a line that points from the starting point to the target location, and it has both a length and a direction (Figure 5.2).

Euler Rotation

In Blender, every object has the option to use either Euler or Quaternion rotation modes. And there are two levels to this: the user-facing level, where we choose how we want to manipulate the rotation, and the internal level, which determines how Blender handles rotation internally.

For rigging, it is essential to understand the different options for rotation, as the behavior of rotation axes and the rig itself will depend on the rotation settings. Blender is highly flexible, as we can set bones to use different rotation modes, and drivers and constraints have their own settings for evaluating rotation.

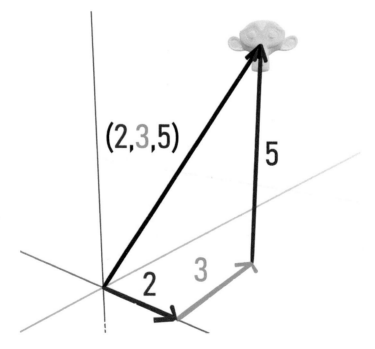

FIGURE 5.2 A vector representing the position of an object in world space.

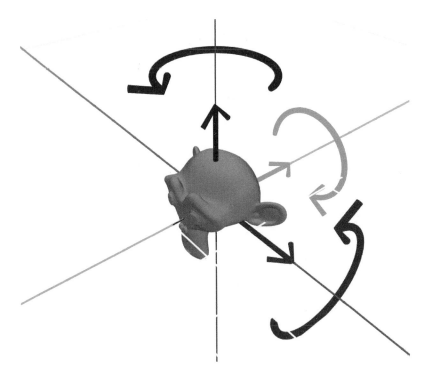

FIGURE 5.3 Visualization of the world space rotation axes.

Euler rotation is defined by rotating around each of the three axes, similar to how translation is defined by moving along the axes. If an object's rotation is specified as (30, −50, 10), this means that the object is rotated around the X-axis by 30 degrees, around the Y-axis by −50 degrees, and around the Z-axis by 10 degrees (Figure 5.3).

Rotation Order

With translation, the order in which Blender applies the transformations does not matter. For example, whether we first move an object in Z, then Y, and then X, or any other combination, the result will always be the same. Euler rotation is more complex than translation. While the order in which the rotations are written and stored is always X, Y, and Z, the final rotation can be calculated in six different ways, depending on the order in which the rotations are applied. These variations are XYZ, XZY, YXZ, YZX, ZXY, and ZYX.

To understand how this works, let's consider the YXZ rotation order and a rotation of (60, 50, −30). The rotation is stored as XYZ, but it is applied in the YXZ order. Euler rotation is applied from back to front, so with a YXZ rotation order, the object is first rotated around its Z-axis, then around its X-axis, and finally around its Y-axis. For our example rotation of (60, 50, −30), the object would first be rotated around the Z-axis by −30 degrees, then around the X-axis by 60 degrees, and finally around the Y-axis by 50 degrees.

The reason the resulting rotation would be different depending on the rotation order is that each axis will also rotate the subsequent axes. For example, when using a YXZ rotation order, the rotation on the Z-axis is applied first, which rotates the Y and X axes around the Z-axis. Then, the rotation on the X-axis is applied, which rotates the Y-axis around the X-axis (see Figure 5.4) and notice how YXZ and XYZ rotation modes, with the same rotation values, produce different end results. You can also see how the axes rotate other axes.

To test this in Blender, follow these steps:

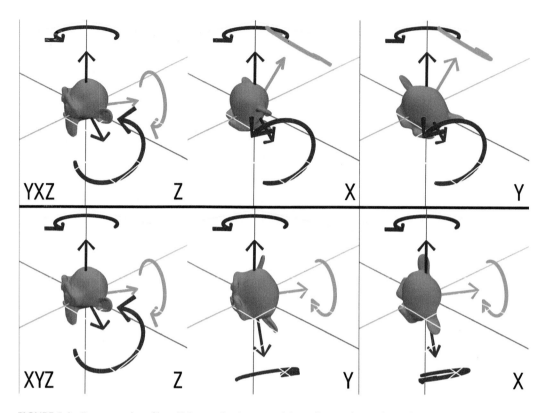

FIGURE 5.4 Representation of how Euler rotation is executed depending on the rotation order.

- Add a mesh object
- Enable the *Rotation* tool
- Switch *Transform Orientation* to *Gimbal*
- With the object active, locate its *Rotation* parameters in the N panel's *Item* tab,
- Change rotation modes and rotate the object in different axes while looking at what is happening to the rotation tool's gizmo.

The *Gimbal* mode will show you exactly what the rotation axes are doing. This is the only true representation of their state. *Local* is easier to work with but can sometimes be misleading, as rotating in Euler offsets the rotation axes and behavior can become somewhat unpredictable, which leads us to the topic of gimbal locks.

Gimbal Lock

In Euler rotation, the rotation of one axis can cause the rotation of subsequent axes to become aligned with each other. This is known as gimbal lock, which occurs when rotating an object around the middle axis in the rotation order. You can test this by rotating an object 90 or −90 degrees around the Y-axis in the XYZ rotation mode. As shown in Figure 5.5, this will cause the X and Z axes to become aligned, making it difficult to rotate the object along the third axis. We can still rotate the object in 3D, Blender will figure out how to do that for us.

The problem is how the object will animate as the axes are aligned. When animating in the Euler mode, gimbal locks are hard to avoid and the best we can do is make sure we set the rotation mode for each control bone to an order that makes it least likely for gimbal lock to happen.

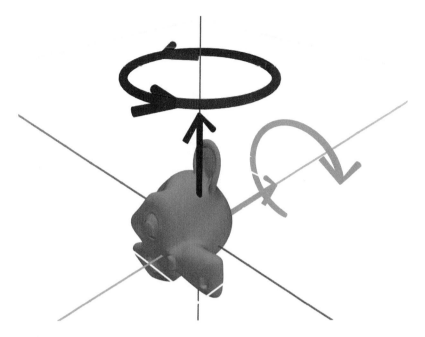

FIGURE 5.5 Gimbal lock caused by rotating an object by 90 degrees in Y, with the rotation order set to XYZ.

Quaternion Rotation

Quaternions are another type of mathematical representation that can describe rotations. While the concept behind them is relatively simple, i.e. a rotation is described by a vector and a twist around that vector, the math involved in working with quaternions can be quite complex. Quaternions are represented by a four-dimensional number (WXYZ).

One advantage of using quaternions is that they do not suffer from gimbal lock. This makes quaternions more predictable and reliable for certain types of rig setups, such as those that depend on having a clear axis for bones to twist or swing around. However, quaternions are less user-friendly than Euler rotations. For character animation, it is often more practical to use Euler rotations and deal with any potential gimbal lock issues that may arise.

Scale

Scale is a transformation that allows you to change the size of an object. It works by multiplying the length of the object's XYZ axes by a scale factor. For example, if you have a cube with all of its vertices a certain distance from the center of the object, and you set the cube's scale to (2, 2, 2), the distance of the vertices from the center will be doubled, making the cube appear twice as large. Scale can affect the size of the object's components and children.

Parenting, Local and Pose Space

Until now, we have been discussing object transformation in relation to the world space. However, it is also possible to transform an object in relation to another object's space. Essentially, every object has its own origin and axes, just like the world, but the world space is fixed and cannot be transformed, while we can transform objects.

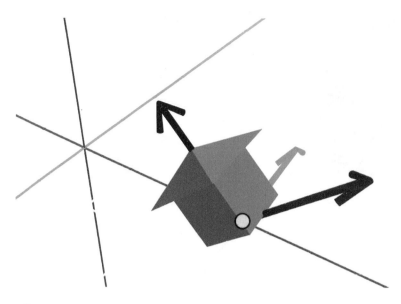

FIGURE 5.6 Objects and axes in relation to the world.

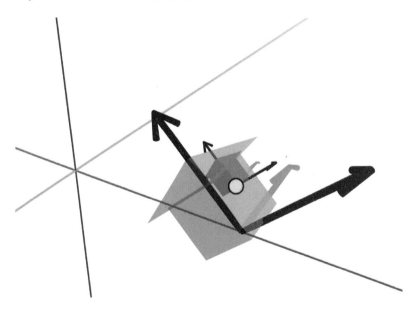

FIGURE 5.7 Nested, or parented objects, where the child object inherits the parent's transformation.

To better understand this concept, let's consider an example. Imagine a house on a field. The house's reference space is the world, meaning that its location, rotation, and scale are all based on the world zero, or the reference point in the world space. If we move the house three units in the X direction, it means that it is three units away from the world zero. Similarly, if we rotate the house −45 degrees around the Y-axis, it means that the rotation is offset by −45 degrees from the world zero (see Figure 5.6).

Imagine that there is a small doll house inside the house we just discussed. We can view the doll house in terms of its location in the world, or in relation to the larger house. If we transform the larger house, the dollhouse will transform along with it. And if we consider what is "up" for the dollhouse, in relation to the larger house, it is towards its roof, which differs from what is "up" in terms of the world. (see Figure 5.7).

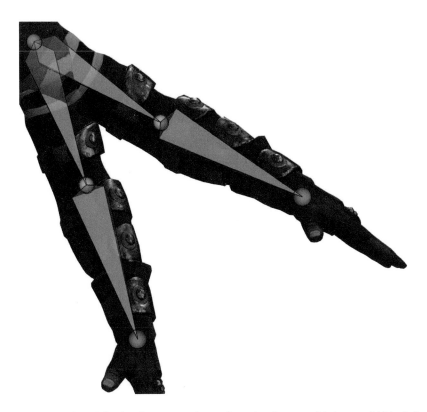

FIGURE 5.8 Lower arm bone following the upper arm's transformation, because of their parent/child relationship.

This concept of one object's transformation being nested within another object's transformation is called parenting. Here, the larger house is the parent and the dollhouse is the child. It's possible for a child object to have its own children, which can be nested infinitely. The transformation of a child object in relation to its parent is called local space.

When a bone is parented to another bone, its transformation is displayed in local space values. This means that the bone's position, rotation, and scale are based on its parent's transformation, rather than the world space. For example, if you set the child bone's location to five units in the X direction, it means that the bone will be placed five units away from the parent bone in the direction of the parent bone's X-axis. Bones are never actually in the world space because they are always nested within an armature object. This means that the armature object is in the world space, while the bones are in armature's space which tools refer to as Pose space.

Parenting is a basic technique used in rigging, which involves creating a hierarchy of objects that mimic the relationships between body parts. For example, to create a simple arm rig, you will need bones for the upper arm, lower arm, and hand. In a real arm, if the upper arm rotates, the rest of the arm will follow along. To replicate this behavior in a rig, you can parent the lower arm bone to the upper arm bone, and the hand bone to the lower arm bone. This creates a chain of objects, with each consecutive bone inheriting the transformation of the previous one (see Figure 5.8).

Order of Execution

The order in which Blender internally evaluates transformation information is independent of the order in which the user applies the transformation. This means that if you move an object and then rotate it, or you rotate and then move it, the resulting transformation will be the same.

Blender always applies rotation last. So, no matter the order in which you apply the transformations, Blender will first apply the location and scale values, and then apply the rotation.

If it applied rotation first, the orientation of the object's axes would change before the location and scale values were applied. This would cause the object to move and scale in different directions depending on the orientation of its axes after the rotation. However, because Blender applies translation and scale first, they are always applied with the three axes matching the space the object is in.

6

Armatures

Fundamentals

We use armature objects for creating and animating character rigs. They host an armature data object that contains bones, which can be manipulated in two different modes: edit mode and pose mode. These modes are similar to how mesh objects have a linked mesh data object and offer a mesh edit mode for manipulating meshes.

An armature object can use other objects, such as empties, curves, or even other armatures, as part of its rig. However, it is not always necessary to do so, and it is often simpler to keep all rigging elements within a single armature. Drivers and actions, which we often use in rigging setups, do not technically belong to the armature, but we still consider them part of the rig.

Bone weights, also known as vertex groups in Blender, are an important aspect of character rigs. However, they are not stored within the armature object. In Blender, bone weights are stored with the mesh object. We will discuss this further in the "Weights" chapter.

To create an Armature, in the 3D viewport's menu and select *Add > Armature*. Or, with your cursor over a 3D view, press **Shift + A** to bring up the same Add menu and create the Armature from there.

I want to briefly mention armature space here. All bones that are contained in an armature behave the same way parenting works between two objects. Meaning if a bone is not parented to another bone, it will be in the armature space.

The usual practice is to keep the armature object at world zero with no transformation applied to it, at least during the rigging process. Non-zeroed-out transforms on the armature object may cause issues in rigging or animation.

Modes

An armature has three different modes: Object, Edit and Pose. Only one mode can be active. To set the current mode, use the modes drop-down menu from the 3D view header. **Tab** and **Ctrl + Tab** can change modes and how this shortcut behaves depends on which mode is currently active.

In Object mode:

- **Tab** toggles between Object and Edit mode
- **Ctrl + Tab** toggles between Object and Pose mode

In Edit Mode:

- **Tab** will toggles between Object and Edit mode
- **Ctrl + Tab** opens a Pie Menu that allows you to select any mode

In the Pose Mode:

- **Tab** toggles between Edit and Pose mode
- **Ctrl + Tab** toggles between Pose and Object

FIGURE 6.1 Armature modes menu, found in the 3D view header.

This might sound complex, but it is something we do very often when rigging, so it is worth remembering these shortcuts (Figure 6.1).

Object

In Object mode, there are only a few actions that we typically perform with an armature. These include binding and parenting meshes to the armature, and selecting the armature as the target for weight painting when entering Weight Paint mode with a mesh.

Edit

This mode is all about creating bones and setting up their default state. At any point in time during the rigging process, we can freely manipulate bones in Edit mode without affecting the attached meshes. And whatever the state we leave the bones in while in Edit mode, this will become their default values in Pose mode. This feature allows us to be more experimental in the early stages of rigging a character. We do not have to commit to bone positions and orientations early on. Bone creation and parenting are only possible in Edit mode.

Pose

Pose mode is where we set up the bone behavior. Mainly using parenting, constraints and drivers. We can also change the look of bones in this mode by replacing their default shape with custom mesh shapes. This mode is also where bones get animated.

Rest Pose

In Edit mode, the state the bones are in is automatically saved as what is called "rest pose". When switched to Pose mode, the location, rotation and scale values will always default to that state. This is crucial for animation, as we want bones to go to this default state when all transformation channels are reset. If we didn't have this extra layer of transforms, all bones would go to world zero when their transforms are reset.

We can preview the rest pose in Pose mode by toggling between the Pose Position and Rest Position buttons from the Armature Data properties menu. Bone transformation will be locked while the Rest Position option is enabled and constraints or drivers will have no effect on bones.

Pose Apply

Changes made to bones in Edit mode are propagated to Pose mode, but transforming them in Pose mode does not influence them in Edit mode. Which is the desired behavior most of the time. If needed, it is possible to transfer the Pose mode transformations to Edit mode using the Apply Pose operator.

FIGURE 6.2 Apply menu activated using *Ctrl+A* in Pose mode.

To apply the current Pose mode bone transformations to Edit mode, in the 3D viewport menu, select *Pose > Apply> Apply Pose as Rest Pose* or *Apply Selected as Rest Pose*. These will apply the pose to all bones or just the selected ones, respectively. You can also bring up the same menu with the **Ctrl+A** shortcut while in Pose mode.

The *Apply* menu has two additional options. *Apply Visual Transform to Pose* writes all transformation values caused by constraints or drivers to the bone's Location, Rotation and Scale properties. *Assign Custom Property Values as Default* will change the default value of custom properties to the values that they currently have.

Applying the pose does not affect the mesh. You might notice it reset when bone transforms are applied as rest pose because this sets a new default transformation for the bones so bone transformations that were deforming the mesh are now gone. If you want to apply the current state of the mesh so it stays at the same state once the pose is applied to bones, simply make a copy of the armature modifier and apply the duplicate modifier. The mesh will be double deformed until the pose is applied as rest pose on all transformed bones (Figure 6.2).

Armature Properties

In this section, we will look at the Armature Data section of the properties view. There are in total seven panels within this section and I will skip three of those (Inverse Kinematics, Motion Paths and Custom Properties) because they are not relevant to this book.

Skeleton

At the top of the Skeleton panel is the *Rest Position* toggle. When enabled, in Pose mode, it will override all transformations that are on bones and force them to assume the rest pose. Quickly toggling between Pose and Rest positions can be useful for identifying problems in a rig, e.g. when something is moving and it is hard to find which bone is causing the motion.

To create sets of bones that can be shown or hidden as a group, every armature has a set of 32 visibility layers, found in the Skeleton panel as small boxes with circles on them (see Figure 6.3). The idea behind this feature is simple: assign any number of bones to a layer, then click on the layer to toggle the visibility of those bones. This is a separate feature from hiding bones using **H**, which overrides the layers and hides a bone regardless of the layer visibility.

We use layers for organizing the rig, hiding all rig mechanics from animators, as well as creating a way for animators to isolate different controls when working with the rig. My approach in creating visibility groupings is to group control bones by body section and by level of detail. As well as designating a layer for each extra section, like a prop, bag or similar. For example, I will have a group for an arm's FK controls, another one for IK controls, then one for tweak controls, and finally one for fingers. I take a similar approach to non-control bones, deformation bones have their layer, as do the intermediate bones and so on.

FIGURE 6.3 The Armature Data properties panels we will be utilizing in rigging.

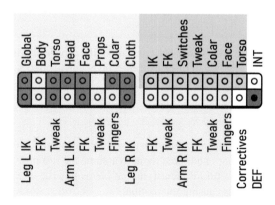

FIGURE 6.4 Visibility layers grouping example.

Figure 6.4 illustrates how bone layers can be used to organize bones. DEF and INT bones have their designated layers, all green layers are reserved for control bones, blue layers host MCH bones split by roles, and lastly, Correctives is a mix of INT and MCH bones used for the creation of correctives.

To switch between layers simply **Left click** on one layer, this will enable it while all other layers will be disabled. To toggle a layers visibility without changing visibility of other layers, use **Shift + Left click**.

There are two major ways of assigning Bones to Layers. The first one is to assign them through the *Bone Properties* menu. In the *Relations* tab, **Left click** on any of the boxes to move the bone to that layer. By using **Shift + Left click** bones can be added to multiple layers. The other way to adjust visibility layer assignments is to use the **M** shortcut while hovering the mouse over the 3D view. This will affect all selected bones.

Protected layers are used as a safety measure so that bone layers that are not intended for animation can't be changed. Each of the protected layers corresponds to the bone layer with the same index and they are only relevant for rigs linked to other files. Any changes done to bones that are in a protected layer will be reverted on file reload.

Bone Groups

We use bone groups for coloring bones in the 3D view. This is useful for color coding different bones by rig side and importance. For example, controls in the middle of the rig get one color, those on left and right get a different color each, and tweak bones get a color of their own. I usually apply this only to control bones but use what works for you.

Each bone group can choose between different colors sets, which consist of three colors each. Which color applies to the bone depends on the selection state of the bone, i.e. unselected gets one color, selected a second one and active the third one.

The process of working with bone groups is:

- Press the+icon to add as many bone groups as desired.
- Click on a bone group from the list to select it, double click to rename it.
- Choose the color for the selected group by selecting it from the *Color Set* menu below
- Select bones you wish to assign to the active group and press *Assign*.
- To remove bones from a group, select the bones, make sure the group is active and press *Remove* (Figure 6.5).

Viewport Display

Display as changes the display style of bones. The options are: *Octahedral*, *Stick*, *B-Bone*, *Envelope* and *Wire* (see Figure 6.6). These display options are relevant for rigging and not as much for animation as animation-oriented control bones will receive custom mesh shapes.

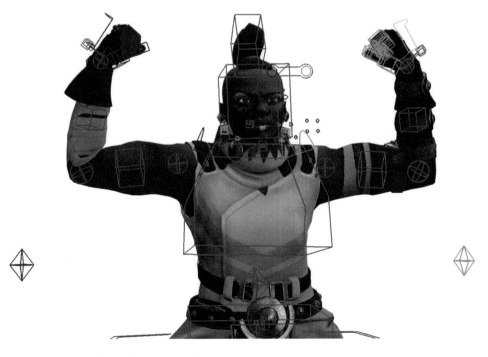

FIGURE 6.5 Example of control bone color coding using bone groups.

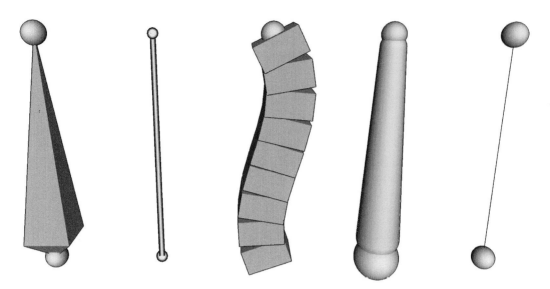

FIGURE 6.6 Bone display modes. From left to right: Octahedral, stick, B-bone, envelope, and wire.

I never use *Wire* and *Stick*. They don't provide any information about a bone's direction, orientation or thickness. *Envelope* is used for previewing bone envelope bounds for envelope based skinning. It's rare to see someone handle weights this way so you won't see this mode used much for game rigging.

Octahedral is a useful mode as it provides us with a lot of information at a glance. My favorite is B-Bone. Besides displaying B-Bone specific information like divisions, twist, or curvature, a unique display property they have is Thickness. This is a purely visual change and allows us to differentiate between bones that are laying on top of each other. To change the thickness on selected bones, use the **Ctrl + Alt + S** shortcut in the 3D view. By adjusting their thickness, we can see all three of them. More on using bone thickness for visual organization in the "Dealing with visual clutter" chapter.

What the rest of the Viewport Display options do is straightforward:

- *Names*: Displays bone names.
- *Axes*: Shows the local axes for every bone. Axes has a position slider which moves the display location of the axes between the head and tail.
- *Shapes*: A global toggle for enabling and disabling the display of custom bone shapes.
- *Group Colors*: Same as above but for displaying bone group colors.
- *In Front*: When enabled, bones will be displayed in front of meshes.

We will be often toggling these on and off depending on what information we require at a certain point in time. I recommend adding them to the Quick Favorites menu for easy access.

Selection Sets

Selection sets are a tool mainly oriented towards animators. They enable us to create groups of bones which can easily be selected or deselected from the Selection Sets panel or from the 3D view using the **Shift + Alt + W** shortcut.

To create a selection set follow these steps:

- From the Selection sets panel press the+button to create a new selection set.
- Double click on the newly created set to give it a descriptive name.
- Select bones you wish to add to this set.
- Press the *Assign* button.

Towards the end of the rigging process, will fill this with selection sets list to create convenient ways for animators to select bones based on rig parts like arms, legs and similar.

7

Bones

Structure

Bones are extremely versatile and much of Blender rigging is done with bones. Based on what we decide to use a bone for, the different aspects of a bone's functionality will become relevant. You might have heard about control bones, deformation bones, bendy bones, etc. There is actually only one type of bone, and those names are describing what the bone is being used for or what functionality of a bone is used.

Where a bone or joint is like an empty group or a locator in other software, they are a bit more feature heavy in Blender. Let's start by looking at their anatomy (see Figure 7.1). A bone starts at the head and ends at the tail. We refer to this as a bone's direction.

Here are a few advantages Blender bones have because of their anatomy:

- Having a head and a tail makes it much easier to place bones since we can grab and move either of them or the whole bone by grabbing the body.
- We can constrain bones to each other and specify if we want to attach to the head, tail or anywhere along the body.
- When we attach geometry to bones, having a head and tail helps Blender guess which parts of the geometry to assign to which bone.

In Edit mode, we have access to a bone's head, body and tail and can adjust any of them. While in Pose mode we can only select and transform the bone as a whole.

Every bone also has an orientation. Toggle the axis visibility in the Armature Data Viewport Display tab. These axes show us how the bone is oriented and helps us see in which direction will the bone rotate for each axis. There is no option to change the bone axis order in Blender. Meaning Y is always going to be the axis that points from a bone's head to tail.

Edit vs Pose Mode

Bones have two layers of transforms. First is the one in Edit mode. We defined this during rigging and it is not possible to animate it in Edit mode. When in Pose mode, we get access to the second layer of bone transformation. These transformations can be animated.

The way we transform bones in Edit mode is somewhat unconventional. Instead of location, rotation and scale, there is head, tail and roll. Under the hood, Blender will convert all these properties into the standard transformation channels, and this interface is there to make it more convenient to work with bones and their extra features.

FIGURE 7.1 Bone parts.

DOI: 10.1201/9781003263166-7

Bone Properties

Depending on which mode is currently active, Edit or Pose, what is displayed in the Bone Properties view might vary. Some options are exclusive to specific modes, others are present in both but have unique values and some are shared between modes.

Transform

The combination of the Head and Tail positions and Roll in Edit mode defines what the default, or so-called "zero", transformation in Pose mode will be. Any changes made to the bone transform in Edit mode will automatically be saved as the new zero transformation for Pose mode. Mesh deformations happen only when bones are transformed in Pose mode, meaning that we can freely adjust them in Edit mode with no consequences on the mesh.

We transform a bone in Edit mode by adjusting the location of the Head and Tail bones, which will change the bones position and rotation, since the bone will orient itself so that its Y-axis is always pointing from Head to Tail. We can further adjust rotation by changing the Roll value which turns the bone around its Y-axis.

The Lock button in Edit mode freezes the bone so that it can't accidentally be changed. Pose mode has individual lock options per transformation channel.

We can change the rotation mode and rotation order in Pose mode at any time, even in the middle of an animation. Changing the rotation mode usually has no consequences on the rig as the features that might depend on the rotation order, i.e. Drivers and Constraints, have their own options for specifying how the rotation should be evaluated independently from what is set in the Transform options. But this is relevant for animation, as it defines how rotation is interpolated between keyframes. Note that keyframes are not shared between Quaternion and Euler rotation. Meaning that even though the rotation mode can be switched at any point, and even animated, keyframes have to be set to the rotation in the mode that is active (Figure 7.2).

Bendy Bones

Bendy bones (B-Bones) are a rigging system within itself. In the most basic terms, this feature converts a single bone into a Bézier curve segment. Which has the same features as a regular Bézier curve, meaning

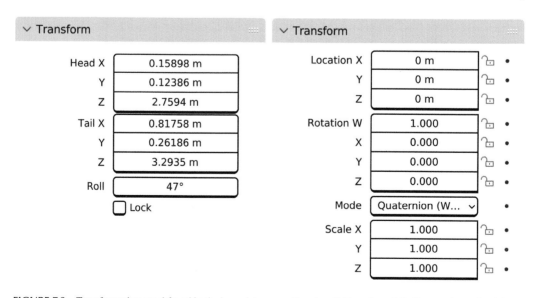

FIGURE 7.2 Transformation panel found in the bone data properties view. Edit mode on left, Pose mode on the right.

control over its tangents, scale of each point and twisting. Figure 7.3 is a visualization of what this invisible Bézier curve that is defining the look of B-Bones looks like.

Every bone can become a B-Bone but we can't see its features until we increase the number of *Segments* and the armature's *Display As* mode is set to *B-Bone*. For game rigging, we cannot use B-Bone as deformation bones. This feature is unique to Blender and it cannot export them to game engines. If you export a B-Bone, when imported into other software, it will look and behave like a "normal" bone. This does not mean we shouldn't use them in rigs at all.

Even though the Bendy Bones properties panel looks exactly the same in both Edit and Pose modes, see Figure 7.4, most of the properties are layered similar to how the transformations have Edit and Pose mode values. Default values can be defined in Edit mode and when switched to Pose mode those values will be stored as the rest pose and the properties will have default values. This applies to all Bendy Bones properties except Segments, Inherit End Roll, Scale Easing and the parameters related to Handles. Those are shared between modes.

Many B-Bone properties have "In" and "Out" values. "In" values adjust the B-Bone at the head of the bone, while "Out" values adjust it at the tail side. Here is an explanation of what each B-Bone property does:

- *Segments*: Defines how many segments the B-Bone should be split into. The higher the number the more defined the bones curvature will be, but extremely large numbers might slow the rig performance down.
- *Display Size*: Changes how thick the bone will be displayed in the 3D view.
- *Curve In/Out*: Changing these values rotates the Bézier curve tangents that define the B-Bone.

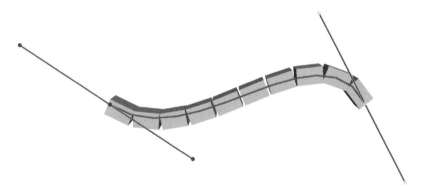

FIGURE 7.3 A visualization of the invisible Bézier curve segment that a B-Bone represents.

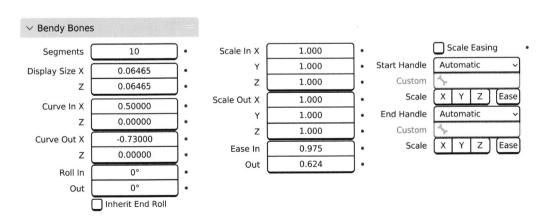

FIGURE 7.4 Bendy Bone properties, found in the bone data properties view.

- *Roll In/Out*: Adds twisting along the bone.
- *Inherit End Roll*: If a B-Bone is a child of another bone, enabling this value will add the twisting that happens at the end of the parent bone to the start of this bone.
- *Scale In/Out*: Scales the B-Bone, which affects any meshes weighted to the bone.
- *Ease In/Out*: This value multiplies the length of the curve's tangent handles. When the value is at zero the curve will turn into a straight line.
- *Scale Easing*: If enabled, the Scale In/Out values will multiply the Ease In/Out values.
- *Start/End Handle*: Handles change how the B-Bones twist and curvature are controlled and provide the option to control a B-Bone's parameters using another bone. The Start/End Handle Type parameter gives us a few options to choose from:
 - *Automatic*: The bone's parent and child will act as the start and end handle, respectively. For this to work, the bones need to be connected.
 - *Absolute*: The position and rotation of bones assigned to the *Custom* fields are used to calculate the tangents. The In tangent will always aim at its handle's head, and the Out tangent will always aim at its handle's tail. The roll is changed by adding rotation on the handle's Y-axis.
 - *Relative*: is unstable and not recommended for use so we will skip it and ignore its existence.
 - *Tangent*: In this mode, the B-Bone is controlled by the custom handle's rotation.
- *Custom*: This option gets unlocked when the handle type is set to anything that is not *Automatic*. It is used to set the handle's target bone.
- *Scale*: When *X*, *Y* or *Z* toggles are enabled, the B-Bone's Scale In/Out values will be multiplied by the scale of its handle bones. It is applied after Scale Easing is applied, meaning it does not affect the Easing values. If we want to multiply the Easing values by the handle's scale, we can enable the *Ease* option. This will multiply the bone's Easing values by the handle's Y scale.

Relations

The Relations panel is where adjustments can be made to a bone's relationship with its parent bone and the entire armature. The following explains what each option does (Figure 7.5):

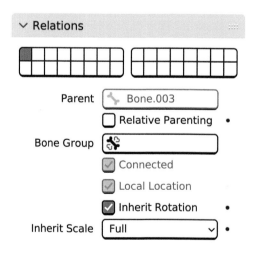

FIGURE 7.5 Relations panel from the bone data properties view.

- *Layers*: Display which armature layers the bone is assigned to. To assign a bone to a layer, **Left click** on any of the layer buttons. **Shift+Left click** to assign to multiple layers.
- *Parent*: Available only in Edit mode. We can assign a parent bone by typing its name in this field or selecting it from the list that pops up when the input field is clicked on.
- *Relative Parenting*: When enabled, makes other objects parented to this bone behave like a weighted mesh, meaning changes made to rest pose don't change the child object's transformation. By other objects I mean other objects in the scene, not bones from the same armature.
- *Bone Group*: Displays the Bone Group the bone is assigned to. When the field is clicked on, the Bone Group can be chosen from a list of existing groups.
- *Connected*: When enabled, the bone's head will connect to its parent bone's tail. While this is enabled the bone can't move in Pose mode. It will always follow the position of the parent's tail.
- *Local Location*: When enabled, the location transform will be aligned with the bones rest pose. If disabled, it is aligned with the parent bone. Useful for orienting the bone's move axes independent from the bone's orientation.
- *Inherit Rotation*: Breaks the rotation inheritance from the parent bone.
- *Inherit Scale*: Provides multiple options which change how scaling is transferred from the parent bone. More on this below.

The reason multiple *Inherit Scale* options exist is that non-uniform scaling (scaling that is not equal on all three axes) paired with rotation causes a shearing effect on child bones. There is no option that always works and different options work better for different situations. I avoid incorporating scale into rigs if it is not required as non-uniform scale can cause issues when the animation is played back in the game engine. But we should still learn how to handle these options, as scaling of different character parts can still be required. If this is the case, try to keep the scaling uniform. Here is an explanation for each *Inherit Scale* option:

- *Full*: Bone will inherit scale from the parent, including shearing.
- *Fix Shear*: Parent's scale is applied to bone in rest pose state and then the bone's own transformations are mixed with it. In my testing, I have seen little shearing improvement with this mode.
- *Aligned*: The scale is applied axis to axis, regardless of how the parent and child are oriented. Meaning parent scale on X will scale the child in its X-axis direction.
- *Average*: The parent's total change in volume is applied as a uniform scale to the child.
- *None*: Scale is not inherited.
- *None (Legacy)*: Same as above but less predictable. This option might be removed in future updates.

Inverse Kinematics

The *Inverse Kinematics* (IK) options are only relevant to Bones that are affected by an Inverse Kinematics constraint. Without the constraint, these options have no effect on the bone's behavior (Figure 7.6).

Here is a quick explanation of what each option does:

- *IK Stretch*: When the chain length is shorter than the distance from the start of the chain to the IK goal, a value greater than 0.0 (0.0001 is usually enough as you want it as small as possible to avoid unnecessary stretching) will enable the bone to change its length in order to reach the IK goal. The Stretch option on the IK constraint will not have any effect until the bones in the chain have an IK Stretch value greater than 0.0.

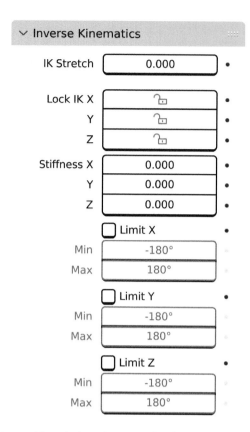

FIGURE 7.6 Inverse kinematics panel from the bone data properties view.

- *Lock IK*: Prevents the bone from rotating on specific axes. Does not work on the root of the chain if we use a Pole Target in the IK constraint.
- *Stiffness*: The higher the value, the more the bone will resist being rotated. Only noticeable in IK chains that are longer than two bones.
- *Limit*: Limits how far the bone can be rotated by the IK constraint.

Deform

The Deform bone property is important for two reasons in Blender game rigging. First one is to specify which bones are to be considered for weight paint tools and mesh deformation. A bone that has Deform disabled will not influence mesh deformation even if it has vertex weights assigned to it. The Armature modifier will always ignore its influence. Weighting tools can also ignore these bones.

The second reason why the Deform property will be important is when we want to export the rig from Blender. For optimization reasons, the exported rig should only include the essential bones. These are the deformation bones and sometimes utility bones like the root or bones we use as a reference transform for prop attachments. The export settings provide an Only Deform Bones option, which will filter out any bones that have Deform disabled and exclude them from the export.

We can change the Deform property at any point, both in Edit and Pose modes. The Deform panel has additional options that are used for weighting using bone Envelopes. We can ignore all of those options, as Envelope weights are not something we will be using.

Viewport Display

We mentioned control bones a few times already and stated that they are the bones that are designated as the ones the animator will use to pose the rig. By making use of the Custom Shape bone property, we

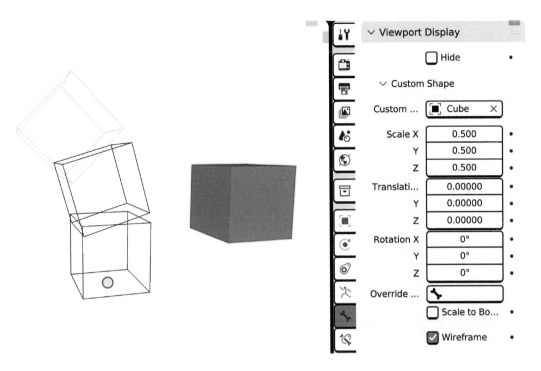

FIGURE 7.7 A three bone chain with a cube applied as their custom shapes.

can make the control bones easier to see and select, and even give visual clues on what they do and how they will behave (Figure 7.7).

The Custom Shape options are only visible while in Pose mode. When in Edit mode, custom shapes are disabled and bones will be displayed according to the armature visibility settings. We can disable the use of custom shapes for all bones by toggling the Shapes option in an Armature's Viewport Display panel. Here is a description of the available options:

- *Custom Object*: A mesh object, from the current file, that a bone will be displayed as. Meaning if you assign a cube mesh, the bone will be displayed as that cube. We can reuse custom objects for multiple bones.
- *Scale, Translation, Rotation*: When a custom object is assigned, the shape will be applied local to local space. Meaning if the shape is a model of an arrow aiming down the objects Y-axis, when assigned to a bone it will be oriented so that it is aiming down the bone's Y-axis. These options add offsets to the displayed shape's transformation. These offsets are purely visual and do not affect the bone's actual transformation.
- *Override Transform*: Gives the option to display the custom shape at the transform of another bone.
- *Scale to Bone Length*: If enabled, the custom shape's scale will be multiplied by the bone's length value.
- *Wireframe*: Toggles if the custom shape's faces will be displayed or only the edges.

Custom Properties

Custom properties allow us to store data on objects. This applies to most object types in Blender, but we are mainly interested in Bones and will focus on those. For rigging, this data is commonly used to create different types of switches. For example, a switch for the eyes that changes if the eyes will rotate together with the head or always aim at a target bone. The behavior itself will be rigged using constraints and we will connect the custom property to those constraints using Drivers. Creating these types of relationships will be shown in this book.

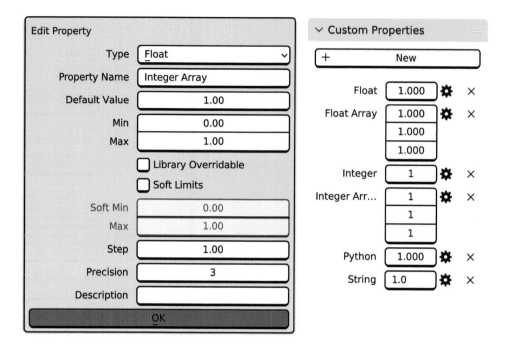

FIGURE 7.8 Left, the custom property editor. Right the custom properties panel.

Keep in mind that when an armature is active, three different Custom Properties panels can be found in the properties view. First is in the Object tab, second in the Armature Data tab, and the third one in the Bone properties tab. We will only work with the third one for this entire book (Figure 7.8).

The *New* button adds a property to the active bone. Once added, the property will be displayed under this panel and in the 3D view's N panel, inside the *Item* tab. These properties can be edited and removed at any point in time. The options for custom properties are quite self-explanatory. In case you need additional information, refer to Blender's official Custom Properties documentation webpage.

One thing I need to address is the Is *Library Overridable* option. Library Overrides are required to animate a linked character and only properties that have Library Overridable enabled can be animated in a linked rig. Enable it for every custom property that you want to give animators the access to.

If we use a custom property as a driver variable, changing the property name will cause an error. The name has to be updated on all drivers that use the property in order for them to function again.

Item Panel

The Item tab, inside the N panel of a 3D Viewport, gives quick access to the active bone's transformation properties. As well as a mix of a few other properties in Edit mode. Any custom properties that exist on the bone will also be displayed. All properties shown in the Item tab are the same as those from the Bone properties view.

Creation

We can create new bones only in Edit mode. And there are multiple different ways to go about doing so. I will focus on a few approaches I like to use. For details on all of them, refer to the Blender online manual.

Add

The fastest way to add a new bone is by pressing **Shift + A**. This will spawn a new bone at the 3D cursor's location. New bones are not aligned with the world, which I would expect to be the default

behavior. Instead, the bone has a rotation of 90 degrees on X, which results in its Y-axis pointing along the world's Z-axis.

Extrude

If we press the **E** key while a bone is selected, a new bone will be extruded from the selection. By dragging the mouse, the position of the newly extruded bone's tail can be adjusted, and confirmed with **Left click**.

The extrude behavior can be strange if head, tail and body selection is mixed. I usually prefer to use extrude only by selecting the tail of a bone and extruding from there. This will also automatically parent the new bone to the one it was extruded from.

If we start and cancel an extrude with **Right click**, it might look like nothing was extruded but what actually happens is that the bone gets created with a length of zero which makes it practically invisible. By pressing undo, it will go away. Another way to get rid of zero length bones is to go into Object mode and back into Edit. This will delete all zero length bones.

Duplicate

A new bone can be created by duplicating an existing one. The shortcut is **Shift + D**. The duplicated bone will inherit the parenting relationship from the original, as well as all properties that were changed on the original, and constraints.

When **Shift + D** is pressed, the duplicate bone will automatically move with the cursor. To leave it at the original bone's location, press **Right click** and the transformation will be canceled.

Subdivide

When creating straight chains of bones, it is easier to create a single bone that spans the entire length of the desired chain and subdividing it into the desired number of bones using *Subdivide*. I usually access this from the Context menu using the **W** key. We can also find it in the *Armature* menu in the 3D view.

Ctrl + Click

This is a quick way to add new bones. By holding the **Ctrl** key and **Left clicking** in the 3D view, a bone will be extruded from the last selected bone to where you click.

Fill

By selecting two bone parts, for example, the tail of one bone and the head of another one, and pressing the F key, a new bone will be created. This bone will span from the first selected part to the last one.

Editing

Since much of the rigging comes down to placing and adjusting bones, I want to outline a few ways this can be done. For organic characters, we rarely rely on placing bones by typing in transformation values in the properties panel. I strongly encourage you to experiment with bones to get a feeling for how they behave. Also, read the bone section in Blender's official manual to see all the options and find the ones that work best for you.

Move

This is where that bone anatomy comes to shine. The bone can be adjusted by selecting and moving the head, tail or body. The bone's Y-axis will always automatically align with the bone's direction and point from head to tail. Y and Z will try to stay pointed in the same direction.

Rotate

A bone can be rotated by selecting the body or the tail. If the head is selected and you try to rotate the bone, nothing will happen. Rotation becomes a lot more versatile when combined with different pivot options.

Scale

To quickly adjust the length of a bone or the distance between the head and tail, we can scale the bone. This becomes more useful when combined with changing the transform pivot.

Using Pivots

As bones in Edit mode ignore their parent-child relationships, rotation won't be inherited from parent bones, meaning we can't rotate the root of a chain and have the entire chain follow. For example, to rotate the upper arm and have the rest of the arm follow along. You could switch to Pose mode and adjust them this way and apply the change to the rest pose, but this is not convenient. Especially if the mesh is already skinned to the bones.

We can emulate this parent-child relationship in Edit mode by changing the transform pivot to *Active Element* or *3D cursor*. By selecting the entire chain and in case of using *Active Element* pivot mode, having the root of the chain as the active bone, the entire selection will rotate around it, similar to how they would rotate in Pose mode (see Figure 7.9). A similar action can be performed by snapping the 3D cursor to the head of the root bone and rotating with the pivot mode set to *3D Cursor*. This works with scaling as well. If the chain is too long or too short, we can scale the whole thing this way.

Individual Origins, *Median Point* and *Bounding Box Center* pivot modes have their uses and you should try them out to see what kind of behavior they create.

With the *3D Cursor* as the pivot, the transformation pivot can be literally anywhere you place the cursor. It allows us to do things like rotate a bone or a bone chain from the opposite end. For example, the cursor can be snapped to the wrist and the upper and lower arm can be scaled or rotated from that point (see Figure 7.10).

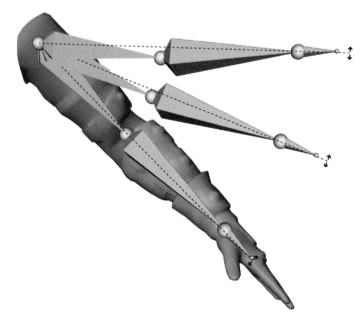

FIGURE 7.9 A bone chain being rotated in edit mode with the pivot mode set to active element.

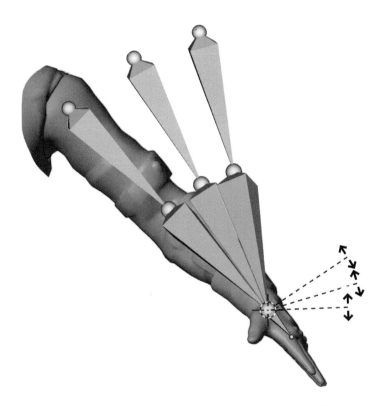

FIGURE 7.10 A bone chain being rotated in edit mode, with the pivot point mode set to 3D cursor.

Snap to Cursor

There is more the 3D cursor can do for us. When a bone needs to be placed at the center of a mesh selection, there isn't an option to select that part of the mesh and snap the bone to it. Instead, we use a workaround of snapping the 3D cursor to the mesh first, and then the bone to the cursor. The shortcut for the *Snap To* menu is **Shift+S**. This applies for all snapping techniques mentioned here (Figure 7.11).

Snap to Bone

I use this when I need to align parts of different bones. For example, when I need one bone to end at the start of another one. Here, I would select the tail of the bone I want to snap, then the head of the target bone and use the Selection to Active snapping option.

This technique doesn't work when trying to snap a head to a tail. Instead, you would have to snap the 3D cursor to the target's tail and then snap the head to the 3D cursor.

Snap to Geometry

We can use snapping to interactively snap bones to the surface of a mesh or the center of its volume. Or to snap one bone onto another.

X Symmetry

We can mirror bone adjustments automatically to the other side of the rig by having *X-Axis* symmetry enabled. This is name dependent, meaning that bones must have the left and right tags in their names. You can read more about this in the "Naming" chapter.

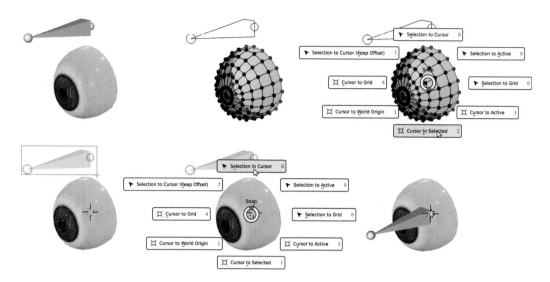

FIGURE 7.11 The technique of snapping the 3D cursor to selected geometry, followed by snapping selected bones to 3D cursor used for bone positioning.

Roll

We will talk about roll a lot more in the section on bone orientations. For now, note that the Roll of selected bones can be interactively adjusted by selecting bones and pressing **Ctrl + R**.

Switch Direction

A bone's direction, or in other words swapping the head and tail, can be done by using the Alt+F shortcut. We can also find it in the Armature menu in the 3D view.

Align Bones

The Align Bones operator can align the rotation of two bones without changing the position or length. The shortcut for this operator is **Ctrl + Alt + A**, and we can also find it under *Armature > Transform*.

Delete and Dissolve

Selected bones can be deleted by pressing **X**, and choosing the *Delete* option. This will remove all selected bones.

The second option in this menu, *Dissolve Bones*, will be delete the selected bones and their children will be connected to their parents. This option is a bit more destructive, since it will also delete the parent and children of Bones connected to it. Another shortcut for Dissolve is **Ctrl + X**.

Separate and Join

Even though most of a rig is contained in one armature, this does not limit us to combine parts of different rigs or even whole rigs into one. This is possible using the Separate and Join operators.:

- *Separate*: Splits selected bones into a separate armature. Done using the **P** key, or by clicking on *Separate* in the Armature menu in the 3D view.
- *Join*: Merges any number of selected armature objects into the active armature. This is done in Object mode and using the **Ctrl + J** shortcut, or by clicking on *Join* from the Object menu in the 3D view.

Symmetrize

The *Symmetrize* operator copies bones and their information from one side of the rig to the other. It can be found in the *Armature Context* menu by pressing **W**, or under the *Armature* menu in the 3D view.

After the operator is executed, it gives the option to specify the direction, or in other words, which side to copy from. Only the X-axis is supported, which is one of the reasons why it is best to orient characters so that their left and right sides are aligned to the world X-axis when rigging them.

Symmetrize does not blindly mirror all bones. Instead, it only works on bones that have the side designated in the bone's names. Meaning it needs to have the word left or right, or one of the other valid variations of those, in the name. The operator will automatically rename symmetrized bones and assign the opposite side token.

When the operator is executed, it mirrors the selected bones together with their parameters and constraints. The constraint targets are automatically updated as well. Keep in mind that if the mirrored constraints have parameters that depend on the bone's orientation, these might need to be updated manually after symmetrization as the orientation of bones might look different after symmetrized. This happens because it is impossible to have the axes of symmetrized bones mirrored perfectly. For this to be possible, the relationship between the bone's axes would have to change. It could work if bones could have a scale of −1 and this is not an option as bones don't have a scale parameter in Edit mode.

To give an example, the Damped Track constraint has the *Track Axis* parameter that might need updating if its value is set to one of the X- or Z-axis options. If that is the case, you will see the bone flipping around when toggling the rest pose on and off.

Symmetrize does not create drivers on the symmetrized bones. If the other side of the rig already exists and has drivers, symmetrize will update the bones and use the existing drivers. They might not update automatically until we reloaded the file.

After symmetrization and the fixing of constraints and drivers, I recommend having the *X-Axis Symmetry* option enabled so that both sides stay in sync. Or continue working on one side and repeat the symmetrization process afterwards (Figure 7.12).

The Symmetrize operator can sometimes produce undesired results, for example, it can delete drivers from the side that is being symmetrized. I have encountered this when running the operator for the first time as that executes it with Direction set to −X to +X. So the way I always use this operation is like so:

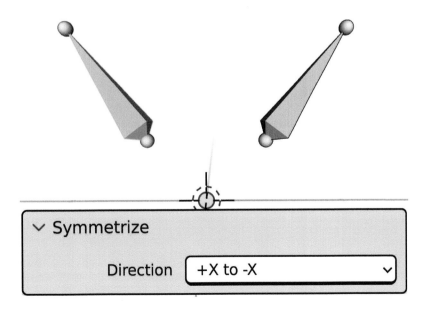

FIGURE 7.12 I created bone on the left using the symmetrize operator with the +X to −X option.

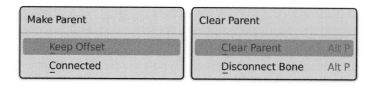

FIGURE 7.13 Make parent, left, and clear parent menus, right >.

- Execute *Symmetrize*.
- In the options dialog that shows up at the bottom left corner of the 3D view, change *Direction* to *+X to –X*.
- Press **Ctrl + Z** to undo the *Symmetrize*.
- Execute *Symmetrize* again.

The second time Symmetrize is executed, it will do so with the *Direction* value already set to *+X to –X* and this always produces the correct result on the right side without affecting the original bones on the left side.

Parenting (Figure 7.13)

Parent

A fast way to handle Bone parenting is by making use of the *Make Parent* operator. The process of using this operator is this:

- Select one or multiple bones that you want to parent.
- **Shift** select the bone that is to be the parent and by doing so making it the active bone.
- Press **Ctrl + P**, in Edit mode, and choose between *Connected* and *Keep Offset*. Both will parent the selected bones to the active one. The difference is that *Connected* will enable the *Connected* property on the child bones and their heads will connect with the parent bone's tail. *Keep Offset* will set this option to be disabled.

Clear Parent

The operator for disconnecting bones and removing their parents is called *Clear Parent* and can be triggered using the **Alt + P** shortcut. It will offer two options:

- *Clear Parent*: The selected bones will get their parents removed and become parentless.
- *Disconnect Bone*: The bones' Connected attribute will be disabled, which will make it possible to move them away from the parent. Bones will stay parented to their parent bone.

8

Mesh Topology and Deformation

Introduction

A model with poor topology, odd proportions, or other issues can severely affect the rig quality. In order to create a successful rig, it is essential to start with a clean and well-structured mesh. If the mesh is not in good condition, the rig will be more difficult, time-consuming, and frustrating to create, and the final result is likely to be sub-par.

Topology refers to how edges flow across the surface of a mesh and the structure that they create. It is like the concept of folds in origami, where the number, quality, and precision of the folds determine the success of the project. In 3D meshes and rigging, if we place edges improperly or have them flow in the wrong direction, good-looking deformation will be hard to achieve.

If you are working on a low poly style or mobile game, you can expect that the budget for meshes and rigs will be small. This means that topology will be crucial for achieving good deformation, as you will not have many bones or shape keys to help improve deformation. Instead, you will need to rely on carefully placed edges, where each edge has a specific role in the deformation.

Mesh Elements

This section covers different mesh elements and how they come together to form polygon meshes.

Vertex

A vertex is the most basic component of meshes. It is a point in 3D space. In case you are wondering, the plural is vertices. Not vertexes. A mesh cannot exist without vertices. The other components, i.e. edges and faces, are made by creating connections between vertices (see Figure 8.1a).

The vertices are the part of the mesh that bones are transforming. This control this relationship using vertex groups.

Edge

An edge is a line that connects two vertices. Blender supports free floating vertices and edges, but those are not supported by any game engines I know (see Figure 8.1b).

Face

A face or polygon is the surface created by connecting three or more edges into a closed loop. Faces are what is rendered in game engines. They will have materials applied to them that set their color and other properties that define how their surface is shaded and how it reacts to light (see Figure 8.1c).

Depending on the number of edges in a face, we call them different names. A face with three edges is called a triangle, four edges make it a quad, and we usually refer to anything above four as an ngon.

Under the hood, every face is actually a triangle. Any face that has over three edges is being cut into triangles, but these cuts are not displayed for convenience. Game engines care more about optimization

DOI: 10.1201/9781003263166-8

FIGURE 8.1 Mesh vertices (a), edges (b), faces (c), normals (d), triangulated faces (e), and UV map (f).

than convenience and will expect that a mesh is made up entirely out of triangles. If not, it will divide all non triangles into triangles on import. Some engines might delete ngons or the import might fail completely (see Figure 8.1e).

Normals

Faces also have a direction, i.e. a front and a back. This is defined by what is called a normal, which is a vector that represents the direction the face is facing. For optimization reasons, most game engines will only render the front side of a face with the possibility of instructing it to render both sides. We refer these cases to as single-sided and two-sided or double-sided (see Figure 8.1d).

UV Maps

UV maps are used to define how a 2D image, i.e. texture map, is applied to a 3D mesh. A common analogy is to imagine a chocolate Santa and its wrapper. When the wrapper is taken off and flattened out, it goes from being a 3D image to a 2D one and is essentially how UV mapping works (see Figure 8.1f).

High Poly vs Low Poly

Modeling and sculpting tools enable artists to work with very high-density meshes, sometimes with resolutions of several million polygons. These meshes are not suitable for rigging and animation because they require a lot of processing power. The purpose of the high poly model is not to be used in the game itself, but to serve as a reference for creating a lower poly version that can be used in the game.

A lower density version of the character mesh, called the low poly mesh, is created for rigging and animation purposes. This process, known as retopology, involves creating the low poly mesh either manually using modeling tools or by "wrapping" an existing low poly mesh around the high poly mesh. The low poly mesh should closely follow the forms of the high poly mesh, but with a much lower polygon density. This is the mesh that we will use for rigging and in the game itself.

Grid Division vs Form Describing

There are two main approaches to mesh topology. One focuses on using edges to describe the ridges and valleys of the forms (Figure 8.2a), while the other emphasizes creating grids of equally sized quads (Figure 8.2b). Ultimately, a topology that describes the forms will produce a more usable and effective mesh. However, if you are working with a stylized character with tube-like limbs and little detail, evenly distributed quads may be sufficient. They also help produce smoother looking deformations and are easier to weight paint.

A topology that follows the mesh details allows us to keep control over how those areas deform. If the topology is made up of evenly spaced quads with no alignment to landmarks, preserving details during deformation can be challenging.

FIGURE 8.2 Different mesh topology approaches. Form describing (a), equal quad division (b), and very low poly (c).

There is a third type of character mesh with a very low polygon count, often seen in retro style games. The edge loops in these characters are often concentrated around joint areas (see Figure 8.2c).

Edge Flow

The most optimal edge flow for achieving smooth deformation and bone weights is to have edges flow parallel and perpendicular to the direction the geometry will travel when deformed. See Figure 8.3 for some examples.

The impact the edge flow has on the deformation can easily be seen if we try to paint mesh weights on a mesh that has the edges laid out so they travel in the deformation direction versus a mesh that has the edges at arbitrary angles (see Figure 8.4). Both legs have essentially the same weights, but the screen left leg will produce much smoother twisting and bending while the screen right leg will produce less ideal results.

Edges should form connected loops around areas such as the eyes, mouth, and limbs, as shown in Figure 8.5. These loops are easier to weight paint and more closely follow the direction of facial muscle movement, resulting in more realistic motion. These loops can divide the face into regions for deformation, such as the eye and mouth regions.

It is not ideal if edges form spirals instead of loops. In Figure 8.6, you see how this unnecessarily complicates things. It removes the clear separation of which loop does what. A single edge loop goes from being the inside of the eyelid to the outside.

Topology can affect how smoothly textures deform with the mesh. For example, in Figure 8.7, a quad that runs counter to the flow of deformation may cause texture warping, while a mesh with edges that follow the direction of deformation will deform more smoothly.

The last topic in this section is poles. A pole is a vertex that has three or over four connecting edges. Poles occur when there is a change in topology flow, often when trying to reduce the number of loops or change direction. We can see examples in Figure 8.8. Poles are a natural byproduct of good topology practices, such as creating rings around the eyes and mouth. These rings must be connected to the surrounding geometry, resulting in poles. It is desirable to have as few of them as possible in the mesh, as they can be trickier to work with.

Triangles

We prefer quads for rigging and deformation because they are easier to work with, but triangles can also be useful in certain situations. They are useful when the shape of the mesh would be improved by using triangles instead of quads. For example, if a quad is bent in half, the way it is triangulated can have a significant impact on deformation and shading. In these cases, it is often better to manually triangulate the quad in the desired direction rather than relying on the software to do it for you. This ensures that the triangulation will be consistent and will not cause any issues with deformation or shading (see Figure 8.9).

Triangles are also often used to control the edge flow of a mesh. For example, in the case shown in Figure 8.10, using triangles can help to create a more desirable edge flow. This is only one example and the point I am trying to prove is that triangles are not bad and should be used when appropriate.

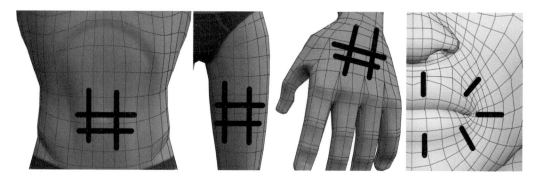

FIGURE 8.3 Example of aligning edges with directions in which the geometry will move when animated.

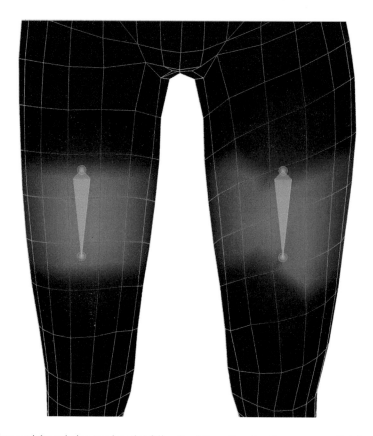

FIGURE 8.4 Same weights painting on edges that follow the deformation direction versus one that does not.

Joint Topology

The first thing we need to get out of the way is the mesh density in joint areas. A common misconception is that more loops equals better looking deformation. Look at Figure 8.11 and notice how adding more edge loops affects the deformation. The outer side becomes more rounded while the inside is almost exactly the same. The volume loss is a result of how bone weights work.

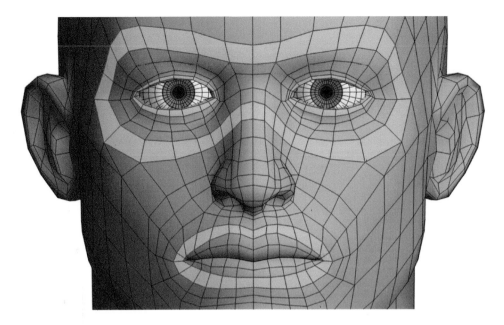

FIGURE 8.5 Edge loops outlining facial features.

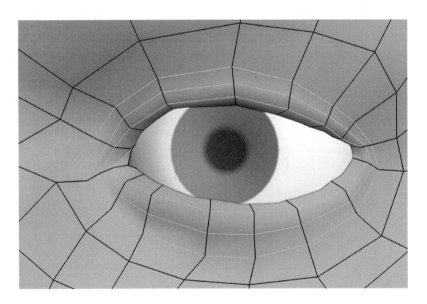

FIGURE 8.6 A spiraling edge, not ideal for deformation.

Outer Side

The truth about good joint deformation is that mesh topology makes up only one third of the equation. The other two parts are bone weights and bone placement. All three need to work together and if one is not set up with care, it can ruin the deformation regardless of how well the rest is done.

For the outer side of joint areas, there is usually a bone that sticks out when the joint rotates, e.g. elbow, finger knuckle, knee. So we need to make sure this area stays sharp and doesn't look like a bendy plastic straw. To achieve this, we need to bring edge loops closer together. If there are no edges to work with, then we have no means to preserve the sharpness. As you can see in the leftmost example in Figure 8.12, this is already an improvement and produces a slightly sharper joint.

FIGURE 8.7 Example of texture warping happening due to faces being triangulated internally.

FIGURE 8.8 Poles i.e. vertices with three or more than four connected edges.

FIGURE 8.9 Example of how different triangulation direction can affect the mesh.

FIGURE 8.10 Use of triangles for reducing the number of edges.

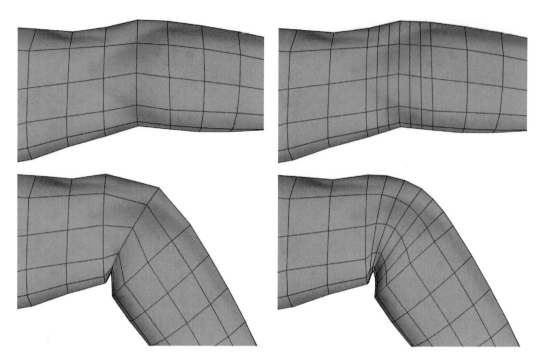

FIGURE 8.11 More edge loops in joint areas do not produce better-looking deformations.

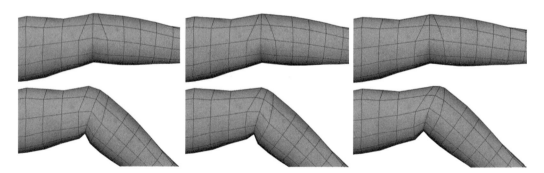

FIGURE 8.12 Modifications to edge loop positions (left), bone weights (middle) and bone position (right) made on the outside of a joint to improve deformation quality.

Next ingredient are the weights. If the distribution of weight is overly smooth, then the edges that we brought closer together will just spread out again. Also, the smoother the weight distribution, the more volume loss will occur, which will produce even more roundness. See the middle example in Figure 8.12, it shows the same topology with adjusted weights.

Finally, I adjusted the bone location. I dedicated an entire chapter to bone placement and we will discuss it there. For now, look at the rightmost example given in Figure 8.12. Again, we have the exactly same topology but the elbow looks significantly more defined.

Inner Side

If the model allows it, meaning if no important detail will be lost, we can remove the edge that goes across the inner side of the joint to get rid of the volume loss. If there is no edge that produces the volume losing motion, there can be no volume losing (see Figure 8.13). We can see this technique in very low poly models and often in fingers.

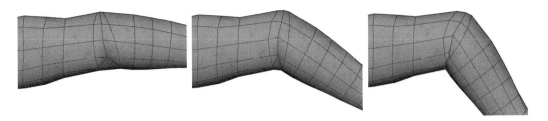

FIGURE 8.13 Preventing volume loss by removing the inner edge.

More than often, this edge is important and the area might be more dense in general. In those cases, we have two options. One is to use a corrective bone. The vertices from the inner joint area would get partially weighted to this bone, which would be rigged to move those vertices outwards when the joint bends. This method produces the best results because we get to define what should happen during deformation, but it comes at a cost as it requires additional bones.

The other approach we could take is to not have very smooth weight transitions in those areas. This will cause the upper and lower segments collapsing into each other, which produces a good-looking silhouette with no apparent volume loss. But on closer inspection, players could notice the trickery we are trying to pull (see Figure 8.14).

Conclusion

The techniques discussed here involve only minor changes to the mesh, but can greatly improve the results. The difference between the mesh we started with, which has equally distributed edges and smooth weights but suboptimal deformation, and the final mesh which visually looks the same but contains the improvements discussed here and deforms significantly better.

This is just one of many approaches to joint topology and may not work for every case. We will later look at improving joint deformation using additional bones, which can counter volume loss and prevent a mesh from collapsing into itself.

Twist Support Edges

Limbs will need to handle a lot of twisting motion that gets distributed along the limb segments. This might not be an issue if you are working with higher polygon count models, but it is worth looking at the difference a single edge ring makes when it comes to very low poly models. Look at Figure 8.15 and compare the results. Example A has no edges that can support the twisting motion, so the arm folds like a candy wrapper. One edge ring, like in example B, is already drastically different. Three edge rings are enough to produce a smooth transition as seen in example C.

Mesh LODs

It is also worth mentioning LOD (level of detail) meshes, which are simplified variations of the main character mesh. The base character, labeled as LOD0, is the highest quality version used in the game. We derive other LODs from it, with higher numbers indicating more optimization. These LODs are set up so that as the camera moves further away from the character, higher LOD versions of the mesh are used (Figure 8.16).

LOD creation is usually done using tools that remove edges from the mesh based on certain logic. These tools often provide input parameters that allow the user to specify the desired polygon count or reduction percentage. These tools also typically take care to preserve certain features, such as mesh borders, in order to avoid significant changes to the character's appearance.

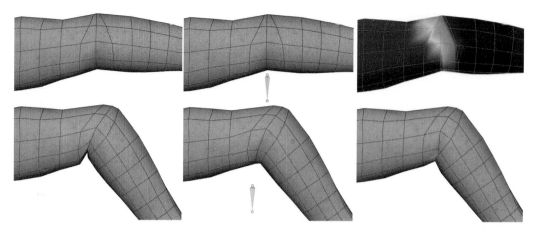

FIGURE 8.14 Improving the deformation and silhouette of the inner joint area by adding a corrective bone (middle) and removing smooth weights (right).

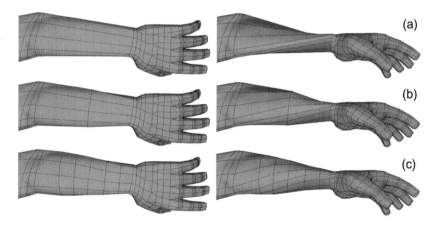

FIGURE 8.15 Comparison of volume preservation and twist distribution in meshes with different numbers of supporting edge loops.

Edges that do not significantly alter the shape of the mesh are suitable candidates for removal. Flat surfaces are more likely to have their edges removed, while edges that create strong surface changes are less likely to be removed. This is where a mesh topology that accurately captures the forms of a character is better than one made up of evenly distributed quads, as it can aid in LOD creation.

Overlapping Geometry

Sometimes you may encounter characters with multiple layers of geometry that overlap each other. For example, a character may have a base body with interchangeable parts added on top. In these cases, it is important to ensure that the topology of the different layers is similar, with matching density and edge flow, to avoid issues during deformation. Figure 8.17 illustrates an example of what can happen when the topology of the layers does not match. If adjusting the topology is not possible, you can minimize the risk of clipping by increasing the distance between the two layers of geometry.

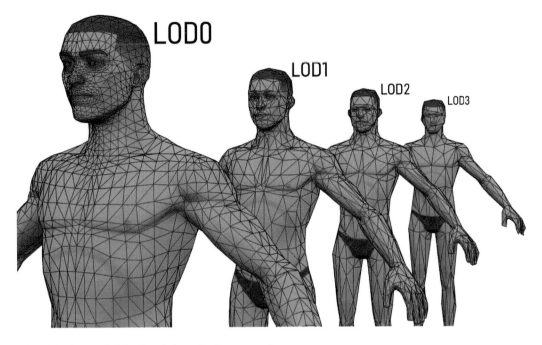

FIGURE 8.16 Level of detail variations of a character mesh.

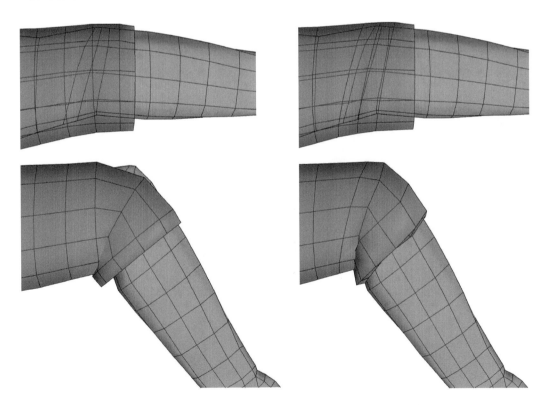

FIGURE 8.17 Clipping issues caused by overlapping geometry with disparate mesh topologies.

Uniform Meshes

When multiple layers of overlapping geometry do not need to remain separated, it's beneficial to merge them into a single uniform mesh. This has several advantages, such as easier weight painting, no risk of clipping, and no extra geometry used to hide seams.

However, this approach can sometimes result in distortion, particularly when merging layers with unique material properties (e.g. cloth and metal) that have conflicting weighting requirements. In such cases, it may be difficult to skin the shared edge to satisfy both materials (Figure 8.18).

Base Mesh

A base mesh is a reusable mesh that streamlines production by allowing certain processes to be completed once and applied to multiple instances of the mesh. Ideal topology, bone placement, weight painting, and facial shape keys should be done on the base mesh itself. When creating a new character, an instance of the base mesh is molded to its shape and textures are baked onto it.

Figure 8.19 shows two characters created in Character Creator 4, which are visually distinct but technically identical as they share the same mesh.

Bind Pose

The bind pose, also known as the "rest" pose in Blender, is the default pose in which the character is modeled and serves as the starting point for rigging and animation. You may also have heard of T-pose and A-pose, which are variations of the bind pose. A T-pose is a pose in which the character is as straight as possible, with the legs straight and knees facing forward, arms lifted to a 90-degree angle and parallel to the ground, and fingers flat and in line with the hand. An A-pose is similar, but we typically rotate the

FIGURE 8.18 Uniform geometry example.

FIGURE 8.19 Two different characters created from the same base mesh using character creator 4.

arms to a 45-degree angle, with the elbows also at 45 degrees and sometimes the knees slightly bent. We may model the fingers in a relaxed pose or fully straight. Both T-pose and A-pose have their pros and cons (Figure 8.20).

T-pose is easier to rig and animate because the many bones and controls align with the world axes, resulting in cleaner animation curves. It is also beneficial for animators as it ensures that all starting angles are removed, so that bending the arm by 60 degrees results in the arm being exactly at a 60-degree angle. Without A-pose, the starting rotation of the arm would also need to be considered. T-pose is also well-suited for motion capture, as it is the standard used in motion capture recording.

The downside of T-pose is that it places the arms in a less than ideal starting position for further deformations. T-pose is very different from a relaxed pose, which is the state that the character will probably spend most of its time in. This can cause excessive stretching and bending in the joint areas of the mesh when the arms are rotated to a more relaxed position. This means that the mesh may be well-sculpted in T-pose, but appear distorted in a natural pose. Additionally, when the arms are lifted to a 90-degree angle, the shoulders also rotate so the character has shoulder rotation modeled into the pose.

In contrast to T-pose, with A-pose the initial rotation allows for a more natural split in the deformation, requiring less stretching and bending in the mesh. This makes A-pose a better choice in most cases, as it allows for easier modeling of good-looking shoulders and a more smoothly deforming rig.

Figure 8.21 illustrates the difference in deformation between different bind poses. When using an A-pose, we split the deformation difference, resulting in minimal volume and quality loss when the arm is straight or bent. In contrast, when using a T-pose, the deformation required to go from a straight arm to a bent arm at a 90-degree angle significantly affects the visual quality of the mesh.

When creating non-humanoid characters, it is important to consider the character's intended movement and actions in the game. For example, if the character is a creature that moves on all fours, it may not make sense to force it into a T-pose, as this pose may not apply to the character's behavior. Instead, it may be more effective to create a bind pose that more closely reflects the character's intended movements. Alternatively, if you are rigging something like an orangutan that will walk on two legs and swing on branches, it may be easier to achieve a natural deformation with a T-pose rather than an A-pose, as this pose allows for decent deformation for both raised and lowered arms.

FIGURE 8.20 A-pose on the left and T-pose on the right.

With other elements like hair, belts, weapons, etc., the question you should ask is how this item will behave. If it is a rigid piece, that will not deform much, then it is probably better to model it in that shape and not force it to be fully straight in the model so that it can then be posed back to its original shape in the animation. In most other cases, it is probably best to give it a neutral straight shape.

Proportions

Knowing the proportions of a character's limbs and limb segments is important when rigging them. While it is not our job as riggers to change the proportions of a mesh, understanding what proportions work well allows us to give constructive feedback to character artists and designers. It also helps us to know what the character will be capable of doing or not doing once rigged.

Legs

With equal length leg segments, poses like sitting on the floor with bent knees, standing on one knee, crouching, the "super hero" Marvel pose, and similar, will look a lot more natural. If the upper or lower leg segments are significantly shorter/longer from each other, then posing the character into these types of poses will require a lot more effort (see Figure 8.22).

Arms

The same rule applies to arm proportions. The lower and upper arm segments should ideally be the same length. A quick test that can be done is to bend the arm at the elbow and compare the length of the upper arm versus the lower arm. Ideally, the wrist should land around where the armpit is.

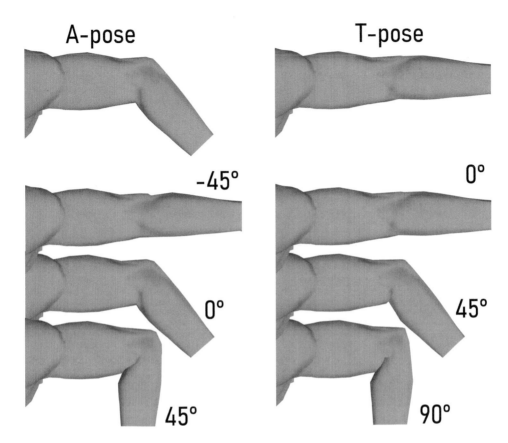

FIGURE 8.21 Comparison of elbow deformation between an A-pose type initial bend in the model, and a T-pose type straight arm.

FIGURE 8.22 Demonstration of the impact leg proportions have on a pose. The greater the difference in the length of the two leg segments, the more difficult will it be to create natural-looking poses.

Hands and Fingers

The ideal palm-to-finger ratio is 1 to 1, see red lines in Figure 8.23. Finger bone proportions are conveniently in a relationship that matches the Fibonacci sequence. We are starting the sequence from 2

instead of 0. This is represented by the green lines in Figure 8.23. To enable a natural curl of the thumb across the other fingers in a fist shape, its first two digits should be about the same length as the index finger's metacarpal bone.

A common mistake is to measure the fingers from where the palm ends. The knuckle is buried deeper into the palm and the finger should be measured from that point instead. See the blue lines in Figure 8.23.

If you don't want to do any math as you measure these proportions, you can make a mesh cube and eyeball its size until it matches one unit for a certain proportion you are measuring, Apply its scale and then scale it by the proportions to get the lengths you need.

Shape Keys (Blendshapes)

Shape keys store and edit vertex offsets without permanently applying changes to the mesh. Multiple shape keys can be mixed to create complex deformations, making them useful for facial rigs and corrective sculpts in rigging. It is important to note that shape keys only store vertex positions, and cannot be used to change the mesh (Figure 8.24).

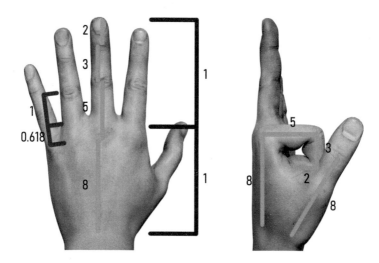

FIGURE 8.23 Various hand proportions. Green lines represent the relation of individual finger bones, red is the relation palm to fingers, and blue shows how much of a finger is embedded in the palm.

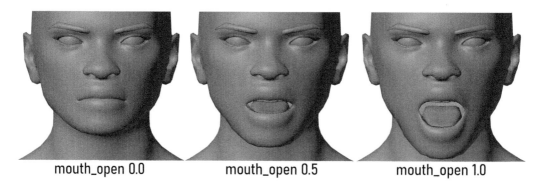

FIGURE 8.24 "Mouth_open" shape key gradually applied by changing its value.

Non-Manifold Geometry

Non-manifold geometry refers to a mesh that has issues with its topology, or how its vertices, edges, and faces are connected. The *Select Non-Manifold* option, found in *Select > Select All by Trait* menu found in the 3D view, can identify any non-manifold issues. It does not fix the issues, only selects the problematic geometry. Boundary edges are considered non-manifold but are not problematic for games and don't have to be fixed. After we execute the operator, the Adjust Last Operation menu allows further tweaking of what gets selected.

These are the available options:

- *Extend*: When enabled, the current selection will be preserved and added to the non-manifold geometry. If disabled, the new non-manifold geometry will replace the current selection.
- *Wire*: Selects all edges that are not connected to any faces (i.e., they are "free floating").
- *Boundaries*: Selects edges that are only connected to one face. We should typically disable this option unless you have a specific reason for wanting to fix these cases (e.g., for 3D printing).
- *Multiple Faces*: Selects edges that are connected to more than two faces.
- *Non-Contiguous*: Selects edges that are shared by two faces with opposite orientations (normals).
- *Vertices*: Selects points that are part of wire edges, multiple-face edges, and non-adjacent faces, as well as isolated points in the mesh.

To fix non-manifold geometry, you will need to change the mesh to ensure that all vertices, edges, and faces are properly connected and form a solid object. This may involve merging vertices, removing double faces, or deleting floating geometry.

Gravity

It is important to consider technical limitations when designing characters, particularly regarding any loose clothing or appendages that need to react to gravity and motion. This may require special attention during the rigging process, such as using bones or cloth simulation to ensure that these elements are moving realistically. It is important to be aware of these limitations and to communicate with the rest of the team to ensure that you can make the characters to look convincing in the game.

9

Scene and Model Preparation

To make sure we are off to a good start, we will prepare the file and model ready for rigging. Make this process a habit and go through these preparation steps every time before you dive into making a rig. Most things mentioned here can be addressed later in the process as well, but it is easier to set things up from the get go and never have to worry about things not working or looking wrong down the line.

Workspace

Start by making a new file and delete any default objects that might be in the scene. We do not need the timeline for most of the rigging process, so adjust the layout to remove it. We will work a lot with the Properties and Outliner views so we can leave them as is. Adjust things from here to your liking.

As discussed in the "Units" section of the "Blender tools and concepts" chapter, to ensure that characters and animation come into Unreal Engine or Unity at a correct size, we need to adjust the Unit Scale values to 0.01. This does not automatically adjust the View Clipping values, so proceed with setting the *Clip Start* value to 0.01 m and *Clip End* to 100 m.

Save the file and name it according to your character's name (Figure 9.1).

Collections

Make two collections under the Scene Collection. Name the first one as your character and the second one "WGT" plus the character's name. We will place the entire rig and the mesh in the first collection, which we will refer to as the "rig" collection. The second collection is where we will place all the meshes used as custom shapes on control bones. "WGT" stands for widgets (see Figure 9.2).

Make sure that the widgets collection is not nested under the rig collection. This will prevent it from showing up when the rig is linked to an animation file.

Model Preparation

As you might have noticed, I have not mentioned where to download characters from the book so you can follow along and rig them in parallel with reading the book. This is because I do not want you to use the same character and simply copy what you see. The goal of this book is to teach you why things are done in certain ways so that you can apply it to any character.

If you don't have a character at hand, there are plenty of places where you can find some. To name a few: BlendSwap, FlippedNormals, Artstation, Sketchfab.

Import/Append

If the character mesh is in a blender file, use *Append* to bring it into the rig file. If it is in a FBX or OBJ, import it using the suitable importer. Once that is done, make sure the mesh is named properly and move it into the rig collection.

DOI: 10.1201/9781003263166-9

FIGURE 9.1 The rigging workspace used in this book, including the unit scale, and clip start/end settings.

FIGURE 9.2 The "Titus" collection is named after my character and will host the rig and mesh. "WGT-titus" is where we will keep all custom mesh shapes.

Position, Size, Rotation

Position the character so that its feet are aligned with the ground. Make sure it is rotated so that it is looking down the −Y world axis. Check the *Dimensions* properties to see the size of your character. In Figure 9.3 you can see how my character has a height of 1.82 m, represented by the Z *Dimension*. Scale your character to a size that makes sense for it. You can do this by changing the *Dimensions* or *Scale* properties.

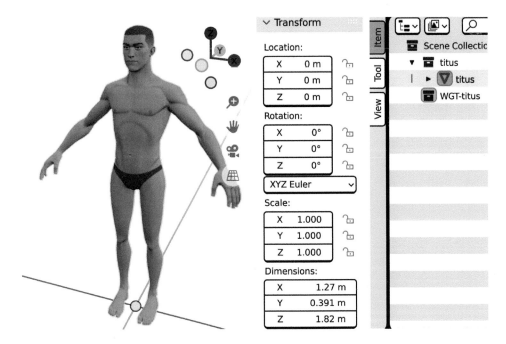

FIGURE 9.3 Character ready for rigging. All transformations have been applied, dimensions make sense, object is named properly and placed in the correct collection.

Apply all transformations to ensure Location and Rotation are at 0.0, scale at 1.0 and origin aligned with world zero.

Mesh Cleanup

Check the mesh for any non-manifold issues or any other problems that might cause problems with deformations and compatibility later on. See the chapter "Mesh topology and deformation" for reference.

10

Naming

Foundation

It is important to give every bone in your rig a descriptive name so that when you read it you know what the bone's purpose is. For example, "DEF-neckLower" reveals that the bone is a deformation bone for the lower part of the neck. If it was called "Bone.046." instead, things would not be that clear. Naming bones is also necessary for some tools to work properly, as discussed in the "Side identifier" section. Although it may be tedious to name every bone, it will save time and confusion in the long run.

Before discussing naming tools and conventions, it is important to know where to find bone names in Blender. We can access this information in several places (see Figure 10.1):

- In the top left corner of a 3D view when the *Text Info* overlay enabled.
- The Outliner. Double-clicking a bone to rename it.
- In the Bone Properties panel. Click on the name field to rename a bone.
- 3D view on top of bones when *Names* are enabled in an armature's *Viewport Display* settings

Naming Tools and Shortcuts

The fastest and most straightforward way to rename any object in Blender is to use the **F2** shortcut. This will bring up a pop-up menu where a new name can be entered. Have an active object or the tool won't work.

Other two renaming options are to double-click on the bone in the Outliner and rename it that way, or clicking on the field with the bone's name in the Bone Properties panel (see Figure 10.2).

I want to mention a slightly hidden tool which is the *Batch Rename* tool which we can activate by pressing **Ctrl + F2**. This tool allows you to rename multiple bones at once and has other features like Find and Replace. When working with bones, change the target type from *Objects* to *Bones*.

Naming Convention

My number one rule for naming bones is to not overthink them. The number two rule is to name the bone so that you, other riggers on your team, and the animators, can find out what a bone does by reading its name. And the number three rule is to pick a naming convention for the project and stick with it.

This is the naming convention used in this book: [*prefix*]-[*bodyPart*]_[*bone_role*].[*suffix*].

An example of how I might name a bone: MCH-armLower_bbone_handle_start.L

Here is an explanation of each of the name segments:

- *Prefix*: specifies which organizational layer the bone belongs to, e.g. deformation bones have the "DEF-" prefix. I separated the prefix from the next segment with a "-" symbol.
- *BodyPart*: tells us which body part the bone belongs to. I do not use spaces for multi-word names, instead every word besides the first one is capitalized, e.g. upperArm, lowerArm and hand.

DOI: 10.1201/9781003263166-10

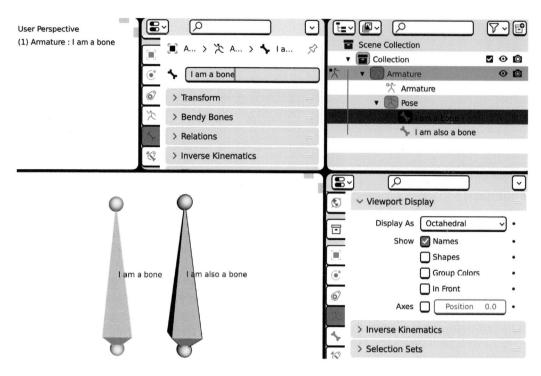

FIGURE 10.1 Display locations of bone names. Top row: 3D view, outliner, bone properties. Bottom row: Overlayed on top of bones when the *Names* property is enabled.

- *BoneRole*: separated from bodyPart using the "_" symbol and needs to describe what the bone does. E.g. _bbone_mid_follower.
- *Suffix*: the sole purpose of the suffix is to specify if a bone is on the character's left or ride side. Bones in the center don't have a suffix. The "." symbol separates the suffix from the rest of the name.

This naming convention is just one example and everyone has their version. So use it as a starting point and if you find that something works better for you, use it.

Prefixes

The bone prefixes used for the rigging shown in this book are:

- DEF for deformation bones
- INT for the intermediate bone hierarchy
- MCH for rig mechanics bones
- No prefix for control bones

These prefixes correspond to the organizational layers discussed in the "Rig creation approach" chapter.

I prefer not to use a prefix for control bones because they are the only ones that animators will see. Therefore, it makes sense to keep their names short and concise. However, some people prefer to use a prefix for control bones and not for deformation bones. It is important to note that you cannot have both without a prefix, as Blender does not allow duplicate names. To have both without prefixes and avoid name clashes, you would have to give control bones and deformation bones different names.

FIGURE 10.2 Top rename pop-up, bottom batch rename tool.

Side Identifiers

A bone name suffix is great for avoiding name clashing in symmetrical rigs. Another reason for using side-identifying suffixes is that this help with symmetrizing or mirroring parts of the rig. These parts can be entire rig setups or other things like weight paint or even poses when animating.

All tools that do these tasks depend on having a valid suffix. Blender considers these options as valid:

- L and R
- l and r
- Left and Right
- LEFT and RIGHT
- left and right

We can also place these identifiers at the start of a name, if you prefer to go that route. Regardless of which you pick, use the same rule for both sides.

We can separate the identifiers from the rest of the name using any of the following separators:

- (nothing): handLeft / handRight
- "_" (underscore): hand_Left / hand_Right
- "." (dot): hand.Left / hand.Right
- "-" (dash): hand-Left / hand-Right
- " " (space): hand Left / hand Right

Note that if you are using the short versions (l/r or L/R), you must use a separator. HandL or handl will not work.

11

Rig Creation Approach

The rigging process can be easier to manage when broken down into smaller stages. These stages may, and often do, overlap and it is sometimes required to go back and forth and adjust different areas of the rig.

The rigging process explained in this book starts with the analysis of the character mesh. It is worth spending some time on investigating the mesh and scene to make sure things are ready to be rigged. Someone might leave modifiers on the mesh, as well as vertex groups, and many problems with the mesh itself could be present. We should ideally fix these before rigging. Blender allows us to make mesh adjustments after we rig a mesh, so we can still address issues if we spot them later in the rigging process. One thing that can be harder to do is to update the character's default pose. It is possible, but moving rig elements around can be tricky, so it is best to fix any pose issues before rigging.

As part of the character analysis, start making a mental, or physical, plan of action and note down what needs to be done on the rig. Think about how the character would need to behave and how to create a rig for it. If you are rigging for someone else, talk to them about their expectations and how they like to animate.

The next stage of the rigging process is to add deformation bones, which will be the ones that manipulate the character mesh, and the ones that we will export to the game engine. They are the foundation of the rig and we will build the rest of the rig on top of these bones. To start, you can add the central bones such as the spine, neck, and head, and then focus on creating one side of the character, typically the left side. If the character is symmetrical, you can use a tool like *Symmetrize* to create the other side once you have finished working on one side. Once the rig is symmetrical, you can enable *X-Axis Mirror* in Edit and Pose mode to automatically update both sides when adjusting bones.

Working on one side and symmetrizing/mirroring should be done wherever possible to save time and energy. No need to do things twice when you can do them once.

With the deformation bones in place, the character mesh can be bound to it so that we can see how the rig influences it. The bounding process, which is also called "weighting", can be left in an unfinished state and completed later, or taken to a finished state before continuing with the other stages.

The rest of the rigging process does not need to happen completely linearly. You can work on different sections and perform some tasks in a different order. For example, one could do all stages on one part like an arm. Or do the same stage on the entire rig before moving to the next stage. Much of this comes down to personal preference. The chapters in this book are structured so that they guide you from start to finish of a rig, but once you understand the techniques, you can start making them your own and finding a process that works for you.

Rig Layers

Character rigs consist of many bones, constraints, drivers, and other elements, and it is important to organize them in a structured way to help keep oversight of what different bones do, what rigging stage they are at and to make sure the ability to export and use the rig in a game engine is maintained. One way to do this is to organize the rig into four different layers, with different roles and rules for their bones. This helps to keep the setup organized and manageable. The layers are only an organizational technique, we do not split bones into different armature objects, and the primary tools we will use to create the separation are *Armature Layers* and a bone naming convention.

DOI: 10.1201/9781003263166-11

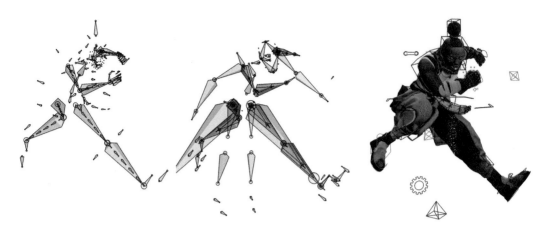

FIGURE 11.1 A character's mesh and different bone layers, separated horizontally for clarity. From left to right: deformation bones, mechanics bones, rig controls and mesh.

The four organizational rig layers are:

- *Deformation Bones*: We attach meshes to these bones. They are not responsible for any rig mechanics and are passively following the intermediate bones.
- *Intermediate Bones*: A safety layer and a filter for how the transformation is transferred from mechanic bones to deformation bones.
- *Rig Mechanics*: These bones add complex mechanics that convert the simple control bone transformation into complex rig behaviors.
- *Control Bones*: Animator-facing controls that are animated. These are the only bones that are visible to animators.

You should set the *Deform* property to disabled on all non-deformation bones (Figure 11.1).

Deformation Skeleton

Only a handful of bones in a rig will deform the mesh. We will refer to this subset of bones as the deformation skeleton. Deforming means that the bones will have mesh vertices following them. Besides having the deforming role in Blender, these bones are the ones that we will export to the game engine. That is why some restrictions apply to them. Part of those restrictions come from engine compatibility issues, as game engines don't support all of Blender's bone features. Another restriction is the bone budget. In other words, how many bones you may use for deformations. The more you use, the more processing power the game will have to dedicate to playing the animations.

In most cases, I don't worry about adding every single deformation bone before moving to the next stage. You can always add more. For example, I usually rig the body first and once that is done, I add the deformation bones for the face and create its setup.

I like to prefix deformation bone names with "DEF-".

Intermediate Skeleton

It can easily happen that during the rigging process, a deformation bone gets parented to a non-deformation bone, or a wrong constraint is added to it, which can be hard to track down once it creates issues later in the rig or game. To prevent this from happening, I prefer to have a buffer between the deformation bones and everything else in the rig. That way, early in the rig process, I ensure my rig will work in the game and deformation bones will not be tampered with as I create the rest of the rig. This buffer is an almost identical copy of the deformation bones, which I call the intermediate skeleton.

These two skeletons essentially split the work the bones need to do. The deformation bones are there to deform the mesh, and the intermediate skeleton bones are there to create a connection between deformation and mechanics bones.

I create the intermediate skeleton by duplicating all the deformation bones and changing their name prefixes to "INT-". Then I connect every deformation bone with its intermediate bone using a combination of *Copy Location* and *Copy Rotation* constraints. Some deformation bones can have a *Copy Scale* constraint too. Mostly the ones that don't have any child bones.

The intermediate bones must maintain the same position and orientation as their matching deformation bones. You are free to change their length and parent if needed. And you can constrain them to other bones any way you want. If you need to make adjustments to a deformation bone, do the same to its corresponding intermediate bone to ensure they maintain the same position and rotation.

Rig Mechanics Bones

This part of the rig can be as simple or as complex as you want it to be, and how much effort you put into it will define how much work the rig will do and how much the animators. For example, take a simple animation of a character going from standing to crouching. As the body moves down, the legs will go down as well, so the animator has to rotate them back to where they are supposed to be planted, on every frame. Or we can build a setup that always keeps the feet at a location. So the animator has to only place the feet once and they will stay there until they decide to pose them differently.

All the bones that fall into this area, I call rig mechanics or just mechanics bones. The name prefix I like to use for them is "MCH-".

Control Bones

This is the only layer of bones that the animators will see and interact with. Besides them being functional, they also need to be intuitive and logical. These bones get custom mesh shapes assigned to them that inform the animator about what each bone does. For example, a bone with a box shape positioned around the head clarifies that this bone transforms the head.

I choose to not add a prefix to the names of bones. As everything else has a name prefix, I know that a bone without a prefix is supposed to be a control bone.

Symmetrization

Once we finish most of the rigging on one side of the character, we can copy this work to the other side by using the Symmetrize operator. It handles most of the work, but not everything. It does not mirror drivers to the other sides, and some constraints which depend on bone axes might need to be adjusted to compensate for how the symmetrized bones get oriented. Those are minor changes and we can do them relatively quickly.

Cleanup

After we make the rig, we need to prepare it and the file for animation. All bones that are not needed for animation should not be visible. If some bones are hidden, make them visible again. The In Front option needs to be disabled, etc. And everything in the file should be clearly labeled and nothing except the rig and the character's meshes should be present. In the "Finalizing the rig" chapter, we will go in depth on this topic and I will show how to go about preparing a rig for animation.

12

Root Bone

Definition

The root is a bone object that tells the game where the character is in the world. The location of the root and the character's actual location are two different things. We create the root by adding a new bone and parenting the deformation skeleton to it. This bone is then either animated to follow the character's motion or the character is animated in place and the game engine transforms the root, as well as the rest of the character. Games can also use a mix of both. For example, walks and runs could be animated in place, and the engine will add transformations to the character while the animation is played in parallel. And something like a fighting combo can be created by animating both the character and root movement. Here the engine lets the animation move the root and takes control over it after the animation blends back to locomotion.

In the game engine, the root usually has a physics collider parented to it. For this reason, it is important that the root is always at the same location as the rest of the character. That way, we ensure that the character interacts with the rest of the world properly. For example, if the character jumps into a wall, its collider will hit the wall's collider and prevent the character from going through the wall.

To learn more about root motion in game engines, I recommend you visit the "Root Motion" page in the Unreal Engine docs: https://docs.unrealengine.com/5.1/en-US/root-motion-in-unreal-engine/

Make the Armature

We want to build the rig with the armature at world zero. To ensure it gets created there, reset the cursor to zero by pressing **Shift + C**. Then add a new armature.

If you at any point notice that the armature is not at world zero but you have already added some bones and started working on the rig, this is easy to fix. In Object mode make the armature the active object and press **Ctrl + A** to bring up the *Apply* menu and select *All Transforms*. This will preserve the rig as is and move the armature object's origin to world zero.

The armature should be called "Armature", the reason for this will be explained in a bit. Move the armature to the rig collection.

By default, new bones are created with their Y-axis aligned with the world Z, meaning they are rotated by 90 degrees in X. I prefer that the root bone is aligned with the world instead. If you have just added a new armature, it will already have a single bone at the origin. It will be tiny if you have Unit Scale set to 0.01. Make it bigger by grabbing its tail and moving it up along the world Z-axis. Its size is not important, it should be big enough so it is easy to see and select. Then set *Transform Pivot* to *Individual Origins and rotate it by −90 in X*. If we set the pivot to anything besides *Individual Origins* or *Active Element*, the bone will not rotate around its head and we don't want that (see Figure 12.1).

Rename the bone to "root" and disable its *Deform* property. Even though we will later export the rig with the Only Deform Bones option enabled because the root has deform bones as children it will not be deleted.

Use Figure 12.2 as a reference for how the root should be positioned and oriented. Notice that its local axes match the world axes.

DOI: 10.1201/9781003263166-12

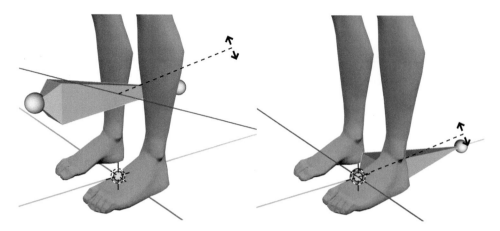

FIGURE 12.1 Left illustration shows the root bone rotated incorrectly using median point as the pivot. Right illustration shows it being rotated correctly using the Individual origins pivot point option.

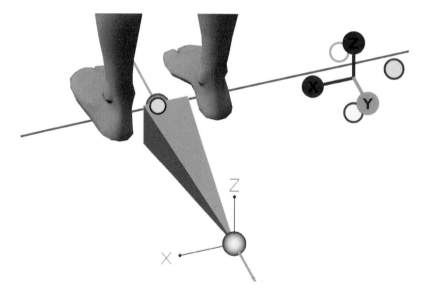

FIGURE 12.2 The root bone with its head at the world zero and rotation set so that its local axes match the world axes.

Armature Transform Workaround

When rigging in Blender, as we already know, all Bones are contained in armatures. Since we want to have everything nicely named, our instinct is to rename the Armature object as well. When this armature is exported to Unreal, it will recognize the armature object itself as the root bone, Figure 12.3a. This is not ideal because we want to have a root bone within the armature so that we can animate it.

We could technically animate the armature object itself, but that is not ideal, as this is not possible from within Pose mode and makes things more complicated.

The solution to this problem luckily already exists. The only thing we have to do is actually not rename our armature at all, which means the armature should be named "Armature". When named like that and exported, Unreal will actually ignore the armature transform and use the top bone in that armature as the root bone Figure 12.3b.

FIGURE 12.3 Left side are armatures in blender, with different names and bone hierarchies. On the right are the results of importing these in unreal engine.

A problem that can arise is that the rig import will fail if there are multiple bones in the root level of the armature. There can only be one, otherwise it is impossible to import the rig into Unreal Engine. All the other base skeleton bones have to be parented to the root bone (see Figure 12.3c).

13

Body Deformation Skeleton

Introduction

It is not necessary to be an expert in human anatomy to be good at rigging for games. In my opinion, the study of the mechanics of body movements matters more. You should understand what motivates a motion, where it comes from and what changes happen in the body during the motion. Your job is to emulate this believably in the rig. By emulate I mean fake. We are not replicating real anatomy, we only care that it looks like there is real anatomy behind it. In simpler terms, if it looks good, it is good. For example, a human spine is made up of dozens of bones. Where in game rigs, we commonly have as little as three or four. Those four are enough to make the spine twist and bend believably.

In the most high-end AAA studios, the technology is reaching the stage where muscles are being simulated on characters in real time. If your goal is to work on something like that, you will need to buy some anatomy books.

Before we get into bone placement, we need to have a basic understanding of how the distance between the mesh and the bone it is rotating around changes the resulting deformation. Look at Figure 13.1. You will notice that the closer the surface is to the bones, the shorter the distance it will travel and less distortion is introduced to its shape. And the opposite is true, the further away the surface is the longer it will travel and with that be more distorted.

None of the examples are necessarily good or bad. We just need to understand the relationship between the bone position and the deformation and use it as a tool when deciding where to place the bones.

The focus of this chapter is solely on the positioning of deformation bones, and we will ignore their orientations for now.

Torso

Let us start by analyzing some real life. Take a look at Figure 13.2. The overlay I added should help easily identify the separation between the torso sections. Based on rigidity, we can split it into three parts: hips, abdomen and chest. Hips and chest deform little and move as mostly solid pieces, while the abdomen area is doing all the bending and twisting.

Based on this information, we can decide how many bones we need to pose the torso believably. Hip and chest need one bone each because of the rigidity we just mentioned. To show flexibility in the abdomen area, we need something that can bend and twist, which is at least two bones. Two might not sound like a lot, but it is enough in most cases. If the character is stylized and will require the body to be more pliable, you can add additional abdomen bones. Splitting the chest into two bones is sometimes done in stylized characters. This allows the animator to create smooth curved shapes throughout the entire torso. Since we are working with a realistic character, for this character I will use two abdomen bones.

The yellow dots in Figure 13.2 mark where the regions meet, which is where we will place the heads and tails of the torso bones. An additional factor that I am considering for torso bones is that the torso is symmetrical, which means we should position the bones at the center of the torso. For the final bone placement in my character, see Figure 13.3.

From the side view, you can see how I placed the bones in the middle of the torso. In a real human spine, the bones are positioned towards the back, but if we were to position the spine bones like this, it

DOI: 10.1201/9781003263166-13

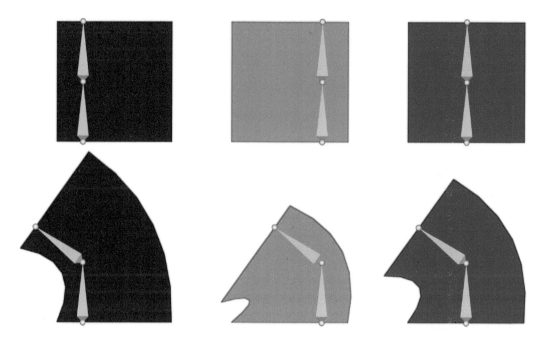

FIGURE 13.1 An illustration of the effect a bone's position has on the resulting deformation.

FIGURE 13.2 Sectioning of the torso based on rigidity.

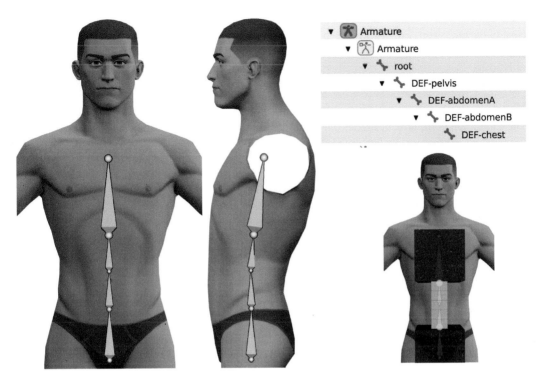

FIGURE 13.3 Torso bone placement, naming and parenting hierarchy.

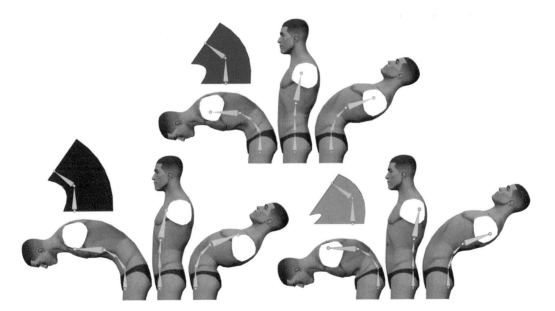

FIGURE 13.4 Torso bones placed at the center produce the least distorted results.

would create too much distortion in the torso's front. It would get squished too much when the character bends forward and stretched too much when bent backwards. The opposite would happen if we position the torso bones favoring the front. So we have to go with the compromise and place the bones in the center of the body. See Figure 13.4. Another reason it is best to have the bones centered is to get the best twisting motion out of them.

As you can see, by analyzing motion and focusing on what the bones need to do, we can eliminate most of the guesswork. And by asking the right questions, the bones will just fall into the most optimal place.

Leg

The leg, as well as the arm, is a series of rigid pieces with soft areas around the joints that connect them. We will call these segments: upper leg, lower leg, foot and toes. We mainly rigged toes in games as a single piece with a pivot at the ball of the foot. If your game is about feet, then you should probably add some individual toe bones as well. I'm sure you will be capable of doing that without my help after you learn how to add bones to the rest of the body. We will start with the upper leg and work our way down.

Upper Leg

Let us again do the research first. Look at Figure 13.5. It is pretty clear around which point the leg is rotating from. The pivot is high up, around the middle of the pelvis. It is a good starting point for finding the ideal upper leg bone location, but it is not enough. We need to find some landmarks that can guide us to a more precise location.

If we look at a leg from the front and check how it rotates, we can see that drawing a line from the groin to the iliac crest (i.e. the pointy bit of the hip that sticks out on the side), and another line that goes through the middle center of the leg we can identify a point around which the leg rotates. See Figure 13.6.

FIGURE 13.5 The upper leg joint location.

FIGURE 13.6 Identifying the point around which the leg rotates.

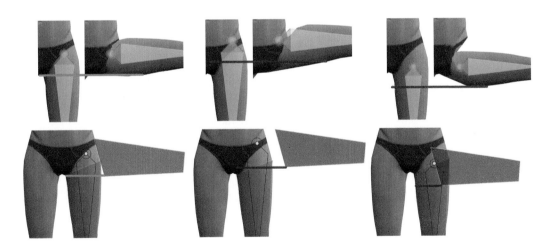

FIGURE 13.7 Checking the upper leg bone placement by rotating the leg or using a reference mesh.

An additional landmark that can we can identify from Figure 13.6 is that when the leg rotates to the side, its underside is aligned with the bottom of the pelvis. We can use this as a method to check if the height of the upper leg bone is correct. Either by rotating the leg bone itself if bone weights exist or by using a cube placed at the location of the pivot and modeled to match the leg dimensions. See Figure 13.7. Rotate the leg bone, or cube, and compare its underside with the height of the crotch. If it is above the crotch, then the pivot needs to be lowered. And if the leg underside is lower than the crotch, the pivot needs to be raised higher. Move the bone head up or down in small increments and repeat the test until the bottom of the leg is creating a straight line with the crotch.

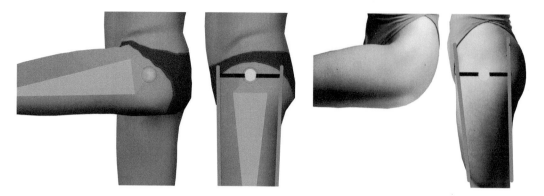

FIGURE 13.8 Positioning of the upper leg bone from the side view.

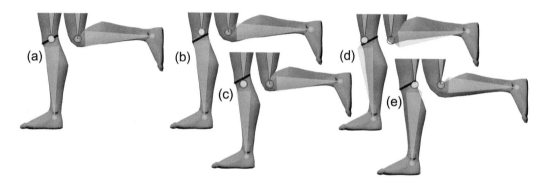

FIGURE 13.9 Different lower leg bone positions and the deformation created by rotating them.

The last piece of information we need for this bone is where to place it when we look at the leg from the side. We humans can't rotate our legs backward much, but we can rotate them a lot to the front. So let's focus on what happens when we rotate the leg forward. See Figure 13.8. Since we want the leg to keep its form as much as possible, moving the bone closer to either the front or the back of the leg is not ideal. So the best approach would be to put it at the center of the leg volume. Make sure to not move it up or down as we already established the height earlier.

Knee

The knee is a hinge joint, meaning it rotates on one axis only. And since the knee won't rotate side to side, from the front we can position the bone at the center of the knee and call that part done.

We can find the location for the knee by drawing a line from the bottom of the kneecap to the top where the calf meets the thigh. Place the knee in the middle of this line. See example A in Figure 13.9.

You can see the results of different placements in the other examples. B produces an overly rounded knee. C is what I often try if A does not work well. Examples D and E have the pivot favoring the front and back sides of the leg, which does not work well at all.

Ankle

We can find the position of the foot bone by looking at some poses of a real human foot. See Figure 13.10.

We can conclude that the pivot around which the foot is rotating can be placed right under where the actual ankle bone protrudes. You can see the results of this in Figure 13.11. Notice that the foot bone is parallel to the ground instead of pointing at the toes. The reason for this is that to me, it makes sense the foot bone has the same rotation as the foot, and in this case the foot is parallel to the ground as well.

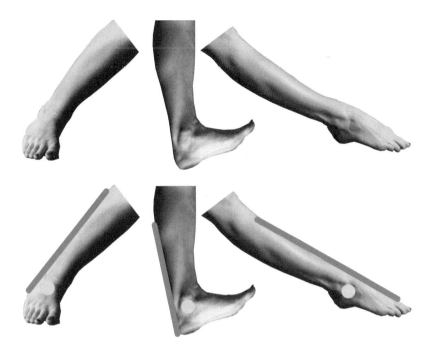

FIGURE 13.10 Finding the ankle pivot in a human foot.

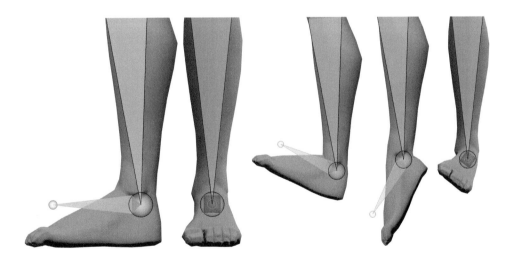

FIGURE 13.11 Foot bone placement.

Toes

As mentioned at the start of this section, what we usually call the toe bone is actually a pivot at the ball of the foot. If you look at your own foot, you find that the ball of the foot is at around one third of the foot's length. You can see this illustrated in Figure 13.12.

Angle Check

It is important that the upper leg, knee and foot are forming a straight line when observed from the front of the leg. This will ensure that when the knee is bent, the upper and lower leg bones will stay in the same line and the direction in which the leg is bending does not make the leg look broken. You can

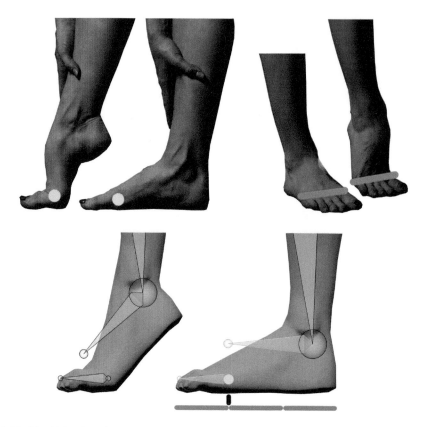

FIGURE 13.12 Identifying the point around which the ball of the foot rotates.

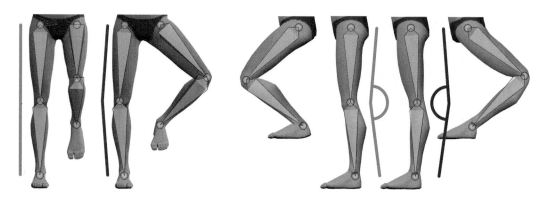

FIGURE 13.13 Correct and incorrect angles between the upper and lower legs.

check this by drawing a line through the leg using the annotation tool. If needed, we can move the knee slightly off-center to ensure that the three bones stay in a straight line. Otherwise, it might be required to adjust the mesh so that the knee is facing the same direction in which the leg is bending. See the left side of Figure 13.13.

When we look at the leg from the side, at least a slight bend between the upper and lower leg bones must be present. If they are forming a perfectly straight line, then inverse kinematics that we will add later will not work. We should also avoid an angle in the opposite direction of the leg, as that will cause the leg bending in the wrong direction. See the right side of Figure 13.13.

Figure 13.14 shows the full character state at the end of this stage, as well as the final naming and parenting of the leg bones. As you can see, I parent the start of the leg chain to the pelvis.

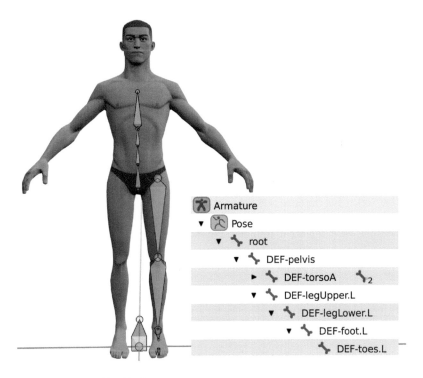

FIGURE 13.14 The bones created in this chapter.

FIGURE 13.15 Shoulder bone placement.

Shoulder and Arm

As the arm and shoulder have a broad range of motion, we need to be very careful with the bone placement to ensure that things look mechanically correct and deform as best as possible. They are very often part of close-up shots and are quite important for conveying emotion. The rest of the arm, from the shoulder down, is much easier to solve.

Shoulder

Since this bone has to do the work for both the clavicle and the scapula, it makes sense to put it at an equal distance from both, meaning placing it at an equal distance from the front and back of the chest. See Figure 13.15. Notice that the bone is not at an angle, like a clavicle would be. I like the shoulder bone to be like this as it gives the animator clean rotation values. One axis rotates front/back, and another up/down. From the front, we can place it around where the clavicle rotates from as this gives us a natural-looking motion.

Upper Arm

If you look at Figure 13.16 you can see a reference for arm rotation in a human arm. A side note: when the arm is lifted above 90 degrees that the shoulder rotates as well and moves the arm up. To find the pivot on

FIGURE 13.16 Finding the rotation pivot for the upper arm by analyzing human motion.

the model, we can use a mesh cube and find where the arm needs to rotate from so that when it is rotated down, it sits snugly with the ribcage. As shown on the model's left arm in Figure 13.16.

Once the initial placement is done, tweak the position until the arm sits against the ribcage correctly when lowered. If there is a gap between the ribcage and the arm, then the pivot needs to be higher on the arm. And if the arm is ending up in the ribcage, then the pivot needs to be lowered down the arm. Check Figure 13.17 for placement examples.

Elbow

When the lower arm is rotated, it creates a very sharp line at the elbow, and if we look closely, we can see that the backside of the upper arm part becomes slightly curved. This creates an appealing play of sharp vs curved lines and makes the elbow area more interesting. To emulate this, we can position the lower arm bone slightly below the exact center of the arm. See Figure 13.18. Positioned like this, and weight painted so that most of the elbow weight is on the lower arm, the lower arm will push the elbow out and give us the sharp line we are looking for.

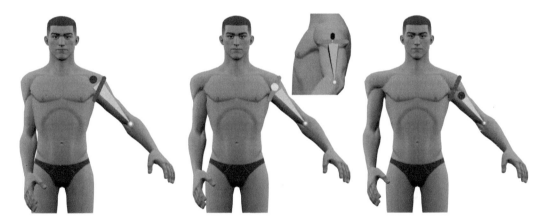

FIGURE 13.17 Finding the correct arm placement based on where the arm lands when lowered. Left example has the bone positioned too high, the middle example looks correct, right one has the bone positioned too low.

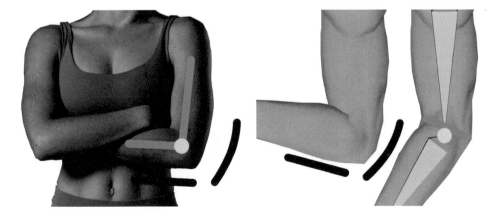

FIGURE 13.18 Bone placement at the elbow.

Wrist

As we can see in Figure 13.19 the point around which the hand rotates is slightly above the wrist. Pay attention to the hand's silhouette in the different poses and test the pivot placement by checking if your character's hand is creating similar shapes. Position the tail of the hand bone so that the angle of the bone echoes the angle of the hand mesh.

Fingers

Let's start the fingers off by adding three metacarpal bones. They will help create less boxy-looking hands. See Figure 13.20. I chose three bones for more control, but we could achieve similar results with two or just one metacarpal bone. The positioning of these bones is not critical and can be eyeballed, as they will only slightly rotate.

Getting a powerful fist pose when the fingers are curled is crucial, so we need to make sure we position the bones in such a way that there is no gap between the finger digits when they close into a fist. And the knuckles should stay quite angular. Luckily, both can be achieved by placing the bones closer to the top

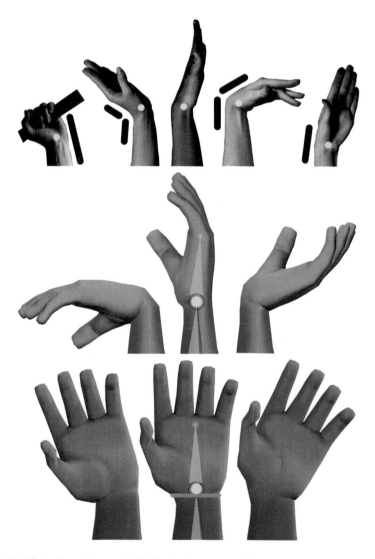

FIGURE 13.19 Identifying the point around which the hand seems to rotate.

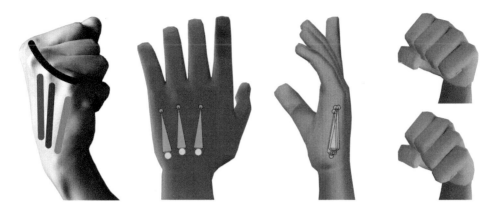

FIGURE 13.20 Metacarpal bone positioning and example pose.

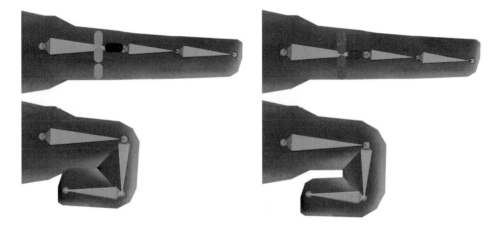

FIGURE 13.21 Finding the finger bone distance from the side view.

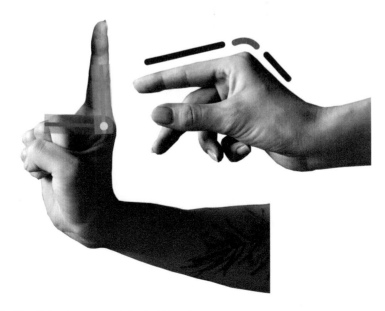

FIGURE 13.22 Identifying the position of the first finger bone.

of the finger, see Figure 13.21. Placing the bones at the center will produce a gap when the finger bones are rotated, which will cause weak-looking poses, as seen in the right side example in Figure 13.21. After bones are placed, and initial weight painting is done, test how well fingers close the gap between them and adjust the bone position from there.

The first bone in each finger is dug deep in the palm. Don't make the mistake of placing it where the finger and palm meet. This won't produce believable hand poses. Start the placement by putting it where the knuckle is modeled or textured on. Then test by curling the fingers and checking if the knuckle is sticking out from the palm. If it is sticking out too much, then move the bone deeper into the hand. And if it is too flat, then move the bone in the other direction. See Figure 13.22.

We can simply place the rest of the finger bones at the center of their joints, see Figure 13.23.

FIGURE 13.23 Finger bone placement.

FIGURE 13.24 Locating the position around which the first thumb bone rotates.

Thumb

If we look at a few thumb poses, see Figure 13.24 we can see that its first bone is rotating from a point close to the wrist at about a quarter of the palm width. Place the bone in this area and rotate it to see how what the hand poses look like. Adjust until the silhouette lines it creates with the hand are like those notated by the purple lines in Figure 13.24.

We can position the other two thumb bones the same way as the finger bones. Follow the rule from Figure 13.21 to create sharp knuckle silhouettes. See Figure 13.25.

With those two in place, we have added all the arm bones and set their locations. Check Figure 13.26 for naming of each bone and parenting setup.

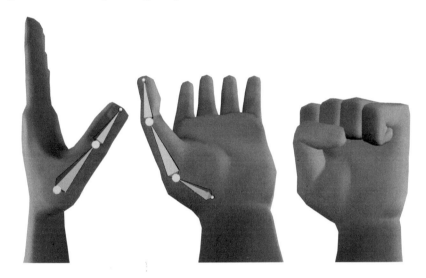

FIGURE 13.25 Last two thumb bone locations.

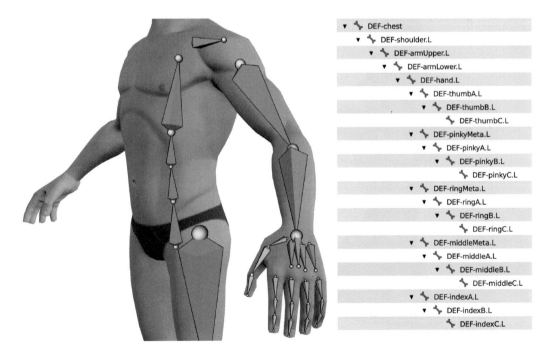

FIGURE 13.26 A look at the final arm bone positions, parenting hierarchy and naming.

Neck and Head

Look at the range of motion of the neck and head in Figure 13.27. The first thing to note is that the head is a rigid piece, so all we need for it is a single head bone. The neck is more flexible. To achieve neck curving and twisting, we need at least two bones. Notice that the neck does not actually bend much. The bottom section is usually straight and the upper part is slightly curved when it rotates backwards together with the head.

Since we know that the head and neck are symmetrical when looked at from the front, we know that all their bones should have a position of zero in X just like the spine bones. We can also find the placement of the neck start from this view. Based on the reference images from Figure 13.27 we can conclude that the point around which the neck rotates is behind the dip between clavicles, which is called the jugular notch. See Figure 13.28.

Next we move on to the side view and position the head bone slightly below the earlobe. Around half way between it and the lower jaw corner. We can then split the neck bone into two, with the upper part being slightly shorter. If they were equal in length, because the chain starts inside the chest area it would seem like the neck is bending off center. Final parenting and naming can also be seen in Figure 13.23.

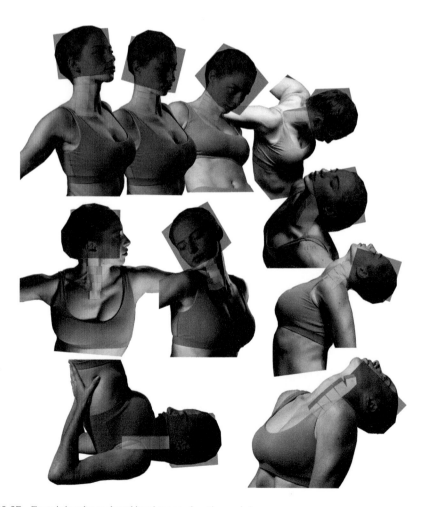

FIGURE 13.27 Examining the neck and head range of motion and shapes.

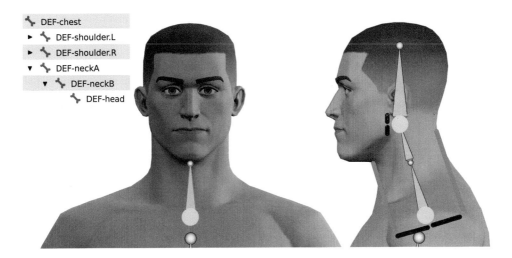

FIGURE 13.28 Neck and head bone positioning guide, parenting hierarchy and naming.

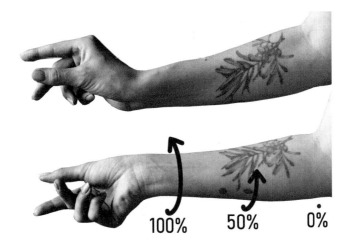

FIGURE 13.29 Twist distribution in a forearm.

Twist Bones

Most of the motion our limbs do involves some sort of twisting. We can look at a forearm as an example. See Figure 13.29. There is a lot that is happening here, but we are mainly interested in what is happening with the surfaces, not the anatomy that causes it.

On the surface level, we mainly see a twisting rotation that is distributed along the forearm, from wrist to elbow. At the wrist, the forearm rotates as much as the wrist does and it gradually falls off towards the elbow, where we don't see any twisting at all. In order to create this in a rig, we can create additional bones along the forearm bone and set them up in such a way that they rotate less and less the closer to the elbow they are, as shown in Figure 13.30.

The number of twist bones is important. The more we have, the smoother the rotation will be and the better the volume preservation will be. As we can see in Figure 13.30a, has no twist bones and all the mesh gets completely ruined at the wrist. Figure 13.30b shows the effect of adding a single twist bone. The deformation looks significantly better, but notice that volume gets lost and the forearm shrinks slightly. In Figure 13.30c, we have the best-case scenario with a smooth twist distribution and no volume loss. But at the cost of adding a high number of additional bones to the rig. When going above five twist

bones, the difference stops being noticeable, so I suggest adding up to five depending on the bone budget you have. We usually add the twist bones to the upper and lower arm and upper and lower leg.

The easiest way to create a set of twist bones is to duplicate the bone they will twist with, then subdividing that duplicate to get a desired number of equally spread twist bones. We should parent twist bones to their corresponding limb segment. There are a few benefits to this type of hierarchy. One is real-time rigging compatibility. For example, real-time IK which sometimes requires a three-bone chain to work. Another reason is LODs. By having the twist bones in their own hierarchy, we can delete them in LODs without breaking the animation of the rest of the rig. Figure 13.31. Shows the example character with the added twist bones, their parenting and naming.

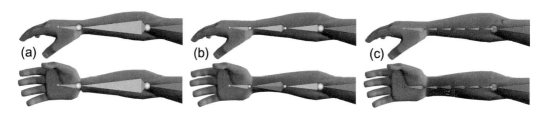

FIGURE 13.30 Twisting quality based on number of twist bones.

FIGURE 13.31 Twist bone hierarchy and naming.

Summary

The base of the rig is now completed. We can and will continue adjusting these bones and adding new ones as we go, so don't fret if you are unsure if all the work you've done up to this point is perfect. There is no need to chase perfection right now. Continue and address issues once you spot them.

To summarize, up to this point, we have added the body deformation bones and set up the parenting relationship between all bones to create a proper hierarchy. The root needs to carry the rest of the rig. It should be at the top of the hierarchy. We then parented the rest in a logical order.

14

Bone Orientations

Fundamentals

In rigging, the term "orientation" is used to describe the rest pose rotation of bones. It is important to orient bones in such a way that axes align with directions that make the most sense for animation and rigging. For example, we orient a lower arm bone in such a way that one of its axes is perpendicular to the elbow, which will, in effect, make this bone and the arm bend in a natural-looking motion when rotated on that axis (See Figure 14.1). Carefully thought-out orientations are important for both rigging and animation.

Orientations influence how control bones will behave and how their transformations will interpolate between keyframes. For example, if the animator is posing a jump and wants to move the character up. The body control could be oriented so that its axes match the world axes. This creates a clear relationship between how the character moves and how the transformation values are changing. Especially important when working with animation in the Graph Editor or Dope Sheet, as they don't have a visual representation of what each axis does, only the transformation channel name.

What would happen if we orient the body control to some random values? This simple upward motion could involve all three location axes, and we would have three values to animate. The first is clean, logical and easy to use. I would send the second one back to you to fix it, as no animator would want to work with it.

Animating is already complex and time-consuming and the rigger's job is to make the animator's job as easy as possible while providing them with all the control they need for the job. The difference it makes to set a forearm's orientation so that when rotated on one axis it gives a natural and anatomically correct motion, and orienting it so that the animator has to use multiple axes to pose a simple elbow rotation, is a matter of doubling or tripling the work they need to do in order to animate it.

Here is another example: when posing fingers the animator will deal with many controls. Probably 3 per finger, so at least 15 in total. To make them easier to animate, we want to define which axis does what and apply that same rule across all finger controls. So if rotation on X-axis curls the finger, the animator can select all the controls and expect that all finger controls will curl together in the same direction (See Figure 14.2).

Besides being important for clean animation, orientation plays a big role in setting up rig mechanics. Rigging involves a lot of layering and copying of different transforms, meaning that how we orient a bone will affect how other parts of the rig will behave. If we are rigging a target for eyes and want both eyes to always rotate so they are looking at this target. The constraint used to create this kind of behavior needs to know which bone axis is the one we want to point in the target's direction. So we would have to orient the bone in such a way that we have an axis which is pointing in the pupil's direction. Then, in the constraint's settings, we specify this axis is the one that should be used as the one that points at the target. This is just one example, and we will manipulate orientations to define much of how a rig behaves. From defining a proper leg orientation so the knee automatically bends in the right direction, to defining how the eyelid will move when closing the eye. We will go through orienting an entire character in the later chapters.

One last thing, we can orient bones after or in parallel with weight painting. Any adjustment done to bones in edit mode will not affect the weights. Which is useful as we can test and tweak both the weights and bones in parallel.

DOI: 10.1201/9781003263166-14

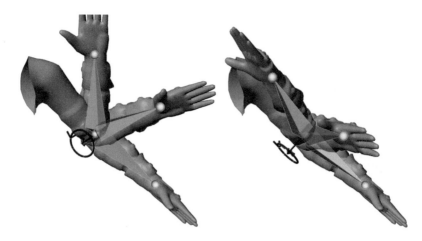

FIGURE 14.1 Left, bad orientation resulting in the arm looking broken. Right, bone's X-axis perpendicular to the arm, creating a natural-looking elbow rotation.

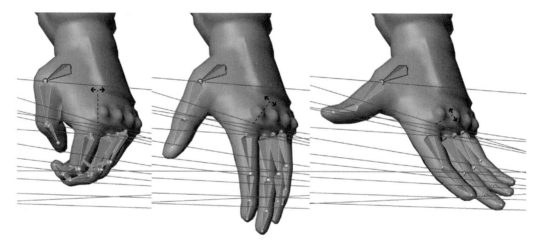

FIGURE 14.2 Example of the same bone orientation rule applied to multiple bones, which creates a uniform behavior when rotated together.

Bone Orientation Convention

There is no universal rule for how bones should be oriented and everyone has their own conventions. I will share my thought process behind bone orientations and what works for me.

My convention for setting orientations for all deformation bones is this: +X rotation flexes the corresponding body part. Which also means −X rotation extends the part. See Figure 14.3.

We will have two exceptions to the orientation rule. First exception are bones that should align with the world. Which are usually utility bones, like the root or prop bones. The second exception will be some mechanics bones. These are solved on a case-by-case basis, depending on what kind of rig mechanic is being built. In most cases, we will orient the mechanics and control bones the same way as the base skeleton bones they are driving. So by setting the orientation on all base skeleton bones first, we are solving orientations for much of the setup we will do later on.

The trick to knowing which direction the bone will rotate when rotated in positive X is to look at where its Z-axis is pointing. Positive X rotation will always rotate the bone in the direction toward Z. Refer to Figure 14.4.

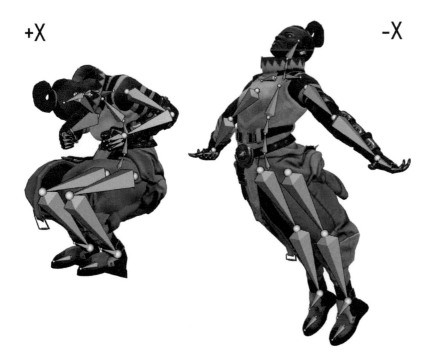

FIGURE 14.3 The deformation bone orientation convention used in this book. +X flexes, –X extends.

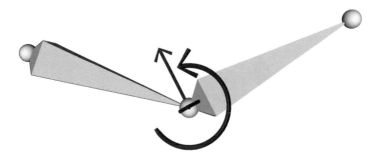

FIGURE 14.4 Key to knowing which rotation will cause positive numbers is to look down the X-axis. Rotating the bone towards the Z axis is rotation in positive X.

Setting the Roll

If you enable the bone axis visibility and move a bone's head and tail around, you will notice how the bone's orientation is changing when parts of it are being moved. The Y-axis will always point from head to tail. Notice how the X and Z axes are behaving. What the bone tries to do is to change those axes as little as possible. So if Z is pointing up, Blender will try to keep it that way as you move the bone parts around. But this attempt will mostly not be successful and the X and Z-axis orientation will change as well. So when you are adjusting a bone, first move the parts, then adjust the roll. And repeat as many times as needed until both the position and orientation look correct.

We can adjust the roll by changing the Roll property or, to adjust it interactively in the 3D view, you can start the Roll tool by pressing **Ctrl+R** and moving the mouse to adjust the value. Once happy with the results, **Left click** or press **Return** to apply the roll, or cancel it by pressing **Right click** or **Escape**.

One more thing to know about the interactive roll tool is that it supports numerical inputs. After we activate it with **Ctrl+R**, we can type in a numerical value and confirmed with **Left click** or **Return**. This is very useful for nudging the Roll by 45, 90, 135, etc. degrees.

The Roll Value Is Irrelevant

A Roll value of zero does not mean the same thing for every bone. It is relative to how the bone is rotated so a Roll of zero, or any other value, on one bone does not mean that it will have the same orientation as another bone with the same Roll value (See Figure 14.5).

What this tells us is that we can't blindly trust the Roll value. Setting it to 0 or 90 does not mean we will align a bone with a world axis. It might, but only where the bone's Y-axis is laying on the plane formed by two world axes.

Giving multiple bones the same Roll value to match their orientations will not work only when the bones have exactly matching rotations. In all other scenarios, we will need to rely on the Recalculate Roll tool.

Recalculate Roll

This is an operator that sets bone Roll values based on certain criteria. It is very important to be familiar with it as the tool we will use for most of bone orienting. Recalculate Roll only affects the Roll. The rest of the bones transformation will stay intact. To adjust the entire rotation of a bone, combine Roll adjustments with other bone editing techniques, like moving, snapping and aligning.

Recalculate Roll works on selected bones in Edit mode. To run it, open the *Armature* menu in the 3D view and select *Bone Roll>Recalculate Roll*. Or use the **Shift+N** shortcut. When the tool is activated, a pop-up window will show up and offer a selection of roll recalculation targets. See Figure 14.6.

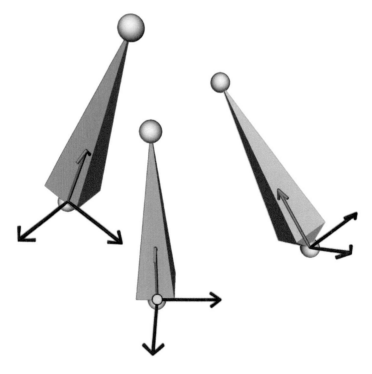

FIGURE 14.5 The local axes of three bones with the same Roll, but different orientations because of their different rotations.

Recalculate Roll					
Positive		Negative		Other	
Local +X Tangent	Shift N	Local -X Tangent	Shift N	Active Bone	Shift N
Local +Z Tangent	Shift N	Local -Z Tangent	Shift N	View Axis	Shift N
Global +X Axis	Shift N	Global -X Axis	Shift N	Cursor	Shift N
Global +Y Axis	Shift N	Global -Y Axis	Shift N		
Global +Z Axis	Shift N	Global -Z Axis	Shift N		

FIGURE 14.6 Roll options menu invoked by activating the recalculate roll operator.

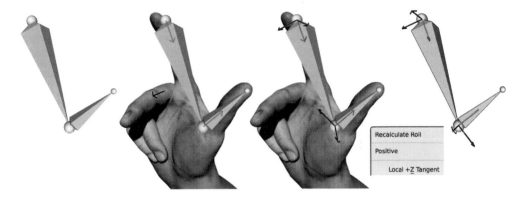

FIGURE 14.7 Visualizing the tangent direction using the right-hand fingers and aligning an axis to it.

Local Tangent

In Local Tangent mode, this tool will orient the bone so that the chosen axis is perpendicular to the bone's parent. In Figure 14.7, you can see a method of using the right-hand fingers to find the direction of the tangent. To do this, align the index finger so it points at the head of the parent bone and the thumb so it points at the tail of the child bone. Bend the middle finger so it is perpendicular with the palm. The direction the middle fingers points in is the tangent direction for those two bones.

If we run the tool on the two bones in Figure 14.7, and choose the Local +Z Tangent option, bones will be adjusted so that their Z is aiming in the same direction as the middle finger. This direction is perpendicular to the two bones, so if the child is rotated on its Z-axis, it will stay aligned with the parent bone.

This technique is great for orienting hinge joints like elbows and knees. For those, it is crucial they have a precise orientation in which one axis is exactly perpendicular to the two bones.

Local Tangent behaves differently if the bone it is operating on has a parent and/or child. Based on those facts, there are three potential outcomes. Those are:

- *Bone Has a Parent*: The tangent is calculated based on this bone and its parent. Even if the parent is not selected. When using the right-hand technique to check the tangent direction, align the thumb with this bone and the index finger with the parent. When a bone has a parent, it doesn't matter if it has a child or not. Children are not part of the calculation in this case.
- *Bone Has A Child but No Parent*: In this case, the tangent will be perpendicular to this bone and its child. This bone is the index finger, the child is the thumb. If the bone has multiple children, it will pick one of them and there is no option to specify which one/
- *Bone Has No Parent and No Children*: The operation is canceled. To calculate a tangent, it needs to have at least one of the two.

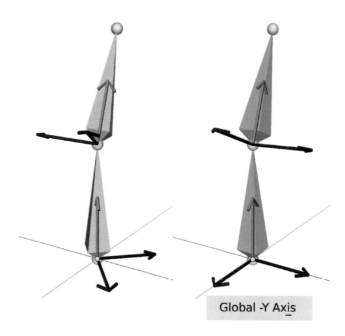

Global -Y Axis

FIGURE 14.8 Two bones oriented using the Global −Y-axis option to align their local Z-axis with the −Y world axis.

Global Axis

In global axis mode, the bone's local Z-axis will be aligned with the chosen world axis. It is great for perfectly aligning bone axes with the world. For example, spines are usually perfectly straight when looked at from the front. So it makes sense that spine bones have their axes aligned with the world. In Figure 14.8 you can see the result of using the Global −Y-axis. It perfectly aligned the local Z axis of each bone with the negative direction of the world Y-axis.

Since this method does not give us the option to choose if we want the Z- or X-axis aligned with one of the world axes, we can use it so that it first aligns the Z-axis in the desired direction and follow that up with the Interactive Roll (**Ctrl + R**) tool and type in a roll of 90, 180 or −90 to change which bone axis is aligned with the world axis.

Active Bone

This operation will align the orientation of all selected bones with the active bone. It does not copy the Roll value itself, it aligns the axes of the bones.

View Axis

The 3D view has an invisible camera that is rendering everything we see. The direction in which this camera points is called the view axis. When the Recalculate Roll tool is executed in the View Axis mode, the selected bones will have their Z-axis aligned with the view axis.

Cursor

In this mode, selected bones will be oriented so that their local Z-axis points at the 3D cursor. They are very useful in combination with cursor snapping.

15

Body Skeleton Orientations

Introduction

In this chapter, we go over all the body skeleton bones and set their orientations based on the convention from Chapter 14. Before we start, we need to make sure the workspace is set up properly so we can see what we are doing.

None of the bone display modes allows us to see the full bone orientation. With the Octahedral mode, we can see easily differentiate between the head and tail of bones, meaning it gives us information about the direction in which the bone's Y-axis is pointing. But that is not enough as for the orientation process, we are mainly interested in the X and Z axes. And to see those, we need to enable the *Axes* option in the *Armature Properties* view. I also prefer the axis *Position* set to *1.0*. See Figure 15.1. It might also help to have *In Front* enabled as well.

In the illustrations that follow, the axis visualization has been changed for improved visibility. For instance, refer to Figure 15.2 to see an example of the custom shape that I created to improve visibility. It differs only visually from what you would see in Blender, otherwise it is exactly the same as the bone axes shown in Figure 15.1.

It is absolutely crucial that you adjust the orientations before adding rig mechanics. Most of the bones we will create there will be made either by duplicating or by referencing the deformation bones, so it only makes sense we first complete those as much as possible.

Root and Prop Bones

The root will follow the character around the world, so it only makes sense we align it with the world axes.

We should also orient generic prop bones to match the world, as the props themselves will be made with no rotation applied to them. If there is a prop with a predetermined position and rotation, orient the bone so that it makes sense for that prop. For example, if a prop has a holster, it should sit in the holster perfectly when constrained to the prop bone.

Since we align the root bone with the world, its orientation can be set up simply by setting its *Roll* value to zero. Another way to achieve this would be to use the *Recalculate Roll* tool with the *Global +Z Axis* option.

Torso, Neck, and Head

When we flex muscles in our torso, as well as in the head and neck, they all bend forward, which means we can set the orientation on all of them in one move. If we apply the rule for orientations we mentioned earlier, orientation needs to be set in such a way that a rotation in +X is flexing these areas and banding them forward. To achieve that, the X-axis would have to point to the side of the character. And we know that in order to have positive rotation in X bend the body forward, Z needs to be pointing forward.

To achieve this, follow these steps:

DOI: 10.1201/9781003263166-15

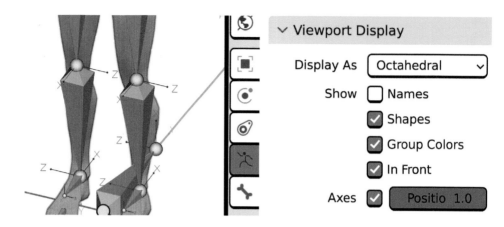

FIGURE 15.1 In front and axes enabled to provide an unobstructed view of bone axes.

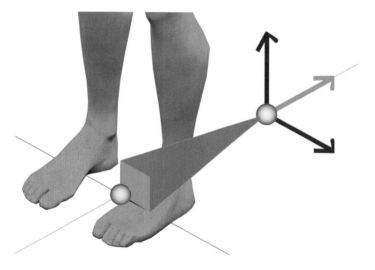

FIGURE 15.2 Root bone orientation.

- Make sure you are in Edit mode.
- Select all torso bones, neck bones, and head bone.
- Trigger the *Recalculate Roll* tool using **Shift+N**.
- Select the *Global −Y Axis* option.

The reason this option gets us the desired result is that it will make the bone's Z-axis point in the world −Y-axis direction. And world −Y is forward in relation to our character. If the bone's Z is pointing forward, it means that rotating them in +X will rotate them forward (Figure 15.3).

Shoulder

If we flex our shoulders, they move up. Meaning we need to orient the bone so that its Z-axis points up. To achieve this, do the following (Figure 15.4):

- Select the bone.
- Run the Recalculate Roll tool
- Choose Global +Z-axis.

FIGURE 15.3 Orienting torso, neck and head bones using recalculate roll.

FIGURE 15.4 Orienting the shoulder bone so that rotation in positive X direction flexes the shoulder.

Arm

Limbs are usually trickier to orient because they are not always perfectly aligned with a world axis, as the torso and shoulder are. For limbs, it is actually less important to align them with the world; it is more important to make sure the relationship between the upper and lower segment is correct.

The lower arm needs to be oriented in such a way that one of its rotation axes continues bending in the direction the elbow is already slightly bent in. When set up in such a way, the arm segments will stay perfectly aligned when the lower arm rotates. We can achieve this kind of alignment using the *Tangent* options in *Recalculate Roll*. As we know, the tangent is a vector that is perpendicular to two other vectors, in this case the upper and lower arm bones. For the standardization we are using in this project, the *Local +X Tangent* option is the one that gives us the correct result. To orient the lower arm:

- Select the forearm bone.
- Run Recalculate Roll with the Local +X Tangent option.

This does two things for us. It sets up the bone so that the +X rotation flexes the lower arm and it also makes sure the bone stays aligned with the upper arm when rotated on X (See Figure 15.5). An alternative way of achieving the same result would be to snap the 3D cursor to the head of the upper arm bone and orienting the lower arm using the *3D Cursor* option in *Recalculate Roll*.

The upper arm bone should rotate on the same plane as the lower arm. Meaning its X and Z axes should be parallel with the lower arm axes. Do this by copying the orientation from the lower arm to the upper arm. I like to change the flex direction of the upper arm so that +X rotation moves the arm closer to the body. This can be done by offsetting the Roll by −90 degrees. See Figure 15.6. The entire process goes like this:

- Selecting the upper arm.
- Hold **Shift** and select the lower arm, and make sure it is set as the active object.
- Run *Recalculate Roll* and choose the *Active Bone* option. The upper arm's orientation is now aligned.
- Select only the upper arm and make it the active bone.
- Press **Ctrl + R** to activate the *Roll* tool.
- Type in "−90" and press **Return**.

FIGURE 15.5 Incorrect lower arm orientation on left. Orientation method and correct orientation on the right.

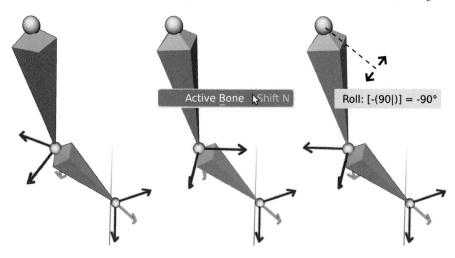

FIGURE 15.6 Upper arm orientation by copying the lower arm orientation followed by further tweaking to comply with the orientation scheme.

Hand

The palm does not need to take any other parts of the arm into consideration. What needs to be achieved is that when the hand is flexed, it rotates in the direction the palm is facing. Which means we need the Z-axis to point in that same direction. We can eyeball this part in organic characters. To do this, follow these steps:

- Align the view so that you are looking at the hand from straight ahead.
- Select the hand bone.
- Press **Ctrl + R** to engage the *Interactive Roll* tool.
- Move the cursor around the bone to adjust the roll until the bone's X axis is parallel to the top of the palm and Z is pointing in the palm's direction.
- Left click when done to apply the roll.

See Figure 15.7 for reference. If you need more precision when doing the roll operation, you can move the cursor further away from the bone, or hold **Shift** for precision mode.

Fingers

The metacarpal bones can be oriented by copying the orientation from the hand bone and adjusting as desired to match the hand curvature (See Figure 15.8). The required steps are:

- Select the metacarpal bones.
- Extend the selection by holding **Shift** and clicking on the hand bone, making it active too.
- Press **Shift + N** for the *Recalculate Roll* tool and select the *Active Object* option.

Fingers usually work best when all three bones in each finger have an identical orientation. Let us make sure that is the case first (see Figure 15.9):

- Select all three bones from one finger.
- Make one of those bones the active one.
- Press **Shift + N** and choose *Active Bone*.
- Repeat the process for the other three fingers.

After this, we need to make sure that rotating all finger bones in +X will lead to a good-looking first pose. I do this by selecting all three bones of a finger and using the *Interactive Roll* tool (**Ctrl + R**) to adjust the roll so that the Z axes are pointing towards the palm. Roll the index, ring, and pinky

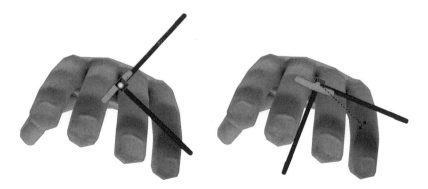

FIGURE 15.7 Orienting the hand bone using the *Interactive Roll* tool.

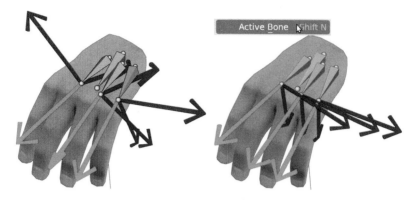

FIGURE 15.8 Copying of the hand bone orientation to the metacarpal bones.

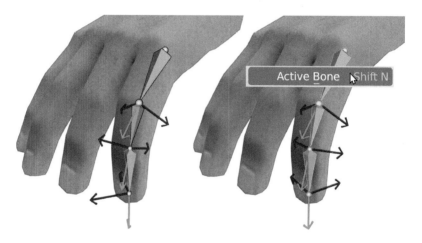

FIGURE 15.9 Matching the orientation of individual finger bones.

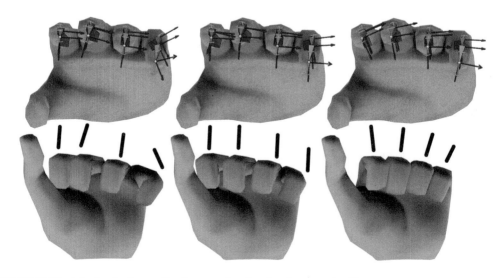

FIGURE 15.10 Adjusting the finger roll to form a perfect fist when they rotate in +X.

slightly towards the center of the palm so that when they rotate, they will move slightly towards each other and form a more believable fist. Do the opposite if they are rotating into each other (see Figure 15.10).

Be careful not to overdo it with this trick. If you offset the roll too much, you will create a visible mismatch between how the bones are oriented and how the actual finger mesh is oriented. In extreme cases, it might be better to make adjustments to the model and have the fingers modeled so they are oriented properly.

Thumb

The process for orienting the thumb bones is very similar to what we did with the fingers. To orient it do:

- Select all three thumb bones, making sure one of them is the active bone.
- Press **Ctrl + N** for the *Recalculate Roll* tool and select the *Active Bone* option.
- Press **Ctrl + R** to engage the *Interactive Roll* tool.
- Adjust the roll until the X axes are orthogonal to the thumb and the Z axes are pointing to the front of the thumb.

Ideally, the thumb should rotate towards the middle finger when rotated in X, but this depends mainly on how the finger is modeled (Figure 15.11).

Leg

The process for orienting the leg bones is the same as for the arm. Actually, if you are comfortable with the tools and techniques for orienting bones that I have shown up to now, then you already know everything you need to know about orienting any skeleton. There is not much else to it.

So instead of going step by step through orienting the leg, I will show you the final results so you have it as a reference and let you figure out how to get there. If you get stuck, go back to previous sections in this chapter to refresh your memory. For the final leg orientation reference, see Figure 15.12.

Twist Bones

Twist bones should be rotated and oriented the same way as the bones they will twist with; e.g. for an upper arm, this means the twist bones are to be rotated and oriented the same way as the upper arm bone. The fastest way to do this is by copying the complete rotation of a bone to selected bones using the **Ctrl + Alt + A** shortcut. Do this for all twist bones to quickly copy the orientation from the segment they belong to (see Figure 15.13).

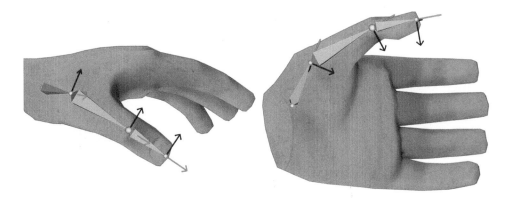

FIGURE 15.11 Finished thumb orientation.

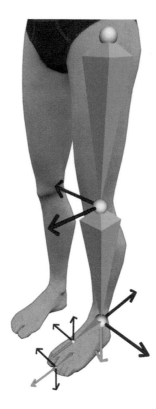

FIGURE 15.12 Final leg orientations.

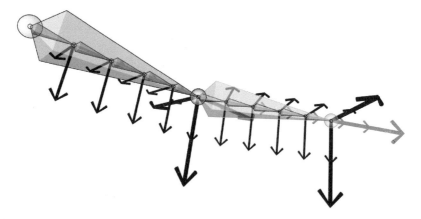

FIGURE 15.13 Example of twist bone orientations. Larger axes belong to the source bones that the twist bones get the orientation copied from.

16

Weights

DOI: 10.1201/9781003263166-16

Introduction

Bone weights connect mesh vertices to bones, allowing them to transform together. The weight is the percentage of the transformation that applies to the point, with 0% having no effect and 100% applying the entire transformation. Instead of it being a value between 0 and 100, we will scale it so it spans from 0.0 to 1.0.

Multiple bones can influence a vertex, called "influences" in bone weights. More influences require more processing power to calculate the vertex's position, so using the smallest number of influences possible helps maintain game performance.

Weight can be defined by assigning weight amounts directly or through weight painting, which uses painting brushes to modify influences on the mesh. Weight painting involves raising or lowering the value of influences and smoothing the differences between vertices.

Linear Blend Skinning

To make the most out of bone weights, it's important to understand the underlying calculations and how they affect the final deformation. Only by having this knowledge we can make the most out of our weights and learn how to work around the limitations of linear weight blending.

The way a final position of a vertex which has multiple influences is calculated depends on which algorithm is used. A few exist, but we are only interested in the one that is used in game engines as we want to apply the same effects to the mesh in Blender as those that will be in the game. Since game engines care a lot about efficiency, the most common approach to calculating the final vertex positions is the simplest one called "linear blend skinning". Skinning is another term used for weighing a mesh.

Linear blending is a straightforward operation. As the name suggests, it linearly blends the point's position with its influences. Look at Figure 16.1. It shows a mesh with two bone influences. The numbers represent the vertex id's and the influence amount based on each bone.

The following explains what effect this has on each vertex:

- *1 and 4*: Bound to the yellow bone and will transform exactly the same as the bone does.
- *3 and 7*: Bound to the red bone and will transform exactly the same as the bone does.
- *5*: Will inherit 50% of each bone's transformations.
- *2*: Moves 100% with the red bone. These results might be unexpected as the red bone has only an influence of 0.5 but, as seen in the example, it moves the same amount as the bone does.

Based on what I said earlier, we would guess 50% of the red bone's transformation will apply to vertex 2, but Blender does an additional operation on top. Which is weight normalization. Normalization means that all weights will be adjusted so that they always add up to 1.0.

Normalization calculation happens like this: A bone's weight is divided by the sum of all weights. Since we have only one bone influencing the vertex, the equation would be 0.5/0.5 = 1.0. So yes, the total weight for this vertex is 0.5 but after normalization that weight is 1.0, which means this vertex will follow the full movement of the red bone.

Linear blending comes with one major downside, which is volume loss. It is most prominent when bones rotate, so we will use rotation as an example. Take a look at Figure 16.2.

To better understand why this is happening, we will break down the process of how linear blending works. First, look at where each of the bones wants to take that problematic vertex. See Figure 16.3. The first example shows where the vertex would end if the first bone had 100% influence over it. The second one shows what would happen if the second bone had full influence over it.

If we draw a line between these two points, we get all the possible locations of where this vertex can end up based on the amount of influence from these two bones. Since they both have an influence of 50%, the vertex will end up in the middle of this line. And therefore, volume loss is inevitable on vertices that have multiple influences. See Figure 16.4.

FIGURE 16.1 A mesh with two influences and the deformation that happens when the red bone moves.

FIGURE 16.2 Mesh deformation expectations (a) versus the reality (b).

FIGURE 16.3 Reference for how each of the bones would deform the vertex if they had full influence over it.

FIGURE 16.4 Visualization of linear blend weight calculation.

Vertex Groups

Blender manages weights through Vertex Groups, with each group representing a bone. The creation of vertex groups is not tied to a specific armature and they are only applied when connected to a mesh using an Armature modifier. Matching names automatically map vertex groups to bones, so the mesh must have vertex groups named after the bones storing their weights for an armature to deform it.

To add and manipulate vertex groups in Blender, find the Vertex Groups panel in the mesh object's Object Data Properties tab, see Figure 16.5. Hovering the mouse over each option will help you understand its purpose. In Edit or Weight Paint modes, options for adding vertices to groups appear. While this is a basic way to create weight groups, more interactive methods are available.

Blender excels at keeping Vertex Groups intact no matter what changes we make to the mesh. The topology can be freely adjusted and changed, parts of the object separated, other objects merged into a weighted one, armature modifier added or removed, etc. None of these and similar operations will destroy the existing weights.

To inspect vertex groups and influences, use the Spreadsheet view or Item panel in the 3D view N panel. The Spreadsheet can be overwhelming, while the Item panel only shows the weights for the active vertex and can be edited. See Figure 16.6.

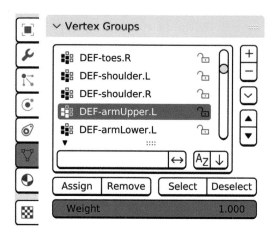

FIGURE 16.5 A mesh's vertex groups panel.

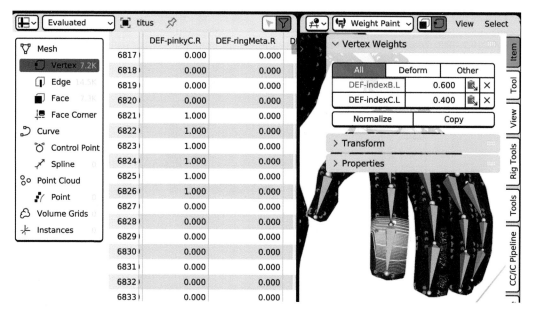

FIGURE 16.6 Numerical vertex group values found in the spreadsheet editor and 3D view toolbar.

Armature Modifier

As the vertex weights live on the mesh and bones in armatures, we need to connect the two. We do this by adding an Armature modifier to the mesh. To ensure the mesh deformation looks exactly the same as how it will deform in the game engine, the settings used should be the same as the ones in Figure 16.7, which are actually the default settings. The only parameter we should be concerned with is *Object*, as this is where the armature we want to connect with the mesh is assigned.

Bones that have the *Deform* property disabled are ignored completely. The other bones will transform the mesh according to their weight. If the modifier is disabled, deleted or the *Object* property cleared, the armature's effect will be removed and the mesh will go back to its default state. For game rigging, we should use only one armature modifier per mesh.

Binding

We can add the Armature modifier and create all the vertex groups on the mesh manually, but it is faster to let Blender do that work for us. To automatically create vertex groups and armature modifiers, do the following:

- Select one or multiple meshes you want to be bound to an armature.
- Add the armature to the selection and make sure it is the active.
- From the 3D view menu, navigate to *Object > Parent*, or press **Ctrl + P**.
- Select one option:
 - *Armature Deform*: Creates an Armature modifier on the selected mesh objects, parents them to the armature and assign the armature as the target in the modifier. It will not create any Vertex groups.
 - *With Envelope Weights*: Ignore this one because we don't use the envelope weight mode.

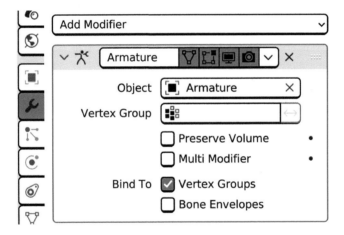

FIGURE 16.7 The armature modifier with the correct settings for game rigging.

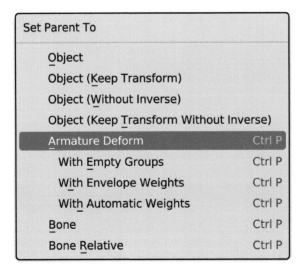

FIGURE 16.8 The *parent to* menu contains the options for automated armature modifier and vertex group creation options.

- *With Empty Groups*: Same as *Armature Deform*, additionally creates a blank vertex group for every deform bone in the selected armature.
- *With Automatic Weights*: Same as above, besides creating the groups it will approximate vertex weights based on their distance to deformation bones.

I prefer to start weight painting with empty weight groups, so I use the With Empty Groups option. This option is helpful for updating vertex groups with new bones and can be used multiple times to add groups for new deform bones without affecting existing groups (Figure 16.8).

Fixing the Heat Map Failed Error

When assigning automatic weights, sometimes the process will fail with little explanation. Only a not-so-helpful error message will be displayed, which states: "Bone Heat Weighting: failed to find solution for one or more bones". In my experience, one of the following three reasons always caused this:

- *Extreme Scale*: If the mesh is too small or too large, the operator to fail. Temporarily scale the character and armature so that they are between 1 and 2 meters tall, execute the operator and reset the scale back to how it was.
- *Multiple Mesh Bind*: Try running the operator on meshes one by one.
- *Non-Manifold*: If non-manifold geometry is present it needs to be addressed as it might cause issues in the game engine as well.

Normalize Weights

Assigning weight values freely can lead to a problem where a vertex's influences sum to a value higher or lower than 1.0, which affects the weight values applied to the mesh. To avoid this issue, it is ideal for the influences on each vertex to add up to exactly 1.0, ensuring the correct representation of the final weights.

Blender has an operator called *Normalized All,* which adjusts the weights so that they all have normalized values. You can find it in the geometry Edit mode by going to the top menu in the 3D view and selecting *Mesh > Weights > Normalize All*. This operator works on selected vertices only. See Figure 16.9.

Adjust the operator from the adjustment menu in the 3D view. You can choose between All Groups and Deform Pose Bones. The latter option ignores groups without matching bones. The operator also has Lock Active, which keeps the active group at its weight value and adjusts the rest of the groups.

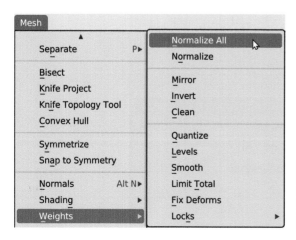
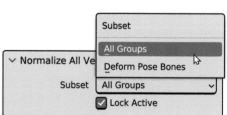

FIGURE 16.9 Location of the normalize all operator and the additional options that become available after execution.

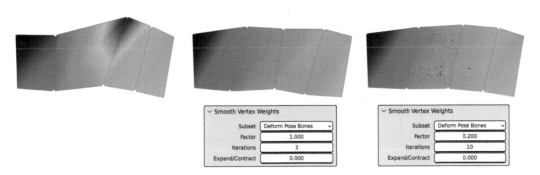

FIGURE 16.10 Smooth vertex weights operator results in different settings.

Smooth Weights

Smooth Weights is a great option for making gradual and smooth transitions between vertex groups. You can find it in the 3D view menu by navigating to *Mesh > Weights > Smooth*. Once you click on that option, a new pop up will appear at the bottom of the 3D view in which we can fine-tune the operation. Here is a breakdown of what each option does:

- *Subset*: choose if the smoothing should affect only the Active Vertex Group or all.
- *Factor*: Ranges from 0.0 to 1.0 and affects how much of the smoothing will apply to the vertices.
- *Iterations*: Number of smoothing operation repetitions, e.g. 10 iterations means run the smoothing operation 10 times.
- *Expand/Contract*: Ranges from -1 to 1 and shifts the bias of the smoothing, i.e. makes the falloff tighter on one side and smoother on the other. It can sometimes be like magic but is also very unpredictable. I encourage you to experiment with this option and get a sense of how it works.

Using a higher number of iterations and adjusting the factor to get the desired results usually produces better smoothing than a high factor value with 1 iteration. See Figure 16.10. Smooth will often produce non-normalized weights, so I recommend normalizing the weights after running smoothly. Especially when mixed with using influence locking.

Mirror Weights

When working with symmetrical characters, time can be saved by painting weights on one side and mirroring them to the other side. To mirror vertex groups follow these steps:

- Select vertices on the side of the mesh that you want to mirror. Mirror copies weights from the unselected side to selected.
- In the 3D view menu, navigate to *Mesh > Weights > Mirror*.
- In the operator menu that shows up in the bottom left corner of the 3D view enable *All Groups*. See Figure 16.11.

If you have *Topology Mirror* disabled, the weights will be projected from one side to the other based on vertex locations. Use this when the mesh is perfectly symmetrical, or close to symmetrical, but the topology is not. If the character has a symmetrical topology, then *Topology Mirror* can be enabled to get the best results. This will give you a perfect mirror, even if the mesh shape is not perfectly symmetrical.

FIGURE 16.11 Mirror weights operator options.

After mirroring, a message will be displayed at the bottom of the screen that informs you of the results of the operation. If it states that points failed, it means your mesh might not be symmetrical. It has to be symmetric for the operator to work, or you will need to manually paint weights in the asymmetrical area.

Limit Total

Blender has an operator called *Limit Total* that adjusts the number of influences by removing the bones with the lowest influence. We can find it in the *Weights* menu in the 3D view. The weights that belonged to the removed influence will be distributed to the remaining bones.

Weight Paint Mode

Weight Paint mode gives access to interactive weight modification tools, aka weight painting. It uses a brush engine that allows the user to change influences by applying brush strokes. Tools and settings for this mode can be found in three places. *Toolbar* is where you choose the active tool. Other two areas, *Sidebar* and *Tool Settings* give access to the active tool settings and general weight painting settings. The **W** key brings up a panel with a few quick brush settings. See Figure 16.12.

Bone Manipulation

Weight Paint mode has some hidden features that are only available when the mode is entered while an armature is selected together with the mesh. The mesh object has to be the active object. An additional requirement is that the mesh is connected to the armature via an Armature modifier. If there is no modifier, with the armature set as the target, this won't work.

When you enter *Weight Paint* mode this way, you can select bones and transform them while painting weights. For transformations, use the usual **G**, **R** and **S** shortcuts. Another useful shortcut is **Alt+Z**, which will toggle displaying bones in front of the mesh. If the armature has *In Front* enabled, then it will always display over the mesh, so it is better to have it disabled before entering this mode so that you can toggle it on/off as desired. **Alt+G**, **R** or **S** resets the bone's transformation.

If you are using left-click selection, you will need to hold down **Ctrl** or **Shift** to select bones in *Weight Paint* mode.

Vertex and Mesh Selection

Mesh selection can mask areas that Weight Paint tools affect. In weight paint mode, two selection modes are available: face and vertex. They can be toggled with buttons or keyboard shortcuts, and selections made in Weight Paint and Edit mode are shared. Mesh selection is useful when using tools like Smooth and Gradient, or when painting in a specific area. However, once mesh selection is enabled, bone selecting stops working. To switch between selecting bones and mesh sections, use **M** and **V** (Figure 16.13).

FIGURE 16.12 Weight paint tools on the left, rest are various places where tool settings are found.

FIGURE 16.13 Buttons for toggling face and vertex selection in weight paint mode, between the mode selection button and the view menu.

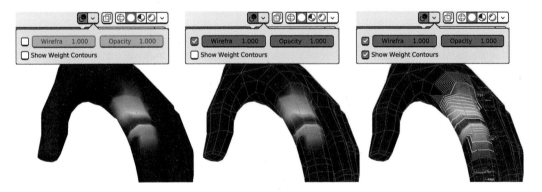

FIGURE 16.14 Useful weight painting overlays.

Display Settings

Minor differences in weight are hard to see with the default weight paint mode display settings. We can improve weight visibility by enabling two settings. First is *Wireframe,* so we can see the topology. The second option *Show Weight Contours*, which draws bright lines inside areas of influence, making the weight distribution much easier to identify. We find both these options in the Viewport Overlays menu. See Figure 16.14.

The downside of having these options enabled, and the weight colors don't help either, is that we can't see the character and its textures that well. So what I do is keep these settings enabled and toggle all Overlays on/off using **Alt + Shift + Z**.

Influence Lock

Vertex group locking enables us to lock the weights of vertex groups so that they are not editable. Vertex group locking works everywhere, it is not exclusive to Weight Paint mode.

When painting weights with *Auto Normalize* enabled, whenever we add weight to one group, the same amount of weight will be automatically subtracted from other groups that are influencing the same vertices. The same goes for subtracting. Whenever we subtract weight from a group, that same amount of weight will be distributed to other groups that influence the same vertices. This can be problematic as it can destroy areas in which we completed weights already. By using the **K** shortcut, we can bring up the *Vertex Groups Locks* pie menu which gives very convenient group locking and unlocking options. When a vertex group is locked, it will display the corresponding bone in red.

Keep in mind that if you want to paint weight and no other groups are unlocked, nothing will happen. You always have to unlock the group you are taking the weights from or distributing the weights to (Figure 16.15).

Assign Automatic From Bones

To generate weights based on the mesh-to-bone proximity, on only selected bones, use the *Assign Automatic from Bones* operator. This is found in the 3D view menu under *Weights*. This operator applies the effect only using the selected bones. It can be masked to specific areas by using face or vertex selection.

To use the operator, follow these steps:

- Enter Weight paint mode with the armature selected, and the mesh object as the active object.
- Select any number of bones.
- If the operator should affect only a portion of the mesh, enable either face or vertex selection and select the area that should be affected.
- Run *Assign Automatic From Bones* from the *Weights* menu.

It will replace the existing weights on the affected mesh area with the weights the operator generates.

FIGURE 16.15 Vertex groups locks pie menu, engaged by pressing the **K** key in weight paint mode.

Set Weights

To flood the mesh with the active weight set in a tool, use the *Set Weight* operator by pressing **Shift+K** or running it from the *Weights* menu in the 3D view. It will only work on selected vertices or faces, meaning we must have vertex or face selection enabled. When executed, it will apply the effect of the active tool to the entire selection.

Note that this operator ignores Auto Normalize. If you want the results to be normalized, run *Normalize All* with *Lock Active* option enabled right after using *Set Weight.*

Weight Paint Tools

Weight paint tools represent different brush engines, each of them having a unique effect on vertex groups when applied by clicking and dragging on the mesh. The active tool can be set by clicking on its button in the 3D view *Toolbar* (Figure 16.16).

Brush Presets

Draw, Blur, Average and Smear have the option to store presets. This is managed from the Brushes section in the Tool panel. When any setting are changed, they get automatically stored to the active preset. Presets can be loaded from other Blender files by using Append and navigating into a blend file's Brush folder.

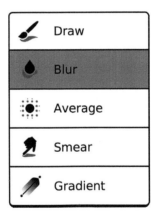

FIGURE 16.16 Weight paint tools.

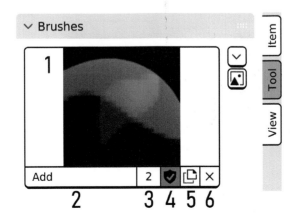

FIGURE 16.17 Brush presets panel.

Here is what you need to know about this panel (see Figure 16.17):

1. By clicking on this area, we get access to the preset selection panel. Click on a preset to select it.
2. Displays the preset name and allows the user to rename it.
3. Number of users. By clicking on it you will duplicate the preset, essentially making a new preset with the same settings as the original one.
4. Fake User toggle. Prevents automatic deletion of presets that have zero users.
5. Creates a new preset.
6. Delete preset by unlinking it.

Brush Settings

We find brush settings in the *Tool* tab in the Sidebar (N panel). *Blur, Average* and *Smear* have the same settings. *Draw* shares all the same settings and additionally it has *Blend* and *Weight* properties. The *Gradient* tool is unique and has only a small selection of settings, which are displayed in the *Active Tool* panel, while the other tools have their settings in the *Brush Settings* panel. See Figure 16.18.

In the following sections, we will discuss the tools and how the settings affect them.

Draw

Draw edits weights by painting them on the mesh using a brush. The workflow is straightforward. Choose a bone by clicking on it, or the vertex group, adjust the brush settings if needed, click or click and drag on the mesh to apply the operation. See Figure 16.19.

The following explains the most useful brush settings:

- *Blend*: Changes what operation happens when you paint with the brush. For example, *Add* will increase the bones influence by the weight of the brush and *Subtract* will remove the weight from the group. To get the most predictable results, it is important to have *Auto Normalize* enabled. Other useful modes to check out are *Value,* which is smoother than *Add,* and *Overlay* which is great for increasing the influence relative to how much influence already is there.

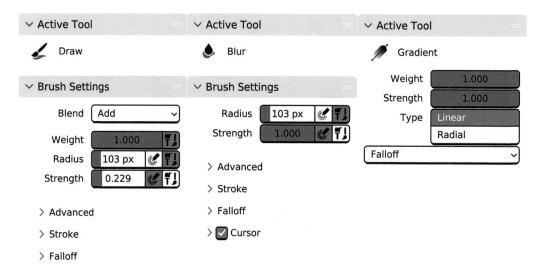

FIGURE 16.18 Brush settings for different weight painting tools. Smear and average have the same set of settings as blur.

FIGURE 16.19 Assigning weights using the draw tool in the add blend mode.

- *Weight*: Specified the weight amount that brush applies.
- *Radius*: is the size of the brush in screen pixels.
- *Strength*: Defines how powerful the effect of the brush is. Essentially multiplying the Weight by the Strength.
- *Falloff*: Defines how the brush effect is applied based on proximity to the brush center. For example, the *Smooth* preset sets the brush intensity to be the strongest at the center of the brush and gradually reduced towards the outer brush limits, making the brush blend softly when applied. Where the *Constant* preset has no falloff and will apply the same effect across the entire brush surface.

Weight, Radius and Strength have the option to use global brush settings. Meaning the values will stay the same when switching between brushes and even tools. Radius and Strength also feature a pen pressure toggle you can enable if you are painting the weights using a pen interface that supports pressure-sensitive input.

The settings under *Advanced*, *Stroke*, and *Cursor*, which I haven't mentioned here, are what I always leave at their default values. If you are curious about what they do, just hover your mouse over them and a description will pop up.

Blur

Blur functions the same as *Draw* but has only one mode. Its sole purpose is to reduce the difference in weights between vertex groups. The effect is like that of the *Smooth* operator. With the difference being that *Blur* is a brush and it will respect *Auto Normalization* and locked groups. Where *Smooth* doesn't and the mesh needs to be normalized afterwards. See Figure 16.20.

Average

Average calculates the average weight value of all points under the cursor and applies that value to the points. It works best with face or vertex selection enabled and falloff set to *Constant*. This tool is useful when parts of the mesh need to have exactly the same weights and deform as a single rigid piece. To achieve this, select the part of the mesh and paint with the *Average* tool over it until all the weights in the selection are equalized. See Figure 16.21.

Smear

When applied, *Smear* will grab the weight values under the cursor, which can then be pushed in any direction by continuing to hold the mouse button pressed and moving the cursor in the desired direction. It is an excellent tool for quickly extending or shrinking the range of an influence. Can produce messy results, but we can easily smooth this out using the *Blur* tool. See Figure 16.22.

Gradient

Applies a *Linear* or *Radial* gradient of weight in an area defined by clicking and dragging. I suggest you experiment with the settings to get a feeling for this tool. It can be useful but can be very destructive and hard to control as it extends indefinitely in directions orthogonal to the gradient line. Combine it with mesh selection to make sure it affects only what you want to be edited. See Figure 16.23.

While using the *Gradient* tool, there is no option to change the *Blend* mode. It always behaves as if the blend mode is set to *Add*. But there is a trick that allows the use of different blend modes, which is to use gradient strokes with the *Draw* tool. To do this, switch to the *Draw* tool and hold **Alt** for linear gradient or **Ctrl + Alt** for radial gradient drawing. All the settings that apply to the *Draw* brush will apply to this gradient, meaning you can use different blend modes.

Falloff

The *Falloff* value changes the brush strength across the brush's radius. *Smooth* is the most common falloff type, which gradually reduces the strength of the brush towards the outer edges of its radius. See Figure 16.24 for a few Falloff type examples.

Another aspect of falloff is the *Falloff Shape* property, which gives the choice between *Sphere* and *Projected*. *Sphere* means that the brush cursor is treated as a sphere and only works on points that are within this sphere. *Projected* can be imagined as the cursor being a cylinder that projects through the mesh indefinitely and affects all points that fall into this shape.

Symmetry

Weights can be painted on both sides of the character simultaneously by enabling *Symmetry*. We can find the *Symmetry* settings in 3D view header as well as the *Tool* tab in the N panel. See Figure 16.25. While a mirror axis is enabled, weight paint adjustments are projected across the active axes enabling painting weights for both sides of the mesh at the same time.

The following explains the options:

- *Mirror Vertex Groups:* changes the behavior of the tool significantly. When disabled, the mirrored changes apply to the active vertex group. If enabled, the mirrored weights will be applied to the opposite vertex group if it exists. Meaning if you are painting weights for a group called hand L. Mirror Vertex Groups will mirror the changes to hand R.
- *Mirror*: Represents the axis across which to perform mirroring.

FIGURE 16.20 Blur tool applied to create a gradual transition between vertex groups.

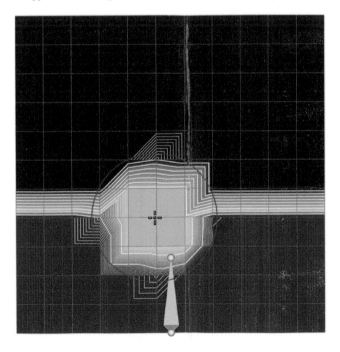

FIGURE 16.21 Pushing and pulling the weights using the smear tool.

- *Radial:* Only useful if mesh has a circle or sphere shape and you want to replicate the painting operation across its radius.
- *Topology Mirror:* Enables topological mirroring, as opposed to projection mirroring when disabled.

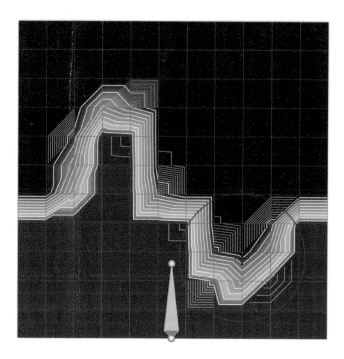

FIGURE 16.22 Pushing and pulling the weights using the smear tool.

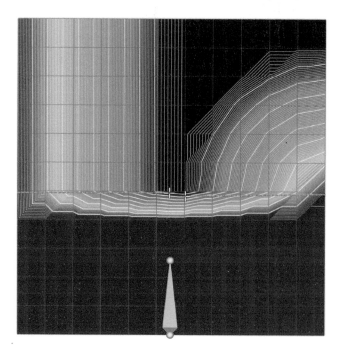

FIGURE 16.23 Effects produced by different gradient tool modes. Linear on the left and radial on the right.

FIGURE 16.24 Examples of different falloff types.

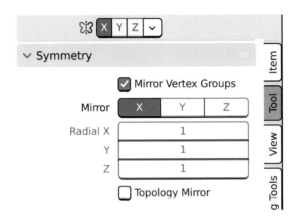

FIGURE 16.25 Location of weight paint mirror options.

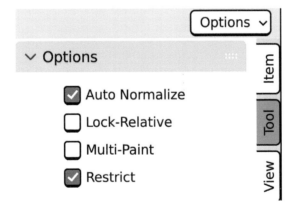

FIGURE 16.26 Options menu locations, which contain weight painting modifications.

Options

There are a few modifiers that can be applied to weight painting, which are found in the 3D view header or the *Tool* tab in the N panel, under *Options*. See Figure 16.26. *Auto Normalize* is something I recommend you always have enabled when painting character weights unless you have a specific reason you don't want to normalize weights.

Here is a description of what each option does, as you might find some useful in your workflow:

- *Auto Normalize*: Automatically normalizes the weights applied with the weight paint brushes.
- *Lock-Relative*: Displays the unlocked vertex groups as if the locked ones were removed, and the rest was normalized.

- *Multi-Paint*: Allows weight painting on multiple groups simultaneously, but comes with a few caveats. Only works if bones are selected, meaning weight paint has to be entered while an armature is also selected. It also doesn't work if selected bones have no influence. The vertices have to already be weighted to the selected bones. The painting is then applied so that the ratio of influence between the bones stays the same.
- *Restrict*: Disables painting on vertices that are not already weighted to the active vertex group.

Useful Shortcuts

Here are a few useful shortcuts that work for most weight painting tools:

- **F** to adjust the brush *Radius*.
- **Ctrl+F** to adjust brush *Weight*.
- **Shift+F** to adjust brush *Strength*.
- **W** for a pop-up menu with sliders for *Radius, Weight, Strength, Unified Weight* and *Pressure*.

17

Weight Painting Method

The Method

The method shown here might seem tedious and slow at first, but it is almost always faster than doing an automatic bind and trying to clean it up. My method removes all guess work and every area of the mesh gets adjusted once and is finished. If we painted weights without a systemic approach like this, We will find ourselves adjusting weights over and over as we face stray weights, weird transitions, non-normalized weights and other mess. This results in frustration and explains why so many people hate and/or don't understand how to paint weights effectively. By using my method, it becomes a smooth and predictable process which can apply to every mesh.

The main idea behind my method is to paint weights in sections while keeping control over how the weight is distributed between bones. I do this in three stages. Let's call them "lock", "section" and "transition". I would execute these three stages on one bone, then we move to the next one and repeat until I go over the entire character. I usually start with the torso and then go down one leg, then the shoulder and an arm, and lastly, the neck and head.

Lock

In the lock stage, we will lock all vertex groups we are not working with and unlock the ones we are distributing the weights between. For example, if we are working on the head weights, we might lock everything except the head and neck bones so that the only area we can change is the one that belongs to those bones. Even though the shoulder and chest groups might overlap with the neck, they won't be affected because we locked them.

In the sectioning stage, we will define the region that should transform with the bone. This is done by assigning a weight value of 1.0 for this bone to every vertex in this entire section. If we take the head as an example again, we would select the head bone and paint the character's entire head mesh so that it is completely weighted to the head bone.

In the transitions stage, we will define how the bone weights transition into each other. It mainly comprises smoothing the borders between vertex groups and fine-tuning the transitions to get the desired deformation. For example, we might transition between the spine bones smoothly to make it look soft and pliable, while the weights on an elbow might have a very short fall off so that the elbow stays relatively sharp when the arm rotates.

Once the desired look is achieved, we move on to the next bone in the chain and repeat the entire process. If you are having troubles visualizing the entire process, we will look at multiple examples which will make things clearer.

Mesh Preparation

Part of the reason this method works is the removal of random variables and keeping full control over how weights are distributed. We want to make sure there are no existing weights on the mesh before we add them ourselves.

DOI: 10.1201/9781003263166-17

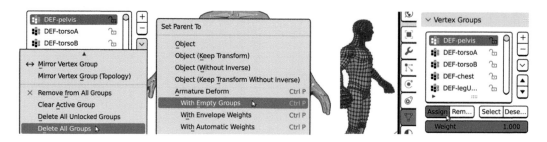

FIGURE 17.1 Mesh preparation steps prior to weight painting.

These should be the first steps done in the weight painting process to ensure we are starting with a clean mesh (see Figure 17.1):

- Remove vertex groups if some exist. If there are some that are used for purposes other than armature deformation, you can leave them in. Just lock them.
- Bind the mesh to the armature using the *Armature Deform With Empty Groups* option.
- Weight the entire mesh to the deformation bone that is at the top of the deformation bones hierarchy. Which is usually the pelvis bone. A quick way of doing this would be to enter Edit mode with the mesh selected, select all points, in the mesh properties *Vertex Groups* section, make the pelvis vertex group active and press the Assign button with *Weight* set to 1.0.

Workspace Preparation

The following sections go through essential settings that will help streamline the weighting process and remove as many distractions and menu digging as possible.

Presets

We heavily use the Draw tool in the method, so let's start by making a few brush presets. You can work without presets, but I find them to be much more convenient than having to adjust brush settings for different tasks.

To create the Add and Subtract presets, edit the existing brushes to match the settings shown in Figure 17.2. The Draw Hard preset can be made by selecting the Add brush and duplicate it by clicking on the user number next to its name, usually this will be number "2". Then rename the duplicate and adjust the settings to match those in Figure 17.2. The settings not displayed in the figure are left at their default values.

A *Weight* value of 0.05 works well for me but you can adjust it to your liking. Usually, a low value like 0.05 allows a steady and controlled buildup of weight, but it is not too subtle. The initial *Radius* value does not matter. This is something we will adjust often as we paint weights.

Viewport Settings

As the weights are hard to read by looking at the weight colors, it helps to have both *Wireframe* and *Show Weight Contours* display options enabled. I also like to add them to the Quick Favorites menu so I can easily toggle them depending on what I want to see. If you need a refresher on these settings, refer to the "Weight paint mode" section in the "Weights" chapter.

Quick Favorites

Add the *Smooth* and *Normalize All* operators to *Quick Favorites*. These are most of the tools and options we will use, so it helps to have them at hand without the need to dig through menus. In Figure 17.3, you can see

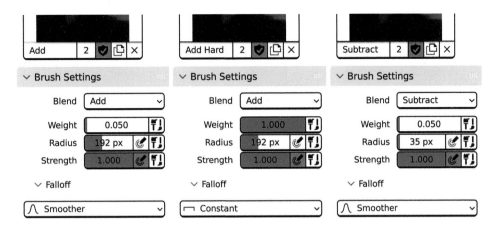

FIGURE 17.2 Brush preset settings for the weight painting method shown in this book.

FIGURE 17.3 Creating convenient access to frequently used weight paint mode options.

FIGURE 17.4 Symmetry and normalization settings.

my full Weight Paint mode *Quick Favorites* menu. I usually use shortcuts for the last two items on the list. Technically, you could create keyboard shortcuts for all of those items if you prefer to do things that way.

Auto Normalize and Symmetry

In the *Symmetry* panel enable *Mirror Vertex Group* and activate the *X* axis. If the mesh topology is symmetrical, then enable *Topology Mirror* as well. In the tool *Options* enable *Auto Normalize*. See Figure 17.4.

Demonstration

We have covered everything needed to effectively paint weights. Let us see what all of this looks like in practice and discuss the process in more detail. For the following demonstration, I have already executed all steps from the "Workspace preparation" section and I am ready to work on the weights.

In Figure 17.5, you can see the mesh and bones we will use for the demonstration. During the preparation process, I have bound it to the armature with the empty groups option. After that, I selected all the vertices and assigned a weight of 1.0 to the bottom bone's vertex group because it is at the top of the deformation bone hierarchy. The armature has two additional bones, so we will need to execute the three stages (lock, section, transfer) twice.

Branch Bone, Lock

Before doing any painting, we have to decide which vertex group we want to work with. Both bones that don't have any weights are children of the bottom bone, so in this case, it doesn't matter which one we take. If these bones were parented to each other, then it would make sense to pick the one that is the first child of the bottom bone. This is not the case here, so I started with the branch bone so it will stay unlocked.

Auto normalization is enabled, so any weight we want to add to this bone needs to be taken from another bone. And we know I weighted the entire mesh to the bottom bone. So it needs to stay unlocked so I can take weight from it in order to add it to the branch bone. We now have the bone which we want to add weights to and the one we will subtract the weights from. And everything will stay normalized.

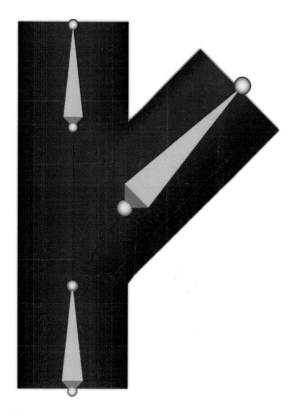

FIGURE 17.5 The status of the mesh and weights at the start of the weight painting process.

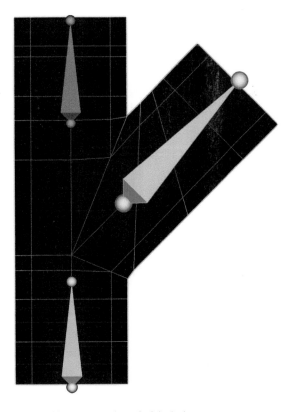

FIGURE 17.6 Weight and group locking status at the end of the lock stage.

What is left to do is to lock the rest. Here, there is only one more group, the one belonging to the bone at the top. I will lock it and move to the second stage. In Figure 17.6, you can see the current state of the things.

Branch Bone, Section

The tool we need for this stage is the *Add Hard* draw brush. Alternatively, you can also use the *Set Weights* operator in combination with mesh selection.

With the *Add Hard* brush active, and the branch bone selected, paint across the entire mesh area that looks like it should transform with this bone. That is all that is required for this step. Don't worry if you are unsure if things are perfect. Paint it as best as you can and move on to the next stage. If you have done everything correctly, when the bottom bone is selected, the influence it had in the area that was just painted should be removed from it because of normalization. See Figure 17.7.

Branch Bone, Transition

Now we are purely interested in shaping the transition of influence between the unlocked bones. I find the best tools for this part are the *Smooth* operator, *Add* and *Subtract* brushes, and the *Blur* tool. I might try one of those to see what results I get, then continue tweaking the results or undo and try something else. Repeating this until the deformation looks good in my eyes. It is all about balancing the weight. Adding and subtracting until it looks like we got as much as we can from linear blend weights. Run *Normalize All* from time to time to ensure what you are looking it is normalized.

There is a certain look that we want from each section, so I can't give you one approach that will work every time. Here, I imagine that this is a somewhat rigid object, so I try to keep the transitions relatively

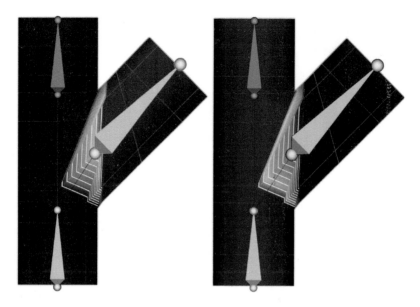

FIGURE 17.7 The first bone sectioned in. Due to auto normalization, the influence from the bottom bone was removed from that area.

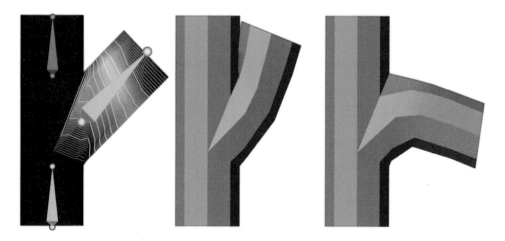

FIGURE 17.8 Results of adjusting the transition between the bottom and branch bones.

sharp and to preserve as much volume of the mesh as possible. Meaning not much smoothing is applied to keep the shapes relatively straight.

At this stage, I am transforming the bones into different poses and checking the deformation. The deformation matters the most. The colors and weight values help inform us of what is happening with the mesh, but in the end, the main thing that we need to look for and that matters is that the mesh deforms well. See Figure 17.8.

Top Bone, Lock

We have finished working on the branch bone and we can lock it and forget about it. The next step is to focus on the top bone, which we need to unlock first. By making these two moves, we have set ourselves up for success because any adjustments we make to the weights will not affect the branch bone, making

it much harder to mess something up. Instead of having to constantly switch between the three bones and dealing with the resulting push and pull of influence, we are only balancing the weight between two unlocked bones again. See Figure 17.9.

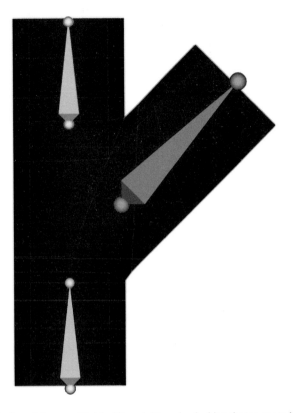

FIGURE 17.9 Locking the branch bone as I finished its weights and unlocking the top one to be worked on.

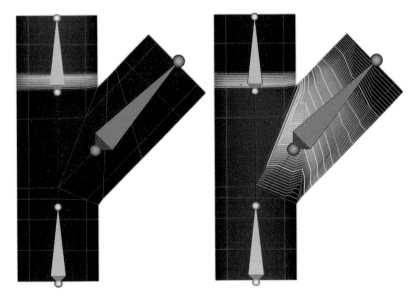

FIGURE 17.10 The second bone's weight blocked in.

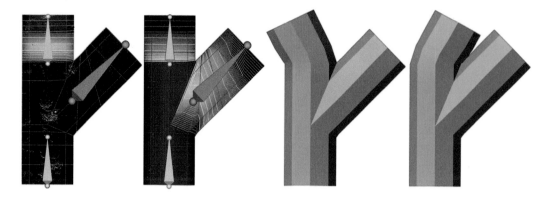

FIGURE 17.11 Finished weights of the top bone.

Top Bone, Section

Grab the Add Hard brush again and block in the part of the mesh that obviously belongs to this bone. See Figure 17.10.

Top Bone, Transition

Since there is no way to get to a point of no return, meaning we can always grab the base bone, paint over the top bone and start over, you can experiment and play around with different tools to see if it will improve the transition or make it worse. In my case, while working with the example in Figure 17.11, I used *Smooth* to create a less harsh transition and then mostly used the Subtract brush to tighten things up so it still feels rigid where it should. Again, because of normalization and the fact that only these two bones are unlocked, I always know that if I remove weight from one bone, it goes to the second one. And if I add weight, it is taken from the second one. So no matter how I approach this, the weight stays normalized, and it does not get taken from or distributed to any other bones in the rig.

This was a relatively simple example, but we could still end up in an endless loop of fighting against the weight distribution if we didn't use a controlled approach. We will look at some more complex examples soon. For example, the shoulder area where you have the shoulder bone, upper arm, chest, neck and maybe breast bones fighting for control and adding weight to one bone means subtracting it from up to four other ones. But we will not have those issues and all regions in any character are equally complex as we are always setting things up to work with just the transition between two bones.

18

Weighting the Body

Torso

In the weight painting method, I explained how we approach the weights by painting bones one by one and the first thing we will do with the spine is bend that rule slightly. Instead of going bone by bone, we can make the process faster by tackling the whole torso at once.

Start by locking all groups except those belonging to the pelvis, abdomen and chest. If you have gone through the preparation steps, the entire body should be weighted to the pelvis. In the section stage, paint weights using the Add Hard brush and section off the weights that should belong to each of those bones. Extend the chest group to everything connected to the chest, i.e. arms, neck and head.

The third stage can be started by selecting vertices from the top of the pelvis to the bottom of the chest. Select the entire abdomen area and as much of the pelvis and chest area as it seems required for getting a relatively soft transition between them and the abdomen area. Add some rotation to the torso bones and run the Smooth operator. Adjust its effect until the transition between the regions becomes smooth and doesn't go beyond that point. The more smoothness is added, the more volume loss will occur. As you change the strength of the operator, watch how the edges move closer to each other and at a certain point, they stop doing that and start moving into the body. This is the sweet spot. You want them smooth but with as little volume loss as possible. Finally, use the Add and Subtract brushes to refine the transitions while rotating the bones to different poses and checking the deformation. See Figure 18.1 for all three stages.

Repeat this process of changing the spine pose and refining the transitions a few times. Always keeping in mind that it should feel like there are bone structures under the pelvis and chest with a soft section between them.

Leg

In order to give weight to the upper leg, we need to take it from the pelvis. So for the lock stage make sure the pelvis and upper leg weight groups are unlocked and all other groups are locked. Then proceed to the section stage and block in the entire leg weights using the Add Hard brush. Just like we did with the chest where we added everything connected to the chest, we will do the same with the upper leg. Meaning that you should paint over all the vertices in the leg, not just the upper leg. By doing this, when we finish the upper leg and move on to the lower leg, we can lock the pelvis as it has no influence on the leg anymore and we will take weights from the upper leg to give it to the lover leg. Then the same is repeated with the foot and the lower leg and so on. This rule applies to all bone chains. Always section of the entire segment connected to the area you are working with.

The area where the upper leg connects with the pelvis is one of the hardest to get right. Regardless of how well you paint the weights, the large range of motion of the leg and its thickness will cause the leg to penetrate the pelvis. Trying to counter that with a lot of smoothing will cause volume loss. So the best we can hope for is to balance between those two well enough to get a passable result. If the project allows it, we can address these issues by using deformation improvement techniques like corrective bones. Which we will talk about in a later chapter (Figure 18.2).

DOI: 10.1201/9781003263166-18

FIGURE 18.1 Torso weight painting stages from left to right: Lock, section, transition.

FIGURE 18.2 Upper leg bone weights.

For the lower leg first stage, unlock the lower leg group and lock the pelvis so that only the upper leg and lower leg are unlocked and everything else is locked. Then block in the entire lower leg, including the foot, so that it is weighted to the lower leg bone. Then add a bit of smoothing before moving on to refining the transition. As you can see in Figure 18.3, we are going for a certain effect on these weights. The smoothing in the knee's front is happening mostly in its upper section. I mainly weighted the bottom section to the lower leg so that we get a curved shape on the top followed by a straight line on the bottom.

The backside of the knee has the transition concentrated to a tiny region at the center of the bend. This prevents volume loss and creates a nice silhouette when the knee bends. Extreme bend angles will push the lower leg into the upper leg but that is expected as it produces a better-looking shape than what we would get if we would smooth the transition to prevent the two parts from collapsing into each other.

I believe you know the drill at this point. Lock everything except the lower leg and foot. Then block in the foot and work on the transitions. The transition between the lower leg and the foot is unique as we are aiming for different effects depending on which direction the foot rotates. Check Figure 18.4. As you can see there, the foot weights are going in an arc around the tail of the lower leg bone. The main reason

FIGURE 18.3 Knee bone weights.

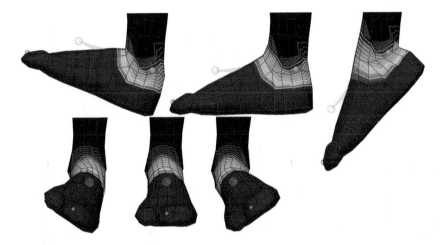

FIGURE 18.4 Finished foot bone weights.

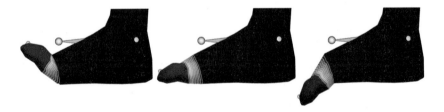

FIGURE 18.5 Toe bone weights.

for this is seen in the front view of the foot. By painting weights in such a way, we achieve the impression of the foot pivoting around a large bone, which produces a strong silhouette.

Next, we have the toes or rather the ball of the foot. This one is more straightforward. My model does not have that many edge loops in this area, so I didn't even need to smooth the transition. After I sectioned the front of the foot off, the weighting was done (see Figure 18.5).

Neck and Head

We can pick between tackling the shoulder or neck next. The order does not matter and I feel like doing the neck first. To spice things up, I will show you a variation of the weighting method. What we will do is ignore the second neckbone and pretend there is only one. And once the weights are done for that

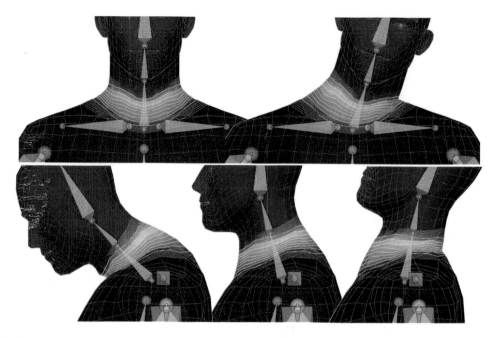

FIGURE 18.6 Lower neck bone weights

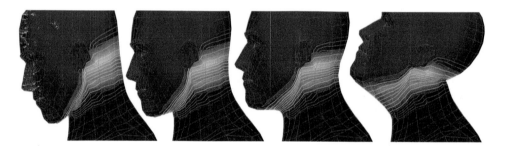

FIGURE 18.7 Head bone weights.

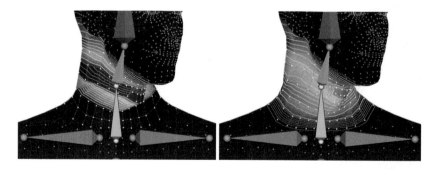

FIGURE 18.8 Distributing the weight between the two neck bones.

neck bone and the head, we will take the neck weights and distribute them between the two neck bones. Essentially we are splitting up the weight painting task between creating the transition between the chest, neck, and head, and the weight distribution along the neck.

Start by doing the usual locking process. All the weights that we want to assign to the neck belong to the chest at this point. So lock all groups besides the chest and lower neck groups. Then select the neck bone and section off the entire neck and head mesh by painting over it with the Add Hard brush.

Next work on the transition between the neck and the body. Aim for a sharp transition between the two so that the neck stays relatively straight (see Figure 18.6).

The head is next. Lock everything except the head and lower neck bones then select the head and section of the entire skull and jaw by painting it using the Add Hard brush. Then work on the transition as you rotate the bones to see the deformation. The transition should be relatively sharp at the back of the head and slightly smoother in the front. With most of the smoothness being in the lower jaw area, while the neck stays mostly weighted to the neck bone (see Figure 18.7).

The transition between the neck and the rest of the body is done and to finish the neck we need to divide the lower neck bone weights between it and the upper neck bone. We will do this the same way we did all the weights. Lock everything except the two neck bones then section off the upper neck bone using Add Hard. You will notice that as you paint over the top of the neck, where it blends with the head, because the head is locked you can only take the weights that belong to the lower neck and the transition itself stays intact. After about half of the neck is weighted to the upper neck bone, we can define how much of an overlap will the two neck bones have by selecting vertices in the neck. Finally, add some twisting rotation to the upper neck bone so you can see what is happening with the weights and use the Smooth operator to create a smooth transition between the two bones. To make sure everything stays normalized, I suggest using *Normalize All* after the *Smooth* (see Figure 18.8).

Shoulder

The shoulder is where this weight painting method really shines. Mainly because we need to balance the weight between the neck, shoulder and torso in one area. But since we have the neck doing exactly what we want already, we can lock it so we are only left with balancing the rest of the weights between the shoulder and the chest bones. So start by locking all vertex groups except the ones for the chest and shoulder.

Using Add Hard, section off the shoulder area and the entire arm. Then work on the transition. What you are aiming for in this area is that most of the deltoid muscle, the clavicle and the scapula, are mostly weighted to the shoulder bone. These areas move relatively rigidly, so they will look more

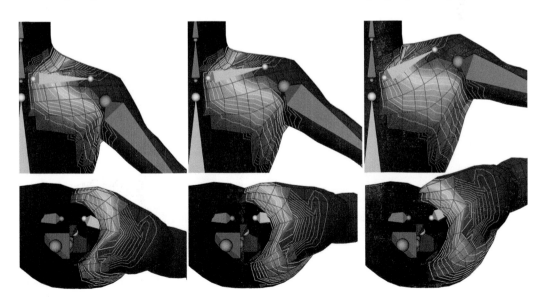

FIGURE 18.9 Finished shoulder weights.

believable with such weights. Then taper off the weight across the chest. Not much influence from the shoulder should be on the neck because it would push the neck in as the shoulder rotates up, which would not look good. In a real human shoulder, the muscle masses at the top of the shoulder move upwards as the shoulder rotates up, but we can't achieve this with only one shoulder bone. This kind of behavior would require an additional corrective bone. For shoulder weight reference, see Figure 18.9.

Arm

You probably already know what to do. Lock the chest vertex group and unlock the upper arm. The thing with the upper arm is that linear blend skinning alone just won't cut it. If the character is in an A pose, like what I am working with here, then lowering the arm down and raising it until it is at about 90 degrees and parallel with the floor is what we can get to look good. The problems show when the arm is lifted to point forward. No matter how good you are at painting weights, the area where the arm and shoulder meet will collapse. Get the deformation to look as best as it can be with just weight painting and if you have the budget for it, we can add corrective bones later to improve the deformation (see Figure 18.10).

We can achieve decent results with the elbow, but if the project allows for the additional bone budget, it is always good to add more definition here using correctives. Other than that, the idea is the same as what we discussed when we were painting the knee joint weights. Some curvature at the top, aim for a straight line on the bottom of the elbow outside. On the inside, make a sharper transition to prevent volume loss and get a good look silhouette with strong lines (see Figure 18.11).

Next up is the hand, and the usual process. Lock everything except the lower arm and hand groups. Then section off the hand. Finally, refine the transitions until you are satisfied with the results (see Figure 18.12).

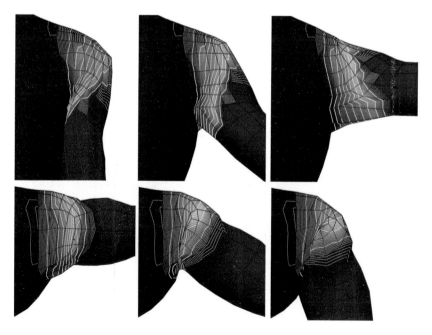

FIGURE 18.10 Upper arm bone weights.

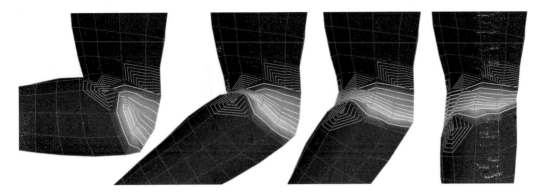

FIGURE 18.11 Finished lower arm weights.

FIGURE 18.12 Finished hand weights.

Thumb and Fingers

There is nothing else left to add, really. We continue doing the same process over every bone until there are none left. The hand is crowded with different bones, but we continue working in groups of two so it does not matter that much that there are so many bones in such a tight area.

In order to not repeat myself anymore, I will not go into explaining how to paint weights for each of the bones in the hand. Instead, let us make it into an exercise so you can figure it out yourself and get a better understanding of the process. My suggested approach is to handle the thumb first, bone by bone. Once those are weight painted, do the metacarpal bones. Then weight paint each finger, bone by bone. You can see a few reference images in Figure 18.13.

Twist Bones

As we painted the weights in the limbs, we pretended the twist bones didn't exist and worked with just the major limb bones. Since the transitions between those look good, we can tackle the twist bone weights. We can weigh them in a similar way I showed for the neck bone weight distribution.

We will use the upper leg for demonstration. The process is exactly the same for the lower leg and the arm twist bones. Start by locking all bones except the upper leg bone and the upper leg twist bones. Then select the first twist bone and use the Add Hard brush paint over the entire upper leg area. This essentially transfers all the weight from the upper leg bone to the first twist bone. After that is done and the upper leg bone has no influence any more, lock it. As you will see later, once we add the mechanics to the rig, the weight needs to be on the twist bones so that we can use them for twist distribution, but also to create bendy limb mechanics.

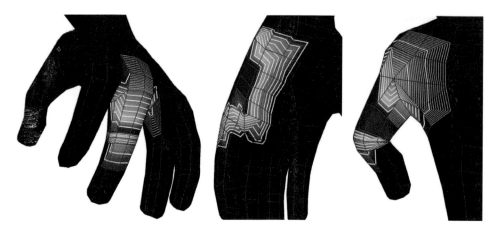

FIGURE 18.13 Examples of weights in finger and thumb bones.

FIGURE 18.14 Step-by-step process of transferring the weight from the upper leg bone to its twist bones.

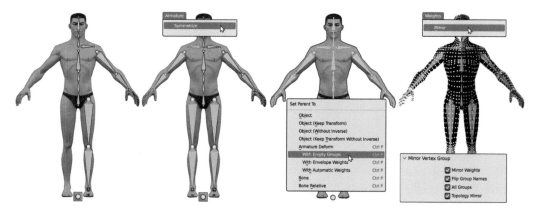

FIGURE 18.15 Bone and vertex group mirroring steps.

At this point, all the upper leg weights should be on the first twist bone. The twist bones are the only unlocked bones and everything else is locked. From now on, we are doing exactly the same process we did with the two neck bones. Section off a part of the limb for each of the twist bones and then smooth the transitions. Then run a *Normalize All* operator just to be safe. That is it. See Figure 18.14 for reference.

Mirror

Up to this point, we have only considered the center line and the character's left side. We could continue like this for a few more steps in the rigging process, but at this point, I prefer to do a preliminary symmetrization. We need to cover three things: bones, vertex groups, and weights. And they have to be done in that order.

The *Symmetrize* operator can get bones from the left side to the right side. Simply select all the character's bones that are on the left side and in Edit mode run *Symmetrize* which can be found in the 3D view's *Armature* menu.

Before we can mirror the weights, we need to create vertex groups for the newly symmetrized bones. Blender can do this for us if we run the binding again. To do this, in Object mode, select the mesh and the armature, with the armature being the active object. Then press **Ctrl+P** for the *Set Parent To* menu and select the *Armature Deform with Empty Groups* option. The mesh should now have an empty vertex group for all the deformation bones in the armature.

To mirror the weights, enter the Weight Paint mode with both the armature and mesh selected with the mesh as the active object. Enable vertex selection and select all vertices on the character's right side because mirror copies from unselected to selected vertices. My preferred way of making the selection is in Edit mode. I press the **1** key to align the view to the front view, then I press **Alt+Z** to enable *X-Ray* and **B** to use box selection and select the vertices. Back in Weight Paint mode, make sure vertex selection is enabled and all vertex groups are unlocked. Finally, execute the *Mirror* operator from the *Weights* menu. In the operator pop-up that shows up in the bottom left corner of the 3D view enable all check boxes (see Figure 18.15).

19

Weight Transferring Techniques

Introduction

We can transfer weights between different meshes based on proximity and topology. This can save hours of work and sometimes help achieve results that would be hard or even impossible to get by manual weight painting.

Many studios reuse body meshes, which either have the weights already stored on them or weights are later transferred to them using a reference mesh that contains final weights. So someone can paint body weights once for the entire project. Another common use case for weight transfers is to create weights for a character's clothing. Transferring is also useful for solving some tricky jobs like painting thin geometry shells like wings.

Data Transfer Modifier

There are two ways to transfer weights in Blender. First is from the source mesh in Weight Paint mode and is found under *Weights > Transfer Weights* in the 3D view menu. The second one is by using the Data Transfer Modifier on the target mesh. The latter one is my preferred way of doing this. If you know your way around Geometry Nodes, you could also use them to create your own weight-transferring tools.

The Data Transfer modifier is feature heavy and can transfer various types of data between meshes. Only a few of the options apply to weight transfers and we can ignore the rest. Check Figure 19.1 for a reference on what the modifier looks like and which options are relevant to weight transferring.

The following explains the modifier's weight transfer relevant options:

- *Source*: Used for assigning which object to transfer the weights from.
- *Vertex Group*: The transfer can be made to only a section of the mesh by using a vertex group. Create a vertex group, assign a selection of vertices to it and add it to this field. The button with the arrows on the right of the Vertex Group field negates the vertex group.
- *Generate Data Layers*: When pressed, it will create the vertex groups that exist on the *Source* but are missing on the target object. This only adds the vertex groups themselves, it does not populate them with weights until we apply the modifier. Remember to always press this button before applying this modifier.
- *Vertex Data*: This needs to be enabled, together with the *Vertex Groups* option, to tell the modifier it should transfer the correct data type.
- *Mapping*: The different options here change how the weights are sampled from the source mesh.

The different mapping options produce drastically different results. There is no best option, each of them is good for solving particular tasks. To help you choose which to use, here is more information on each of the options:

- *Topology*: For this option to work, the source and target meshes must have an identical mesh structure. Meaning they must have the same number of vertices, edges and faces which are connected the same way. The transfer will be made from vertex to vertex based on vertex id's.

DOI: 10.1201/9781003263166-19

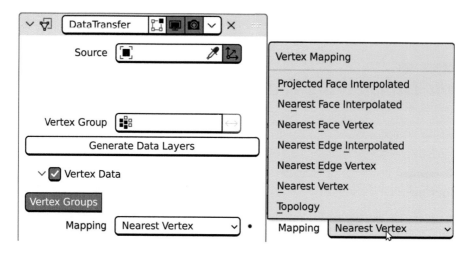

FIGURE 19.1 The data transfer modifier, edited to show only the options relevant to vertex group transferring.

If you have two matching topologies but the vertex ids are not the same, you will need to write or find a script that can transfer the vertex order between two meshes that have identical topologies.

- *Nearest Vertex*: Every vertex on the target mesh will receive the weights from the closest vertex on the source mesh.
- *Nearest Edge Vertex*: Transfers the weight from the nearest vertex to the nearest edge of the source mesh.
- *Nearest Face Vertex*: Transfers the weight from the nearest vertex to the nearest face of the source mesh.
- *Nearest Edge Interpolated*: Instead of transferring the weight from a source's vertex, this approach will sample the weight at the closes point on the closest edge and get the exact weight at that spot along the edge.
- *Nearest Face Interpolated*: Same as the above but instead of the edge, it samples the interpolated weight on the closest point of the closest face.
- *Projected Face Interpolated*: Similar to above, but instead of finding the nearest face, the weight is sampled by projecting the vertices in the normal direction.

After you set the options as desired, click on *Generate Data Layers* and apply the modifier to write all the data onto the mesh.

Separate, Join, and Merge Geometry

We can use these mesh manipulation techniques in combination with the Data Transfer modifier to get more control over weight transfers.

- *Separate*: Select the part of geometry you want to separate into its own object and press **P**, then choose *Selection*.
- *Join*: Combines two or more geometry objects into one. Select all of them, make sure the object you want the other ones to be joined into is the active object, press **Ctrl+J**.
- *Merge*: To merge multiple vertices that are exactly on top or close to each other, select the areas you want to run the operation on and press the **M** key and choose one of the suitable options from the pop-up menu. When separating and joining geometry back together, vertices that are laying on top of each other need to be joined back together. This is best done with the *By Distance* merge option.

The usage of these techniques will probably change the vertex order of your mesh. If you need to preserve the vertex order, first duplicate the object and do your work on the duplicate. We can transfer the work to the original using *Data Transfer* with the *Nearest Vertex* mapping option.

Layered Geometry

This technique is great for any characters that have pieces of geometry layered on top of each other. The most common example is clothing. The approach to these cases is to paint the weights on the largest mesh first and transfer the results to the rest. When working with characters, the body is usually weighted first followed by a transfer to clothing and any other appendages. The results are not always perfect and might need some cleanup post transfer.

If mesh layers are joined in one object, we must separate the layers into different objects and join them together after the transfer is done. This can only cause problems if you may not change the vertex order. Everything else will not break the existing weights, as Blender has no issues with changing the mesh structure that already has weights or shape keys created.

The Data Transfer modifier mapping option that usually works best for body to clothing transfers is *Nearest Face Interpolated*. After applying the modifier, test the deformation and fix imperfect areas using common weight paint tools.

Shells

Often we have a piece of mesh that has two layers of geometry close to each other creating a thin shell. For example the wings of a bird or shirt sleeves. In cases like this, you would want to have the exact same weights on both the inner and outer sides of the mesh. This is quite hard to paint by hand.

I generally use two approaches to weighting shells. First is to create a new single-layer mesh. Either by modeling it from scratch or by duplicating one side of the shell and separating it into a different mesh object. Weights are then painted on that mesh. Once finalized, they are transferred to the entire shell. This transfer requires a Vertex Group mask on the target in order to limit the transfer just to the desired area and not the entire character.

The second approach consists of temporarily splitting one side of the shell into a new object and hiding it. I paint weights on the side that is left on the character. Once the weighting is completed, I transfer them to the separated geometry. Which is lastly joined back together with the character and the vertices that were split are merged.

Selective Influence

While the Data Transfer modifier allows us to create a mask of influence for the target object, it does not have the option to do the same for the source object. It always uses the entire target mesh.

We can use an eyelash mesh to explain the problem and solution. Since the upper eyelash mesh is close to both the upper and lower eyelids, using weight transfer will result in the eyelash mesh receiving influence from both. To prevent this we need to find a way to transfer only from the upper eyelid. This can be achieved by selecting the faces of the upper eyelid mesh, duplicating them and separating the duplicate into a different object. This new object can be used as the data transfer target and will produce the desired result. It can be deleted it after the transfer is complete.

Rigid Pieces

Transferring from organic meshes like a character's body to more rigid pieces, e.g. belt buckles or buttons, will often result in unrealistic looking deformation as they will bend and twist with just like the

organic mesh they received the weight from. We can manually create weights for these elements, but this potentially requires a lot of tweaking in order to match the weights of the body mesh to prevent the meshes from looking like they are sliding on top of, and from clipping into, each other. So it makes sense to automate this process as much as possible.

For completely rigid pieces, we can transfer the weights from a single vertex. Find the closest vertex on the source mesh to the rigid mesh. Duplicate the vertex and separate it into a new object. Then transfer the weights from that vertex onto the rigid piece using the *Nearest Vertex* method. Since there is only one source vertex, the entire target will get the same weighting and deform as a solid piece of geometry.

Semi-rigid objects, like belts for example, need to preserve their structure but still deform with the underlying geometry. This can be done by expanding on the previous technique. Instead of using a single vertex, we will use an edge loop as the source. If the source mesh already has a loop that is spanning along the target mesh, then duplicate and separate it and use it as the source object. If that is not the case, what you can do is duplicate the source mesh, then use the knife tool to cut an edge along the area that matches the shape of the target mesh. Then separate that edge into a new object and delete the duplicate. Choose the *Nearest Edge Interpolated* transfer method for the transfer.

Mirror Modifier Technique

When the *Mirror* weight operator cannot produce good results, we need to find an alternative way of transferring weight from one side of the mesh to the other. Here is a technique that can successfully mirror weights to characters that are not perfectly symmetrical:

- Duplicate the target mesh.
- On the duplicate, create a Mirror modifier. Set *Axis* to X and *Bisect* to X. Rest can be left as is.
- Apply the modifier to the mesh.
- Transfer weights from this mesh to the original using the Data Transfer modifier with the *Nearest Face Interpolated* option.
- Delete the duplicate.

This works because the mirror modifier creates a symmetrical mesh and also mirrors the weights. Depending on how asymmetrical the character is, the result of the final transfer will vary and might require tweaking of weights to clean them up.

Intermediate Mesh Technique

Sometimes, there might not be an underlying mesh we can transfer weights from. This is the case with the Nnema character. She does not have a complete body mesh, only the head and arms. Creating weights for such a character can be hard as painting overlapping layers so their weights perfectly match is quite a hard task.

What we can do instead is to create a new mesh out of the segments and edit it so that the individual parts are merged into one seamless surface. We can do the bulk of the weight painting on this mesh. Once completed, we transfer the weights onto the individual pieces and refine them further. In Figure 19.2, you can see Nnema's individual pieces, the assembled character and the intermediate mesh I made for weight painting.

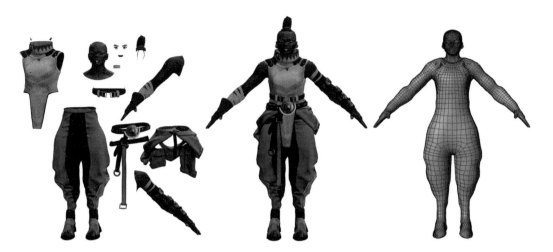

FIGURE 19.2 Example of a character mesh scenario that might require an intermediate-weight painting mesh, shown on the right.

20

Bone Constraints

Constraints are, in my opinion, the most powerful rigging tool available in Blender. They provide an easy way to change a bone's transformation and create complex behavior. Some examples of this are: setting transformation limits, copying transformations from other bones, pointing at other bones, playing animation frames and much more. They also allow for any combination of all of the above. In simple terms, Constraints give us a way to modify how a bone behaves depending on external factors like transformations of other objects. Constraints are not available in Edit mode and their effects are disabled in this mode.

To make things even more fun, constraint properties can be animated. By utilizing this, we can create rigs that give the animators the choice of how they want the rig to function. A very common example is parent switching, which gives the option to make a bone behave as if it was a child of different bones without actually changing the parent. This makes tricky cases like holding a weapon in different hands much easier to animate.

Constraints are contained in the *Bone Constraints* tab of the *Properties* view. The full list of constraints is quite long and might look intimidating. For my approach to rigging, about two-thirds of them are not needed at all. And in the leftover third, many constraints function in similar ways, so they are all easy to understand once you learn to use some of them.

As seen in Figure 20.1, constraints are split into four categories:

* Motion Tracking
* Transform
* Tracking
* Relationship

All constraints share many common properties, like *Influence* or how targets are handled. The categories are merely there to group constraints that have a similar functionality. Any number of constraints, from all categories, can be added and mixed. Constraints in the Motion Tracking category are used for video tracking, which we don't have a use for in rigging for games. Because of that, we will completely ignore this whole category.

Note that there are two constraint sections in armatures. *Object Constraints* operate on the armature object itself, and *Bone Constraints* that work on individual bones. In this book, we will not be applying any object constraints, as I do all game rigging on the bones. In case you find a use case for object constraints, they are essentially the same as bone constraints, so all that you learn about bone constraints will apply.

Besides the *Bone Constraints* panel, there is one more area in the user interface that contains constraint-related options. We can find it in the 3D View under *Pose > Constraints*. See Figure 20.2.

Here is a quick explanation of each of the operators from this menu:

* *Add (with Targets)*: Offers a quick way of creating a constraint and assigning the target. Once executed, a pop-up window with a list of all constraints will show up. Choose a constraint from the list and it will be added to the active bone, with the selected bone as the target. If no other bone is selected, an Empty object will be created and assigned as the target. The usual case is that you want a second bone as the target and not an Empty.
* *Copy Constraints to Selected Bones*: Copies all constraints from the active bone to other selected bones.
* *Clear Pose Constraints*: Deletes all constraints from selected bones.

DOI: 10.1201/9781003263166-20

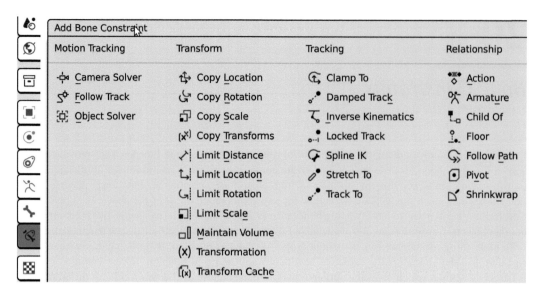

FIGURE 20.1 The add bone constraint menu, found in the bone constraints properties panel.

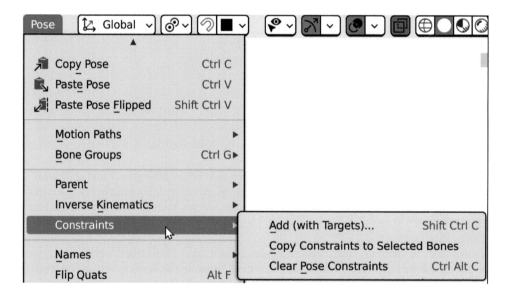

FIGURE 20.2 Bone constraint operators menu.

The Constraint Stack

Constraint Stack is what we call the combination of all constraints that are present on an object. It is what you see in the *Bone Constraints* panel. What is important about the stack is the order in which the constraints are applied to the bone, as changing the order will affect the final output of the entire stack. See Figure 20.3.

The order of execution flows from the top of the stack to the bottom. If, for example, there are two Copy Location constraints on an object. Let's call them constraints A and B, where A is above B in the stack. A will be executed first and will set the object's location to target A. Constraint B is executed next and will set the object's location to target B's location. This essentially means that constraint A is being overridden by B, as both of them are setting the object's location. This can be reversed by changing the order, making B first and having it overridden by A.

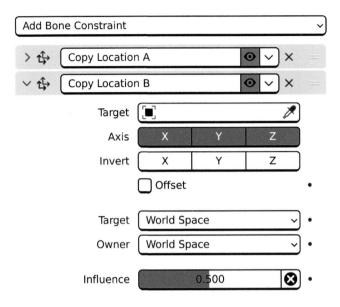

FIGURE 20.3 The constraint stack.

If we want to mix the effect of the two, we can use the constraint's *Influence* property. By setting the *Influence* value to something less than 1.0 on the constraint that is at the bottom of the stack, the effect of the constraint will fade and allow the effects of the constraints above it to come through.

Not all constraints affect the transformation in the same way as in the example above, and they will not always fully override the constraints above them. This means that we can stack different constraints and combine their effects without having to adjust their influence. You can do something like combine a Copy Location, Copy Rotation and a Locked Track constraint to create behavior where the object will first be positioned at one target, then rotated to the rotation of another target. Finally, Locked Track will override rotation on only one axis.

Header

The header section is present on every constraint and is always the same regardless of the constraint type. The following is a breakdown of each of the options found in the header (Figure 20.4):

1. Toggles the visibility of a constraint's properties. This does not change the influence of the constraint and is purely there to reduce visual clutter when working with many constraints on an object.
2. Every constraint has a custom icon. If we changed the name of a constraint, the only way to identify the actual type of the constraint is by looking at the icon or by deducting the type based on properties that are present on the constraint.
3. The name field allows us to give the constraint of any custom name. This is not required, but giving constraints descriptive names can help you and your team remember what they do. If the background of this field is red, this means that the constraint is not functional. Usually, because a target is missing or we have not set up the properties correctly.
4. Enables or disables the effect of the constraint. We can animate directly this property by keyframing it or indirectly using a Driver.
5. Opens the menu, which contains additional constraint options.
6. Deletes the constraint.
7. By clicking on this area and dragging the mouse up or down, we can change the order of constraints in the stack.

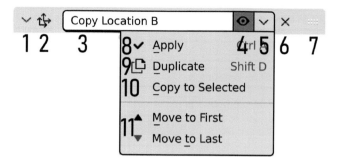

FIGURE 20.4 Constraint header.

8. Applies the effect of the constraint on the object and deletes it.
9. Duplicates the constraint.
10. Copies this constraint to selected objects.
11. Moves the constraint to the top or bottom of the stack.

Target and Owner

A constraint's target is the object that is referenced in the constraint and from which information is being taken. The target does not get affected by the constraint. The owner is the object on which the constraint operates. If we take the Copy Location constraint, for example, it will copy the target's location and apply it to the constraint's owner.

Targets can be any objects in the scene, including bones from the owner's armature or any other armature in the scene. To choose a bone as a target, first the armature it belongs to needs to be assigned in the Target field. This will make a new Bone field visible. The bone name can be written in that field or selected from the list of all bones in the armature.

The following are options commonly present in constraints, which affect how data is fetched from the target and applied to the owner (see Figure 20.5):

- *Head/Tail*: Allows us to choose which part of the target bone to target. Interpolates across the length of the target bone, starting at the head and ending at the tail.
- *Follow B-Bone*: Some constraints have an additional option next to the *Head/Tail* slider called *Follow B-Bone*. When enabled, the targeting will happen along the b-bone shape of the bone instead of a straight line. We find this setting in Copy Transforms and Stretch To among others. See Figure 20.6.
- *Remove Target Shear*: The combination of scale and rotation transforms can cause the bone to become skewed. Enabling this option prevents this from happening if it is undesired.
- *Axis*: Some constraints like Copy Location and Copy Rotation have the option to copy transformation only from specific axes and not the entire target.
- *Invert*: As the name suggests, invert the target transformation before applying it.
- *Offset*: Adds the effect of the constraint to the original transformation instead of replacing it.

Spaces

Before digging into what different spaces are, let us talk about what a space in this context actually is. In the simplest terms, a space is a reference point. When we say that we are taking the world

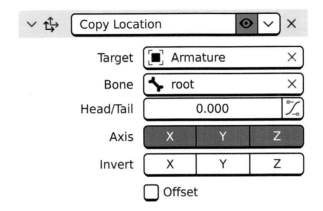

FIGURE 20.5 Common constraint properties found in many constraint types.

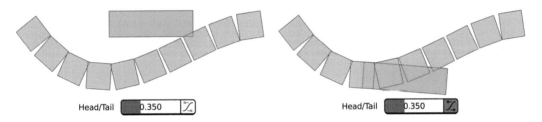

FIGURE 20.6 The effect of a copy transforms constraint with follow B-bone disabled and enabled.

space location of an object, the reference point is the world origin and we are measuring the distance between the object and the world origin. If we instead want the distance the object traveled from its rest state, then we need a different reference point, i.e. space, which would in this case be a space called Local Space.

Here is an abstract scenario that will hopefully help visualize this concept. My wife and I are walking our dogs, Mitzi and Pablo. She has Mitzi on a leash, and I have Pablo. Now let us say we want our dogs to walk at the same distance from their respective owners. We would use one dog as the target and measure its location from its owner. Then we would position the other dog at the same distance from its owner. In constraints terms, we are constraining Mitzi with Pablo as the target. Pablo's location is calculated in relation to me, i.e. in Armin space, and applied to Mitzi in relation to my wife's space.

So if Pablo is walking one meter in front of me, it would set Mitzi to walk one meter in front of my wife. Regardless of where my wife is in the world, and in which direction she is going, the location is applied in relation to her. Mitzi will always be one meter in front of her.

What happens if we were to change the space? For example, we don't measure Pablo's location in relation to me but to our home. And all four of us are out for a walk in the park which is 100 meters away from our home. In home space, Pablo is 100 meters away from the reference point. This applied to Mitzi, who is still in my wife's space, which would mean that Mitzi would move to be 100 meters away from my wife. And I become completely irrelevant to this calculation.

To reiterate, space options in constraints simply represent reference points from which a constraint calculates the transformation. The target space is used to calculate the target's offset in the target space, which applies to the owner in relation to the owner's space (Figure 20.7).

World

Probably the easiest one to understand and use. The frame of reference in this space is the world zero. This is used when we want the owner to exactly match the target's transformation. It will find where the

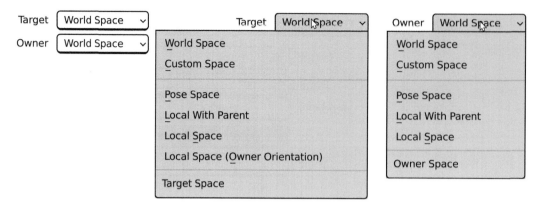

FIGURE 20.7 The space selection options found in constraints.

target is in the world and copy that to the owner. This is very useful as it overrides any transformations that might come from the owner's parent and grandparents.

An example where this is used is when we want to bind a deformation bone to a control bone. We don't really care what the deformation bone's current transformation is or what its parent is doing, we just want it to copy the exact transformation from the target bone.

Custom

When this option is selected, a new target field called *Object* will appear in the constraint. This target object's local space will become the reference point for the transformation. In other words, we can use any bone or any other object in the scene as the reference space.

Pose

I think a better name for this space would be "Armature Object Space" because that is exactly what it is. The reference space for this option is the armature object to which the target or owner bone belongs. It is very similar to the World option, with the only difference being that the transformation is calculated based on the armature's transformation and not the world zero. If the armature is at world zero, then Pose and World spaces would create the same results.

Local with Parent

Here is another badly named one. A better name for this one would be "Rest Pose". The bones' own rest pose, i.e. default state, is used as the reference space. It is kind of like a combination of Pose Space and Local Space, in the sense that it transforms with the armature but it is aligned with the bone's rest pose.

Local

In Local, the transformation considered is only the one of the target and owner themselves. If the target moves one unit in its own Z axis, the applied transformation to the owner would be one unit along its Z axis. But if the target's parent is transformed, even though the target's visual transformation will change as it is following the parent, nothing will happen with the owner because only the direct transformation of the target matters.

I will give you a use case that might help understand this better. Let's say we have a control bone that we want to use as a slider for moving the deformation bones on a character's lips. When the slider is moved up, the deformation bones will copy the location in their own space and move the lips towards the nose. I parent these lip deformation bones to the head. By setting the spaces to Local, regardless of how

the head is rotated, the resulting transformation of the lip bones will always be the same. For them, up will always mean towards the nose.

Local (Owner Orientation)

This space is like the regular Local Space, meaning only local transformations are considered. The difference is that in the regular Local Space, the transformation is applied in relation to the axis orientation of the owner. Here, the transformation is applied in relation to the axes of the target. Meaning if you, for example, rotate the target around its Y axis, the owner will rotate around that same axis, and not its own Y axis. This space gives us the option to have the owner behave the same way as the target, even if we do not orient them the same way.

I hope these explanations help you visualize spaces and make it easier to predict the outcome of using each space. What helps is knowing that for most of our rigging needs, we will be mainly using World, Local and Local (Owner Orientation) spaces. The rest will be needed rarely or never.

Creating and Removing Constraints

When creating rig mechanics, we will spend most of our time on editing bones and constraints, so it makes sense to spend some time getting comfortable with both. In this section, we will go over everything you need to quickly and efficiently work with constraints.

Add

We create a constraint like this:

- Make sure you are in Pose mode.
- Select and make active the bone to which you want to add a constraint.
- Open the *Bone Constraints* tab in the *Properties* view. Make sure you are in the *Bone Constraints* tab and not in *Object Constraints*.
- Click on *Add Bone Constraint*.
- In the menu that pops up, click on the name of the constraint you want to create. It will be added and placed at the bottom of the constraint stack.

Add (With Targets)

This operator is a handy shortcut for adding constraints quickly and automatically filling in the *Target* and *Bone* properties.

Add (with Targets) can be found in the 3D View, under *Pose > Constraints*. Or by using the **Ctrl + Shift + C** shortcut. When executed, the usual *Add Constraints* menu will be displayed where you can choose the desired constraint.

The way you want to use this operator is to first select the bone that will be the target for the constraint. Then, to the selection, add the bone you want the constraint to be added to. When you now execute *Add (with Targets)*, the *Target* and *Bone* properties in the Constraint will be automatically populated.

If only one bone is selected, an Empty object will be added and set as the *Target*.

Delete and Clear All

To remove a single constraint, simply click on the "X" in the constraint's header. If you wish to remove all constraints from one or multiple bones, select the bones and execute *Clear Pose Constraints* from the

FIGURE 20.8 Finding the system console toggle and an example of the error messages caused by a dependency cycle.

Pose > Constraints menu in the 3D. view. Or use the **Ctrl + Alt + C** shortcut. As we create rigs, we will duplicate bones a lot and this operator helps clean up constraints from duplicates.

Copy and Copy Constraints to Selected Bones

To copy a single constraint from a bone to any number of other bones, use the *Copy to Selected* operator found in the constraint's header under the *Additional Constraint Options* menu. This will copy the constraint from the active bone to all other selected bones.

If you want to do the same for all constraints at once, use the *Copy Constraints to Selected Bones* operator found under *Pose > Constraints* in the 3D View menu.

Duplicate

To duplicate a constraint, use the *Duplicate* operator found in the constraint's header under the *Additional Constraint Options* menu, or simply press **Shift + D** while hovering the mouse over a constraint. The duplicated constraint will be placed right under the original one.

Dependency Cycle

Since constraints offer the ability to target any object or bone, what can happen is that the target depends on the owner, which creates a so-called "dependency cycle". A simple example would be constraining a bone to its child using a Copy Location constraint. Since the child is parented to the constrained object, it will follow its transformation, but now the parent follows the child. This creates an endless loop of calculations as the child needs to move because the parent moved and the parent needs to move because the child moved. In cases like this, you might notice bones behaving erratically. A small transformation might cause a bone or the entire character to jump to a random transformation repeatedly.

If you notice this, you can identify if a dependency cycle causes the issue by checking the System Console. Enabling the System Console is done from the Window menu. See Figure 20.8. In case of a dependency cycle, the console will display information on the target, owner and constraint in question. The issue must be fixed, either the constraint has to be adjusted or the bone hierarchy, as this kind of behavior must be avoided.

To disable the System Console window, do not close it. Closing it will also close the Blender instance. nstead, use the same menu button you enabled the console with.

21

Essential Constraints

The following is a selection of constraints which will solve most of our character rigging needs. The constraints not discussed here might be helpful for solving edge cases or serve other purposes like motion tracking in videos, for example, which is not something relevant to character rigging for games.

Copy Location

The Copy Location constraint sets the owner's location to be the same as the target's. This location can vary based on the *Head/Tail* slider and the selected space options. It gives options to copy the location only from specific axes and to invert them.

The *Offset* toggle works like a switch between an Add and Override mode. When *Offset* is enabled, the constraint will add the effect on top of the owner's location. If offset is disabled, the effect will override the owner's location.

There are two common use cases for this constraint. First is to match the locations of two bones. I do this by setting both *Target* and *Owner* space to *World Space*. The second common use case is to have one bone emulate the motion of another bone. If the target moves, the owner moves as well. We achieve this by setting space values to *Local Space*. Other space combinations are possible, and choosing the right one depends on the task at hand. On the left side of Figure 21.1, we have the rest state. On the right, the target bone is moved vertically. The owner (horizontal bone) is used to show what happens with no constraint present and with a Copy Location present with two different space scenarios.

Copy Rotation

The Copy Rotation constraint sets the owner's rotation to be the same as the target's. The effect can be limited to specific axes using the *Axis* toggles and inverted using the Invert toggles. Since the constraint uses Euler-based rotations, the effect can become unpredictable when copying from two axes, because of gimbal issues. Check the Damped Track, Locked Track and Transformation constraints for rotation copying with axis limitations.

Similar to Copy Location, Copy Rotation's two major use cases are to match the rotation of two bones using World Space, and to emulate the rotation of a different bone using Local Space's. See Figure 21.2 for an example. When World Space is used, the constrained bone will rotate to match the target's exact rotation. While Local Space will cause the target's rotation being added to the owner's rotation.

Mix Modes

The Copy Rotation constraint's *Mix* property allows us to choose how the constraint's effect is combined with the owner's existing rotation. Here is what effect each option has:

- *Replace*: Override the owner's rotation with the target's.
- *Add*: Combine the owner and target rotations.

DOI: 10.1201/9781003263166-21

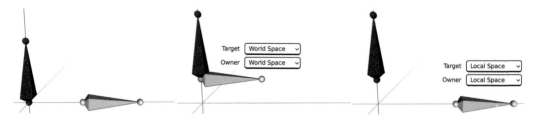

FIGURE 21.1 The effect a copy location constraint has on a bone depending on the space settings.

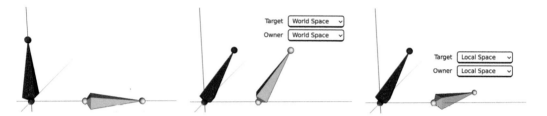

FIGURE 21.2 Effects of the copy rotation constraint in two different space setups.

- *Before Original*: Add the effect before the owner's own rotation, as if the effect applied to the parent of the owner. Meaning the constraint will adjust the owner's local axes, hence changing how the owner rotates.
- *After Original*: Apply the effect after the owner's rotation. This way, the owner's axis orientations are not changed by the constraint. It will rotate first and then the constraint's effect will be applied in that final local orientation, as if we were applying it to a child of the owner.
- *Offset (Legacy)*: Deprecated. Don't use it. The option will eventually be removed from Blender.

Copy Scale

The Copy Scale constraint sets the owner's scale to be the same as the target's. We can limit the influence to specific axes. The strength of the scale can be adjusted using the *Power* and *Influence* properties. The difference between the two is that Influence multiplies the effect and can only lower it, while *Power* raises the effect exponentially.

Make Uniform will divide the effect equally between the owner's all three axes. For example, if the target's scale is (3.0, 1.0, 1.0), it will scale the owner to (1.442, 1.442, 1.442) as that represents the same change in volume, spread uniformly across all three axes.

When *Offset* is disabled, the constraint will override the owner's scale. If we enable it, the effect will be mixed with the owner's scale values, and the *Additive* option will become available. By enabling it, the offset will be added to the owner's scale instead of multiplying it.

Similar to the previous two constraints we discussed, the effect of the Copy Scale constraint can match the scale of bones or mix it with the owner's own scale. Note that this constraint will not match the length of the owner with the target. This would require the use of a Stretch To constraint.

Copy Transforms

The Copy Transforms constraint sets the owner's entire transform to be the same as the target's. The effect is like adding Copy Location, Copy Rotation and Copy Scale constraints to a bone. But the difference is that Mix gives a bit more control over how the three transforms are combined.

A large benefit to using this constraint is that Copy Transforms provides the ability to copy rotation from anywhere along the target bone, using the Head/Tail and Follow B-Bone options. This is actually the only direct way to get the rotation along a B-Bone as the Copy Rotation constraint does not offer this option. This constraint will be heavily used in the rig mechanics demonstrations where we will see different use cases for it.

Mix Modes

The Copy Transforms constraint's *Mix* options give us a way to specify how the constraint's effect is combined with the owner's transformations. In most cases, we will leave it at the default value. The options are:

- *Replace*: Override the owner's existing transformation.
- *Before/After Original (Full)*: Applies the effect as if it applied to an imaginary parent/child of the constraint owner. The Full part means that the transformation will be taken as it is on the target, with no modifications. So if the target has a non-uniform scale and rotation, which causes shearing, the owner will be sheared as well.
- *Before/After Original (Aligned)*: Same as the previous option with one difference. This option will remove all shearing from the transformation by aligning the axes in which it scales the owner with the scale axes of the parent.
- *Before/After Original (Split Channels)*: Works as if the owner had a Copy Location, Copy Rotation and Copy Scale constraint (with Offset) instead of a single Copy Transformation constraint.

Damped Track

The Damped Track will rotate the owner so that one of its axes points at the target. We specify the axis using the *Track Axis* parameter. The *Head/Tail* and *Follow B-Bone* options change at which part of the target to point at.

The owner will use a swing type of rotation, meaning the rotation is a sequence of two single-axis rotations. If *Track Axis* is set to Y, the owner's X and Z axis will achieve the effect with as a minimal rotation on the Y axis as possible. So besides the obvious use for this constraint, which is to have a bone "look at" other objects, we can also use it to copy the rotation of another bone but with the twist extracted from it (Figure 21.3).

Stretch To

The Stretch To does two things. First, it rotates the owner so that its Y-axis points at the target. It does this similarly to how the Damped Track constraint does it. Additionally, it has the *Rotation* property which changes how the rotation is calculated. *Swing* option will cause a rotation identical to the one from Damped Track. *XZ* and *ZX* are similar, but either X or Z will be rotated first and then the secondary axis.

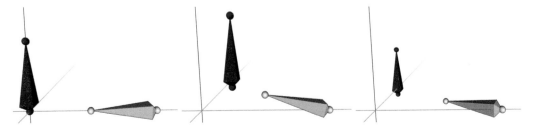

FIGURE 21.3 Damped track constraint example

Stretching is the second thing that this constraint does to the owner. The owner's scale will change to elongate or shorten the bone so that its tail is always at the same distance from the target. The distance is defined using the Original Length property. If the target moves further away or closer to the owner, this will cause a squash and stretch type of effect in the owner. *Volume Variation* multiplies the amount of volume preservation the constraint should create. *Volume Min* and *Max* can limit the owner from becoming too thin or too thick. We can limit the volume preservation effect to specific axes or removed completely by adjusting the *Maintain Volume* parameter (Figure 21.4).

Locked Track

Locked Track constraint is another one that is similar to Damped Track. The difference between the two is that Locked Track affects only one rotation axis. We define the behavior using two parameters: *Track Axis* and *Locked Axis*. *Track axis* defines which axis should point at the target, while *Locked Axis* specifies around which axis is the owner allowed to rotate. See Figure 21.5, it shows a Locked Track constraint behavior example. In the example, *Track Axis* is set to *Y*, meaning the owner's Y axis will point in the target's direction. *Locked Axis* is set to *X* meaning the constraint will only rotate the bone around the X-axis.

You have probably seen wind wanes in movies. Those things on roofs are shaped like a cockerel standing on an arrow, which rotates to point in which direction wind is blowing. It perfectly represents how a Locked Track constraint works.

Transformation

The Transformation constraint is used to map the transformation from the target to the owner. You can look at it as a constraint that makes the owner do something based on the target doing something else. For example, we can set the constraint up so that when the target moves, the owner rotates. We can define the mapping range using the *Min* and *Max* values, and axes can be mixed. To extend on the example, we could set the constraint so that when the target moves from 0 to 1 on the X axis, the owner rotates from -90 to 90 on the Z axis. See Figure 21.6.

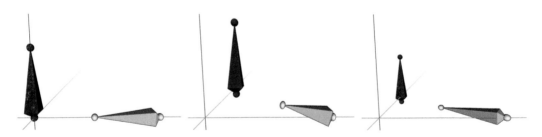

FIGURE 21.4 Stretch to constraint example

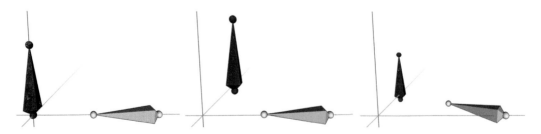

FIGURE 21.5 Locked track constraint example.

FIGURE 21.6 Transformation constraint example in which the target's movement in X changes the owners' rotation in Z.

When *Extrapolate* is disabled, the owner will only transform within the *Min* and *Max* range. If we enable it, the mapping will continue beyond those values linearly.

Rotation Mode

When the Transformation constraint's *From* property is set to *Rotation*, we get access to the *Mode* options. These change the way the target's rotation is treated. These modes are:

- *Auto Euler*: Uses target's Euler mode
- *XYZ, XZY, YXZ, YZX, ZXY, ZYX*: Explicitly uses these rotation orders for decomposing the target's rotation
- *Quaternion*: The rotation is represented as a Quaternion
- *Swing and X/Y/Z Twist*: In this mode, the rotation is broken into two pieces, the swing and the twist.

Swing and X/Y/Z Twist deserve more explanation as it is the most complex mode but also often the most useful one. The beauty of this mode is that it completely removes any rotation decomposing issues that can come from wrong rotation orders or gimbal problems.

You can look at Swing and Twist as a combination of a Damped Track and Locked Track constraint. Damped Track uses two rotation axes to match the direction between two objects, and Locked Track uses the third axis to twist the object and completely match the target's rotation. So we can use the Swing amount to get how much the target rotates sideways, and the Twist gives us the amount it rotates around itself.

The beauty of this mode is that the swing is always calculated first, meaning that we can get the rotation independent of the twist, or the twist itself regardless of how the bone is rotated. Drivers offer an additional axis, W, which returns the amount of swing regardless of which rotation axis causes it.

Action Constraint

The action constraint allows us to drive a bone's transformation using animation curves using Actions. This is a great solution for very complex or non-linear behaviors that would be hard to create using other constraints or drivers. The process of using this constraint would be to first animate the bone and create the desired motion. Then we remove the created Action from the armature and assign it to the action constraint. We can animate multiple bones and give each of them an action constraint with that same action assigned.

We can play the animation in two different ways. One is to assign a target object and use one of its transformation channels as the parameter that drives the playback of the action. The channel is mapped to the start and end frames of the action using the *Min* and *Max* values. Meaning when the transformation channel is at *Min,* the action will evaluate at the *Start* frame. And when at *Max*, the action will evaluate at the *End* frame.

The second way we can play the action back is by using the *Evaluation Time* option. When it is enabled, the *Target* options become unavailable, and the constraint provides us with a slider that drives the evaluation time of the action. This value can either be animated directly or connected to a custom property.

When creating actions for use with this constraint, I recommend animating the bone so it always transforms at a constant rate, i.e. animate it so it does not speed up or slow down. When the action is linear like that, the animator can add the changes in speed as they animate the constraint itself.

If you need to adjust the Action, keep in mind that if the constraint is active and you also assign the action to the armature, you will have the action transforming the bone twice. To avoid this, first disable the constraint, assign the action to the armature, make adjustments, remove the action, enable the constraint. We assign and remove actions through the *Dope Sheet* in *Action Editor* mode.

Inverse Kinematics

When we talked about bone parenting, we learned how every child bone inherits the transformations from their parents. This is called forward kinematics (FK). This behavior is not ideal for every scenario. For example, if a rigged character is standing, and the animator lowers the body to create a crouching pose, the legs will inherit the transformation of the hips and poke through the ground. So the animator needs to correct this by rotating the legs. Animating this would be much easier if the knees would automatically bend so that the feet stay where they are, regardless of what the body is doing. This is exactly what the Inverse Kinematics (IK) constraint does. See Figure 21.7.

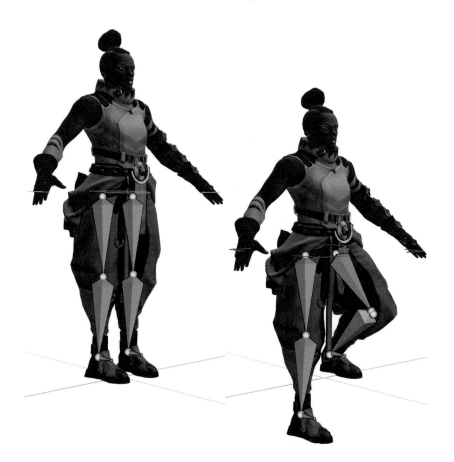

FIGURE 21.7 Example of forward and inverse kinematics applied to a character's leg bones.

The constraint adjusts the rotation of a bone chain so that the end of that chain always stays at the location defined by the IK target bone. Using the leg example again, we would place a target bone at the location of a character's ankle and create an IK constraint on the leg. If that target bone or the hips are moved, the constraint will rotate the leg bones to bend or extend the leg so that the chain always starts at the hip and ends at the target's location.

IK constraint is the only constraint that adjusts multiple bones, not just the owner. We add the constraint to the last bone in the chain and it will influence multiple bones above the owner in the bone hierarchy. The constraint's Chain Length property defines the number of affected bones. It will automatically search for parents above it and operate on them.

Let's now go over the constraint's properties:

- *Target*: The constraint will try to position the end of the constrained chain at the target's location. When the target is moved, the bones will rotate so that the tail of the last bone in the chain is always positioned at the target's head.
- *Pole Target*: An optional second target, which controls how the constrained bone chain twists. In the leg example, without a *Pole Target,* we don't have control over where the knee is pointing. If we assign an additional bone as the pole target, the knee will always point at that bone, which the animator can move to control the leg twist.
- *Pole Angle*: this is another way to add a twist to the entire IK chain. We can use it without a *Pole Target* being present. Or in combination with it to add an offset.
- *Iterations*: defines the maximum number of iterations the IK solver will do when calculating the chain's rotation. The more iterations, the more precisely the end of the chain will be placed at the target's location. You can leave this at the default value.
- *Chain Length*: defines how long the IK chain should be. This number includes the bone that has the constraint. For example, if we set it to 2, the IK chain will control two bones and will not affect any parents above the second bone. This value should always be set to the correct number of bones the constraint should control. If left at default, it will affect the entire hierarchy above the constrained bone.
- *Use Tail*: specifies if the tail of the constrained bone should be aligned with the target. When disabled, the bone's head will be used. Usually left at its default, enabled state.
- *Stretch*: When enabled, besides rotating the bones the constraint will scale them. This only happens when the distance from the start of the chain to the target bone is longer than the length of the entire chain. When this happens the bones will be scaled until the end of the chain reaches the target. The *IK Stretch* property needs to be adjusted on all bones in the chain to make this work. I will show this in the next section.
- *Weight Position/Rotation*: Defines how the IK calculation happens and there is no need to change these. You can leave them in the default values and ignore them completely.

Properties

These settings are not part of the constraint and are found in the *Bone Properties* panel. They are present on every bone, but only relevant for bones that are affected by an IK constraint. See Figure 21.8.

IK Stretch allows the bone to be scaled when *Stretch* is enabled in the IK constraint. It is best to set this value to something very small, like 0.0001. This allows the bone to be scaled but keeps undesired stretching to a minimum. This value has to be set on all bones that need to stretch. If left at the default 0.0 value, the IK constraint's *Stretch* option will have no effect.

Lock IK X/Y/Z prevents the bone from being rotated by an IK constraint on the specified axes.

Stiffness X/Y/Z adjusts the ratio of rotation that applies to bones in an IK chain. Less rotation will happen on the bone if the stiffness value is higher. The values can only go up to 9.9, meaning that this property can't exclude the bone from rotating completely. The constraint will first try to solve the rotations using bones with a lower stiffness value. If that fails, it will start rotating the bones with higher

FIGURE 21.8 Inverse kinematics properties, found in the bone properties panel.

stiffness. This is not relevant for humanoid characters as the limbs have only two bones and both have to rotate in order to solve the IK rotation. You might find a use for it in creature or mechanical rigs as those might feature limbs with over two segments.

The Limit X/Y/Z properties give us the option to set *Min* and *Max* values the bone can be rotated to by an IK constraint.

Common Issues

IK constraint is complex, and we can easily end up with some undesired results. Here is a list of the most common issues that can occur and how to fix or avoid them.

- **Constrained bones are always staying straight**
 Likely caused by the bones in the IK chain forming a perfectly straight line. When this is the case, the IK solver does not know how to bend the chain so it keeps it straight. This is fixed by adding a slight bend in the chain, which then informs the constraint in which direction to rotate the chain. For this reason, you should never create limb bones in perfectly straight lines. Always make sure there is a slight bend in the knees and elbows.

- **Chain gets twisted when a Pole Target is assigned**
 The bone chain will always be twisted so that the X-axis of the bone at the top of the chain points at the pole target. This can cause the entire chain to twist if the X-axis is not pointing at the pole in the rest pose.

We can fix it in two ways. One is to orient the bones so that the X-axis is pointing in the pole's direction in the rest pose. Which will require you to build the rig around this constraint. The second and much simpler way to solve this is to compensate for the offset by adjusting the *Pole Angle* value. Adjust the *Pole Angle* to a value that twists the IK chain back to its default rotation.

- **Stretch is enabled, but bones are not stretching**

 All bones that are part of the IK chain need to have their *IK Stretch* property set to a value larger than 0.0. To fix the issue, for all the bones that are in the IK chain, open *Bone Properties* and in the *Inverse Kinematics* tab set *IK Stretch* value to 0.0001.

22

Dealing with Clutter

The Problem

This section covers some tips on how to make it easier to deal with the inevitable problem of having many bones occupying the same visual space. See Figure 22.1.

Different Bone Lengths

The rigs will contain multiple cases where several bones have the same location, orientation and length, which makes them look like the same bone. To actually see that there are multiple bones instead of just one, we can change their lengths. Changing a bone's length does not affect its position or rotation. This technique is only valid for cases where the length isn't important for the functionality of the bone (Figure 22.2).

B-Bone Thickness

When the bone *Display As* property is set to *B-Bone*, the thickness of each bone can be adjusted. The thickness has no effect on the bone's transformation or functionality. It is purely a visual change. **Ctrl+Alt+S** is the shortcut for adjusting a bone's thickness (Figure 22.3).

Bone Layers

Another way to reduce clutter is to separate bones into different bone layers. For example, FK bones can be in one layer, IK in another one, blend chain bones in a third one and so on. We can then enable each layer to be worked on. Armature bone layers are found in Armature Properties under the Skeleton panel.

Hide Bones

We can hide bones by selecting them and pressing the **H** key. All hidden bones can be made visible again by pressing **Alt+H**.

Clip Regions

Entire regions of the 3D view can be hidden, or clipped, by using the *Clipping Region* tool. This makes it easier to see into the mesh or to remove anything that might obstruct the view of the part we are working on. Clipping Region is triggered by pressing **Alt+B**, then **Left click** and move the mouse to draw the region you want to crop to. Confirm by releasing Left click. Hold **Space** while dragging the mouse to move the region.

DOI: 10.1201/9781003263166-22

FIGURE 22.1 A taste of what a finished rig looks like, with hundreds of overlapping bones.

FIGURE 22.2 Two cases of four bones with the same positions and rotations. On the left, they have the same length, on the right I adjusted the lengths to visually separate the bones.

Clipping regions are quite useful when weight painting. For example, you can use them to crop out the back of the head to make it easy to paint the inside of the mouth. Or you can isolate individual fingers. To remove the clipping region, press **Alt + B** again (Figure 22.4).

FIGURE 22.3 Bones in B-Bone display mode with their thickness adjusted. The right example is a combination of different thicknesses, lengths, and X-ray enabled.

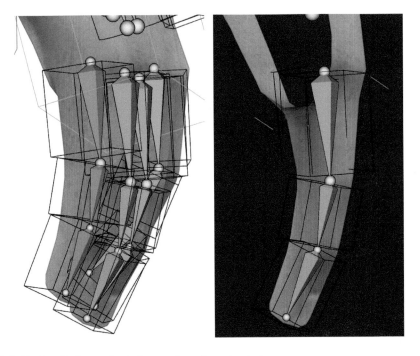

FIGURE 22.4 Region clipping used to isolate one finger for easier rigging.

Material Preview + X-Ray

This setup allows us to display bones in X-ray mode, while the meshes remain opaque. There are a couple of steps you need to do to enable this. First in the *3D view head*er switch Viewport Shading to *Material Preview*. This mode forces the mesh to be fully shaded even if the X-ray is on. Next, enter Edit mode with the armature and press **Alt + Z** to enable X-ray mode.

Bones should become slightly transparent and you should see bones that are overlapping each other. If working in Edit mode, enable the *In Front* option in the Armature Data properties Viewport Display options, to see the bones on top of the mesh. It is important to leave X-ray enabled in Edit mode when switching to Pose mode as this can't be enabled in Pose mode. The **Alt + Z** shortcut in pose mode toggles displaying bones in front (Figure 22.5).

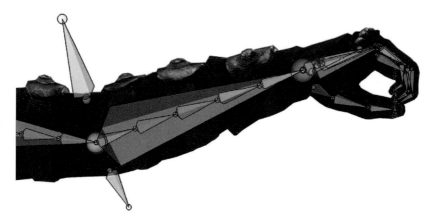

FIGURE 22.5 A combination of opaque mesh rendering with X-ray bones displayed in front of the mesh.

23

B-Bone Rigging

Introduction

Bendy bones are at the core of many of my rig setups. I use them in spines, tails, limbs, and sometimes even faces. In Figure 23.1, you can see Nnema with the main B-Bones visible. We will start with a simple base setup and build on it to create more complex behaviors. These setups contain both control and mechanics bones. As we utilize them in rigs later on, you will see the roles they play and how to attach intermediate bones to them.

FIGURE 23.1 Bendy bones as the core of different rig elements.

DOI: 10.1201/9781003263166-23

Base Setup

The base setup contains three bones. A bone which we will treat as a bendy bone, and two bones that will control its transformation. You can see the setup in its entirety in Figure 23.2. What is not apparent in the figure is that the B-Bone is parented to the start handle and it has a Stretch To constraint with the end handle as the target.

The following is a step-by-step explanation for assembling the base B-Bone setup:

- Create a bone that will serve as the B-Bone.
- Add a second bone and position it at the head of the B-Bone.
- Add the third bone and position it at the tail of the B-Bone.
- Parent the B-Bone to the bone at its head.
- Add a Stretch To constraint to the B-Bone with the third bone as the target. The rest of its settings stay at default values.
- Change the B-Bone's *Segments* property to 10.
- Change the Start and End Handle type to *Tangent.*
- Assign the bone at its head as the *Start Handle.*
- Assign the bone at its tail as the *End Handle.*
- Disable *Deform* for all three bones.

Additional steps are required and depend on how the setup is used. For example, the handles can become control bones that would be directly animated, or mechanics bones driven by other controls. The base setup is the same for both cases. The difference will be that the handles either get custom mesh shapes, or they get indirectly transformed and are hidden from the users. None of these bones will deform the mesh, instead we will use them as a building block for complex setups and as a vehicle for transforming intermediate and in effect, the deform bones.

When creating the bones, make the B-Bone so that it spans across the entire length of the segment it should control. For example, from the elbow to the wrist if its role will be to handle the forearm twist. Or from the pelvis to the chest if it will serve as the bendy part of the torso. Orient handle bones exactly the same as the B-Bone. We can do this by selecting all three bones, with the B-Bone as the active bone, and pressing **Ctrl + Alt + A**.

Where to parent the handles depends on the use case. For example, in a spine, we could use the handles as the actual hip and chest controls, which means we would parent them to the body control. The B-Bone is always parented to the start handle.

When using the handles as controls, we might run into an edge case. Which is that the controls need to be rotated differently from how the B-Bone is rotated. This would add some curvature to the B-Bone which might not be desired. If this creates a shape that is actually matching the shape of the mesh, then

FIGURE 23.2 The elements of the base B-bone setup. The two bone setups are the same and represent what the setup looks like in both octahedral and B-Bone display modes.

we can leave it as is. In case the initial curvature in the B-Bone is not desired, create separate control bones which you can freely rotate and parent the handles to them.

Give all bones a proper name. If you use handles as controls, then give them nice clean names, otherwise give them names according to the naming convention. For example, in a spine rig, I would call them: "MCH-spine_bbone", "MCH-spine_bbone_start_handle", "MCH-spine_bbone_end_handle". To test the setup, move and rotate the handles and check if the B-Bone stays connected to them and is bending and twisting to create a smooth connection between the handles.

Twist Distributor

A few places in a character rig require a setup that blends twisting between two segments. To understand better what I mean, pay attention to what happens to your forearm as you twist your wrist. You notice the forearm will twist a lot close to the wrist, but the rotation tapers down as it gets closer to the elbow. The elbow itself isn't getting twisted by the wrist at all. Similar behavior happens on the upper arm, thigh, neck etc. See Figure 23.3.

The base B-Bone setup already does a twist distribution between the handles, so we have all the elements we need. But we do not want the B-Bone to bend as the handles rotate to the side. This would look unnatural in something like a forearm. To fix it, in Edit Mode, change the B-Bone's Ease In and Out values to 0.0. See Figure 23.4.

We could make the addition and removal of automatic curving into a rig feature. To do this, we would need to connect a custom property or a bone transformation channel to the Ease In/Out values via drivers. The animator could then dial in the desired amount of automatic curvature.

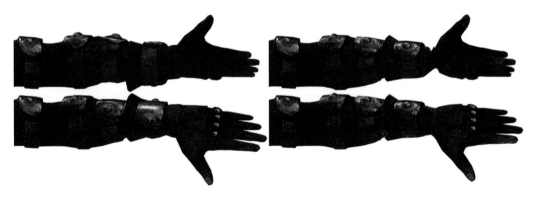

FIGURE 23.3 Twist distribution (left) versus no twist distribution (right).

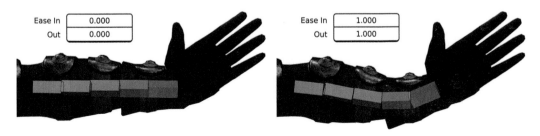

FIGURE 23.4 Base B-bone setup adjusted for twist distribution (left), unmodified base setup (right).

B-Bone Chain

We can chain multiple B-Bone setups by giving them shared handles. To do that, make a couple of base B-Bone setups and make sure that the head of every B-Bone is at the same location as the tail of the previous B-Bone. Then assign the end handle of the previous B-Bone as the start handle of the next one. Repeat the process to create longer chains. See Figure 23.5.

Just like in the base setup, parent every B-Bone to its start handle. The parenting of the handles themselves depends on the use case. We can parent each to the previous one to create a forward kinematics setup, or they could all be parented to one main control and transform independently.

Layered B-Bones

The last setup is a combination of the base setup and a B-Bone chain. The base setup provides a broad level of control, while the B-Bone chain follows it and gives finer control over the shape. For example, when used in a spine rig, the base B-Bone will always automatically produce a nice curvature in the abdomen and create a great twisting distribution. On top of this B-Bone, we attach a B-Bone chain that lets the animator fine-tune the shape of the curve. See Figure 23.6.

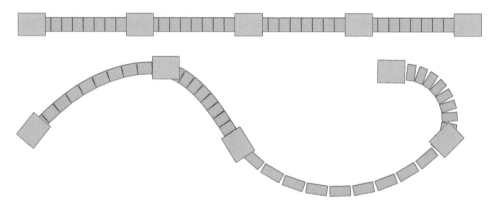

FIGURE 23.5 B-bone chain.

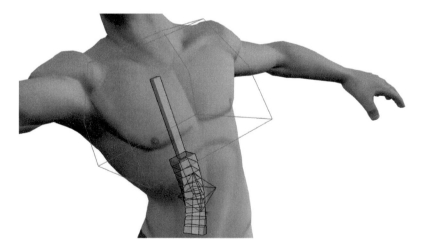

FIGURE 23.6 Example of a layered B-bone chain used in a spine rig.

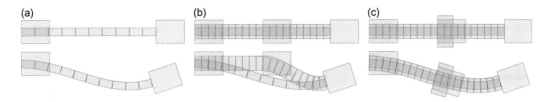

FIGURE 23.7 Layered B-bone creation stages.

I will explain how to create this setup in stages. I illustrated all stages in Figure 23.7. The first stage would be to create the base setup:

- Make a base B-Bone setup, as previously shown.

The second stage is to create a B-Bone chain on top of the base setup. Follow these steps:

- Duplicate the B-Bone and subdivide it to get two bones. This gives us the two B-Bone's for the chain.
- While they are selected, press **Ctrl + Alt + C** to remove all constraints from them.
- The start and end of the chain will use the handle bones from the base setup.
- For the middle handle, create a new bone aligned with the second B-Bone.
- Finish the chain setup by assigning handles and creating the Stretch To constraints.

The start and end of the B-Bone chain are connected to the base B-Bone as they share their handle bones. In the third and last stage, we will make the middle handle follow the base B-Bone. We can't directly constrain the middle handle to it because we want to keep the ability to freely transform it. So we need one more bone which can be constrained instead of it. Here are the steps for doing this:

- Duplicate the middle handle bone.
- Constrain this duplicate to the base B-Bone using a Copy Transforms constraint.
- Change the constraint's *Head/Tail* value to 0.5 and enable *Follow B-Bone*.
- Parent the middle handle to this bone.
- In the middle handle's *Relations* panel, change *Inherit Scale* to *Aligned*.

If you notice that the B-Bone follower bone transforms after adding the constraint, simply select it and use **Ctrl + A** to bring up the *Apply* menu and select *Apply Selected as Rest Pose*. This happens when the bone is not perfectly aligned with the center of the B-Bone.

If the setup needs to follow the curvature of a mesh, adjust the B-Bone's *Curve* properties in Edit mode to get the desired initial curvature. The *Ease In/Out* parameters are also at your disposal. Either to set initial values in Edit mode, or they can be driven by custom properties in Pose mode to give animators control over the shape.

I hope you are seeing how these simple setups can be layered and chained to create different rigs. Multiple variations can be created by changing where the handles are parented and by deciding if B-Bone's share handles or not.

Attaching Bones to B-Bones

We can attach bones to any point along a B-Bone using Copy Transforms and Copy Location constraints. The issue with using Copy Transforms is that there is no option to add this behavior as an offset to the bone's current transformation. It will always force the bone to align with the B-Bone. Additionally, it will prevent the bone from being further transformable.

The solution is to create an additional bone and constrain it to the B-Bone instead. Once the constraint is added to it, we can assign it as the parent to the original bone. That way, it will inherit all the transformation from the B-Bone, while preserving its transformation and is freely transformable.

Common Issues

B-Bone Twists

When the handle type is set to Tangent, the rotation of its handles controls the B-Bone attributes. If the orientation of a handle and the B-Bone is not aligned, the B-Bone will twist to match the orientation of the handle.

To fix this, match the orientation of the handle with the B-Bone. It can be easily done by following these steps:

- Select the handle bone.
- Add the B-Bone to the selection and make it the active bone.
- In Edit mode, since we can't change the roll in Pose, press **Shift + N** and select *Active Bone*.

If there are reasons, you don't want to change the roll of a handle bone, create a new bone, align its orientation with the B-Bone and use it as the handle. Parent it to the bone that was the original handle.

B-Bone Curves

Same way, the roll of the handle can twist the B-Bone if their Y axes are not aligned, the handle can also introduce some curvature to B-Bone. If this behavior is undesired and the setup requires the B-Bone to stay straight, the rotation of the handles needs to be aligned with the B-Bone. To align them completely, follow these steps:

- Select the handle bone.
- Add the B-Bone to the selection and make it the active bone.
- Press **Ctrl + Alt + A**. This will perfectly align their rotation.

If you want to use handle bones as controls, meaning you want them aligned with the mesh, duplicate them to create two sets of bones. We will align the first set with the B-Bone and use them as handles. Align the second set with the mesh to be used as animation controls. The first set of bones needs to be parented to their respective control bone.

24

Drivers

DOI: 10.1201/9781003263166-24

Introduction

A simple explanation for drivers would be that they are small functions that operate on single properties. These can be predefined or custom-made using code written in the Python language. A common use case for drivers in rigging is in creating a connection between two properties. For example, we can make a custom property and use it to enable or disable a constraint by connecting the two using a driver. Another common use case is to connect a bone's transform channel to a shape key's *Value*.

A purple color marks properties driven by a constraint. Adding multiple drivers to one property is not possible.

Creating and Removing Drivers

We access most driver manipulation operators through a property's right-click menu. Depending on the current state of the property, different operators will be available. All options from the right-click menu, which apply to drivers, are shown in Figure 24.1.

Create Driver

To create a driver, right-click on a property and choose *Add Driver*. Or hover the cursor over a property and press **Ctrl + D**. Both approaches create a driver with default settings, which don't have any effect on the property and need to be adjusted to make it functional.

When a driver is created, the floating driver editor will show up. It provides a quick way of setting up the driver. It can always be accessed by right-clicking on the property and selecting *Edit Driver*. We can see the floating driver editor in Figure 24.2.

Copy/Paste

We can also copy a driver between properties. To do so, right-click on a property that has a driver and select *Copy Driver*. Then right-click on the property that you want to paste the driver to and choose *Paste Driver*.

FIGURE 24.1 The property right-click menu options relevant to driver creation and manipulation.

FIGURE 24.2 Floating driver editor window.

Copy as New Driver

To quickly create a driver that connects the values of two properties, we can use the *Copy as New Driver* operator. To do this, right-click on the property that will be the driving variable and select *Copy as New Driver*. Then right-click on the property that is to be driven and select *Paste Driver*. A driver created this way will have its *Type* automatically set to *Averaged Value and a have a variable added for the property that was copied as a driver.*

Delete

To delete a driver, right-click on the property that has a driver and choose *Delete Driver*. We can also do this from the Drivers editor window, which will display drivers for the selected object and any drivers that don't have a target.

Driver Editor

There are two different ways of displaying and editing driver properties. One is the quick edit view, which we discussed earlier. The second place where drivers can be edited is the Drivers editor. It can require a designated view and, like any other editor, is enabled by clicking on the Editors button in choosing it from the pop-up window.

If the right side panel is not visible, enable it by clicking on the chevron icon on the right edge of the view. Or press the **N** key. Switch this panel to the Driver tab. Another way to get a Drivers view is to right-click on the driven property and choose *Open Drivers Editor*. This will create a new floating window. See Figure 24.3.

The left side panel of the Drivers editor will display a list of all drivers that exist on the selected objects and all orphaned drivers. A driver needs to be selected in order to show up in the right-side panel. It can be disabled by toggling the buttons displayed next to the driver's name.

FIGURE 24.3 The driver's view.

A red line displayed under the driver's name means there is an issue with the driver. For example, when a bone that has a driver is deleted, the driver will not be automatically deleted and will show up in the drivers' list with a red underline. To delete selected drivers, press the **X** key.

The right side panel, switched to the Drivers tab, is where we can see and edit driver properties. Drivers usually update automatically whenever changes are made to them, but sometimes they don't recognize the changes and a forced refresh can be triggered by clicking on *Update Dependencies*.

At the center of the Drivers' view, we have the driver curve. By adjusting the curve via its keyframes, we can manipulate the driver's evaluated value. This is useful for creating complex interpolation that would be hard or impossible to do using an expression. We can edit the curve the same way as regular animation curves.

Driver Types

Driver *Type* defines how the output of the driver is calculated, i.e. what the value of the driven property will be.

There are five different types of drivers. Four are predefined functions and the fifth one, *Scripted Expression*, gives us the option to define the driver function ourselves using Python code. The four predefined types all require at least one input variable. If none are present, the driver will not be functional.

Here is a description for each of the five driver types:

- *Average Value*: Outputs the average value of all variables. If only one input variable is present then the output will be equal to that variable.
- *Sum Values*: Adds all input variables together.
- *Minimum Value*: The output is equal to the smallest input variable value.
- *Maximum Value*: The output is equal to the highest input variable value.
- *Scripted Expression*: Provides an input field labeled Expression in which the driver behavior can be defined using Python code.

Driver Variables

There are four available driver variable types: *Single Property*, *Transform Channel*, *Rotation Difference*, *Distance*. The first two reference a single object property. While the last two are small functions and require two targets.

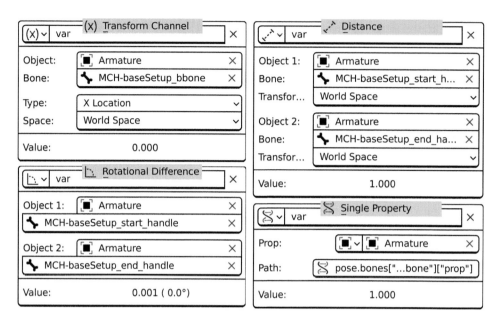

FIGURE 24.4 Driver input variable types and their properties.

We add variables to drivers by clicking on the *Add Input Variable* button in the driver editor. After that, the type can be changed by clicking on the button in the top left corner of the variable view. All variable types have one property in common, which is the variable name, and it is relevant for *Scripted Expression* type drivers. Figure 24.4 shows all driver variable types and their properties.

Single Property

Single property is the most flexible variable type and allows us to use any object property as a variable. To set up a single property, first the target object needs to be assigned to the *Prop* field. Then, in the *Path* field, we add the path to the property. The path is like an address of a property. It can be typed in manually, but an easier way to get the path to any property is to right-click on the property and choose *Copy Data Path*. Then click on, or hover over, the *Path* field and press **Ctrl + V** to paste the path. I mostly used this variable type for custom properties or other non-transformation channels.

Something to remember about copy/pasting paths is that the path will not include the target axis in vector properties. To fix this issue, the axis value needs to be added at the end of the path. For example, we would need to add either ".x" or "[0]" at the end of the pasted path. Both point to the same property and the rule applies for other axes, i.e. ".x", ".y", ".z", ".w" is the same as "[0]", "[1]", "[2]", "[3]", respectively.

Here is an example of the result of copying the path of a rotation Y value of a bone: "pose.bones["MCH-IK_FK_switcher_armLower.L"].rotation_euler". As you can see, at the end of the path, nothing specifies which axis the driver should use. To fix this, we can add ".y" to the end of the path. Like so:"pose.bones["MCH-IK_FK_switcher_armLower.L"].rotation_euler.y".

Transform Channel

The properties that can be used for this type of variable are limited to Location, Rotation and Scale properties. And instead of providing a path, we can select the properties from a drop-down list. If a rotation axis is selected, the Mode option will become available, which gives options to specify for how the rotation is extracted.

Rotational Difference

This variable takes two input targets and calculates the angle between them. The output value is in radians. If needed, it can be converted to degrees in a *Scripted Expression* by using the degrees () function and adding the variable name between the parentheses.

Distance

Returns the distance between two target objects in specified spaces.

Expressions

The Expression field, which is available with *Scripted Expression* type drivers, allows us to enter any arbitrary Python expression which will define the driver's output. If you don't have any Python experience, do not worry, as we can solve most rigging needs using very simple expressions that anyone without prior coding knowledge can understand.

Writing basic mathematical expressions in Python is done the same way you would write them in a calculator. If you want the output value to be "1 + 1", simply write "1 + 1" in the expression field. The result of this expression will be the driven property's value.

Blender has a special subset of expression features that significantly improve driver performance. We refer this subset to as Simple Expressions. The following is a breakdown of all features that qualify as Simple Expressions.

Variables

Variables are used in expressions by referring to them using their names. For example, let's assume we have a driver that has two variables, and they are named var1 and var2, and we want to write an expression that multiplies them. The driver expression would be: "var1 * var2".

Literals

These are integer (ex. 1, 2, 3, 28149) and floating point (ex. 1.0, 1.493, 493.1939) numbers. To give an example, if we wanted the result of the expression to be the value of an input variable multiplied by 10, we would write this in the expression field: "var * 10".

Globals

The only global value that is supported in simple expressions is "frame". Which represents the current scene's frame number. This is useful for writing expressions that change over time. For example, the expression "frame * 2" would result in a number twice the size of the current frame.

Constants

The supported constants are "pi", "True" and "False". "Pi" we all know, and it is approximately equal to 3.14159.

"True" and "False" essentially represent 1 and 0, respectively. And they are used in Python for boolean operations. A boolean operation, for example, would be "1 = 2". Which would result in False or 0.

Arithmetic Operators

Arithmetic operators are self-explanatory and the available ones are: "+", "-", "*" and "/".

Comparison Operators

Comparison operators are used to compare two values, and the result is always either True or False. These are the available conditional operators and their meaning:

- "==" - Equal.
- "!=" - Not equal.
- "<" - Less than.
- "<=" - Less than or equal to.
- ">" - Greater than.
- ">=" - Greater than or equal to.

A use case for comparisons in expressions would be to create switches based on variable values. For example, if we want a constraint to be enabled only when a custom property has a value of 2, we could use this property as an input variable named "var" and as the expression we write "var=2". If the input variable is not 2, the comparison will result in False meaning 0.0. When the variable is 2, the comparison will be True, meaning the output will be set to 1.0 and the constraint will be enabled.

Logical Operators

Logical operators are used to combine comparison statements. These consist of:

- *"and"*: Returns True if both statements are True.
- *"or"*: Returns True if either of the statements is True.
- *"not"*: The statement is reversed, meaning it returns False if the statement is True and vice versa.

"If" and "else"

We can combine the "if" operator with comparison and logical operators to create more complex switch-like behavior. Here is an example: "10 if var1 >= 0". This would return the number 10 if the variable is equal or greater than 0.

We also have the *"else"* statement at our disposal. It can be used to output a different value if the statement is False. For example: "10 if var1 >= 0 else 5". This returns 10 if the statement is true and 5 if the statement is false.

To reiterate, the syntax is: "valueIfTrue *if* statement *else* valueIfFalse"

Standard Functions

The syntax for these functions is "functionName(x)", or sometimes "functionName(x, y)". Most of them take only one input, for example "degrees(3.14)" converts the number in the parentheses to degrees. Here are all the standard functions: "min", "max", "radians", "degrees", "abs", "fabs", "floor", "ceil", "trunc", "round", "int", "sin", "cos", "tan", "asin", "acos", "atan", "atan2", "exp", "log", "sqrt", "pow", "fmod".

Blender Provided Functions

These are:

- "*lerp(minValue, maxValue, t)*": Returns a linearly interpolated value between the provided "minValue" and "maxValue" based on a percentage represented by "t". All three can be constants or variables. When "t" is 0.0, the returned value will be equal to "minValue", and at 1.0 it will be equal to "maxValue".
- "*smoothstep(minValue, maxValue, t)*": - Similar to lerp but instead of the value interpolating linearly, it gradually transitions between "minValue" and "maxValue". Which results in a softer motion.
- "*clamp(num, minValue, maxValue)*": Prevents the number from being smaller than the "minValue", or larger than the "maxValue".

25

Rig Building Blocks

The following sections will teach you how to create various rig setups that are made to solve one task each. Once you understand how to make them, together with the bendy bone setups, you will be equipped with a set of building blocks you can use to create any kind of rig you might need. Once we finish looking at these elements in isolation, we will assemble them into a character body rig.

Control Bone

As the rig will comprise many different bones, serving different roles, we don't want the animators guessing which bones they should be manipulating. Instead, we will make a set of control bones that are meant to be used by the animator and hide everything else. We also want to give these bones custom mesh shapes so it is easy to identify them from each other.

What effect a control bone has on the rest of the rig and how they are connected depends on the mechanics that it is supposed to control. In the simplest cases, an intermediate bone might be parented to a control bone so that it transforms together with it. To give one more example, we could use a control bone as a target in an eye rig so that when it moves, the eyes will follow it.

There are only two steps to making a control bone. The first step is to add a new bone or duplicate an existing one. The second step is to give it a custom mesh shape. We should also name the bone properly so that the name informs the animator about what the bone's role is (Figure 25.1).

Custom Meshes

We use regular mesh objects for custom bone shapes. They can be created and edited like any other mesh in Blender. To display a bone as a mesh, it needs to be assigned to a bone's *Custom Shape* property in the *Bone Properties*, *Viewport Display* panel.

When a mesh is assigned as a bone's custom shape, what gets referenced is the mesh data object and not the scene object. Meaning that any transformation done to the mesh object in Object mode will not produce any changes to the mesh data itself, i.e. the transformations will not change the look of the mesh shown on the bone. We must adjust the mesh in Edit mode.

When we are editing meshes, we are doing this in the mesh local space, while it is getting applied to the bone in its own space. This can make the mesh editing challenging as their local axes could be totally misaligned, meaning it is hard to predict how translating a vertex in its local space will translate to the bone's local space. Instead of trying to predict the behavior, my approach to this is to first match the mesh object's transformation with the bone and then adjust the mesh. This can be done by following these steps:

- Add a Copy Transforms object constraint to the mesh object.
- Assign the armature and the control bone as the target.
- Apply the constraint.

DOI: 10.1201/9781003263166-25

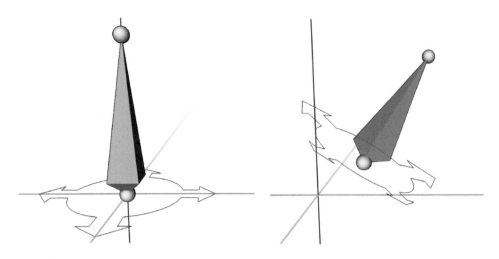

FIGURE 25.1 A control bone and another bone constrained to it to create a simple single control setup.

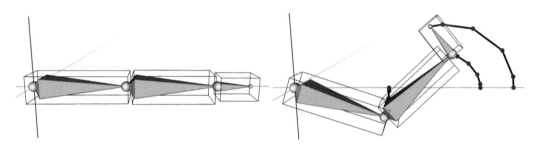

FIGURE 25.2 FK control rig with a second chain constrained to it.

Forward Kinematics Chain (FK)

By parenting bones to each other, the children will inherit transformation from their parent. If the parent moves, the child moves with it. This behavior is called forward kinematics, or FK for short. We create FK rigs in parts that are supposed to move in arcs. For example arms, hair, cloth, etc. This kind of motion is not about being precise but about elegant and smooth motion.

The disadvantage of FK is that the longer the chain, the harder it is to keep control over where the children end up when the bones rotate. If you were to animate a character opening a door, and the torso and arm are all set up as FK chains, you would have a hard time keeping that hand on the door handle. Any rotation happening anywhere in the chain will rotate the hand, so you would have to keep adjusting it to compensate. This kind of rotation, where a control needs to be rotated in order to negate parent rotation, is called "counter rotation".

To create an FK rig, make a bone chain out of many bones. Parent the bones to each other. In an arm rig, for example, you would need bones for a hand, lower arm and upper arm. Hand would be parented to the lower arm and lower arm to the upper arm. If intermediate or deformation bones are already present, we will create FK control chains by duplicating them.

To complete the FK control chain, name the bones using descriptive names, move them to a different bone layer, and create custom bone shapes. Finally, constrain the intermediate bones to this chain or parent each of them to the matching FK bone (Figure 25.2).

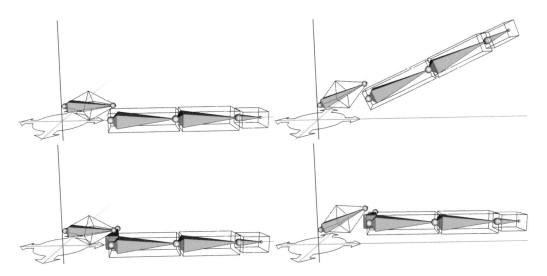

FIGURE 25.3 Regular FK chain (top). FK chain with rotation isolation (bottom).

Rotation Isolation

To help reduce counter rotation in FK rigs, or single controls, we can create rotation isolation setups which break the inheritance of rotation from parent to child. I commonly do this at connection points between different body parts, e.g. between shoulder and arm, or neck and head. By breaking the rotation inheritance, we keep the benefits of FK setups, but the animators will not have to deal with counter-rotation.

To create the setup, do the following steps:

- Create a new bone at the location of the head of the first FK bone.
- Align the new bone's rotation with the world axes.
- Parent the new bone to the same bone the first FK bone is parented to.
- Parent the first FK bone to the new bone.
- Add a Copy Rotation to the new bone with the world control as the target.

If we take an FK arm as an example, we would create the rotation isolation bone at the head of the upper arm control bone. We would parent the isolator to the shoulder and the arm to it. After you add the Copy Rotation constraint and rotate the shoulder, or any control above it in hierarchy, you notice that the arm is staying connected to the shoulder and moving with it, but it is keeping its rotation (Figure 25.3).

Rotation Switch

What if we want to have the option to toggle this behavior on/off? We can easily extend the setup to allow for that. We can actually set it up so that the animator can choose which body part should the arm inherit the rotation from. So we can, for example, isolate it from the shoulder rotation but inherit all the rotation from the chest.

We will make the setup in two stages. In the first stage, we will extend the isolation setup by following these steps:

- Remove the Copy Rotation constraint from the rotation isolation bone.
- Duplicate the rotation isolation bone.

FIGURE 25.4 Rotation switch with three targets.

- Parent the duplicate to a bone you want to inherit the rotation from and align it with the head of that bone.
- Add a Copy Rotation constraint to the rotation isolation bone, with the duplicate as the target.
- Repeat the previous three steps for all bones you want to copy the rotation from. For an arm, I would do this with the shoulder, chest, body and world controls. You do not need a bone copy for the controls that are matching world orientations (like the world control, for example). Use those bones as targets instead.

In the second stage, we will create properties that the animator can use to change the rotation origin, and connect them to the constraints. I do it like this:

- Pick which bone will host the settings for this setup.
- To it, add custom properties of type Float for each of the duplicates made earlier. Set the *Min* value to 0.0 and *Max* to 1.0.
- Rename the properties to something like "Follow [controlName] rotation". Replace "[control-Name]" with the actual names of controls you are targeting.
- Right click on the first custom property and choose *Copy as New Driver*.
- Locate the Copy Rotation constraint that has the corresponding bone as the target, right click on its *Influence* property and select *Paste Driver*.
- Repeat the previous two steps for every property and constraint.

The reason for aligning the rotation isolation bone and its duplicates with the world is that this way we can reuse them for other areas. Regardless of how the control that is being isolated is rotated, we can insert a world aligned rotation isolation bone above it and copy the rotation from any of the world aligned bones in the rig (Figure 25.4).

Inverse Kinematics Chain (IK)

As you might have guessed already, inverse kinematics is the opposite of forward kinematics. Meaning the transformation is not solved down the chain, but from the end to the start.

IK is fantastic for animation that requires precision at the end of a chain. Either to hold the end at a certain spot, or to be moved on a specific path. Think of something like a straight punch or holding a door handle. In these cases, IK setups give us direct control over where the end of the chain is placed. As opposed to an FK chain, where the position of the last bone in the chain is the product of the transformation of all bones above it.

I will break the IK setup creation process into three stages. In the first stage, we will create the target control (pyramid-shaped bone in Figure 25.5):

- Duplicate the last bone in the chain you are rigging. In case of an arm, this would be the hand bone or a foot bone in a leg rig.
- Clear the parent of the duplicate or parent it to the world control.

FIGURE 25.5 Inverse kinematics setup.

- Give it a custom shape and a descriptive name.
- Navigate to the *Relations* panel in the *Bone Properties* view and disable *Local Location* for the control bone. This step is not required but recommended as it produces world axis matching animation curves for location channels.

Moving on to the second stage, in which we will set up the constraints:

- Create an Inverse Kinematics constraint on the semi-last bone in the IK chain. Use the earlier created control bone as the target (yellow bone in Figure 25.5). For example, in an arm rig, we add the constraint to the lower arm bone. Not on the hand.
- Change the Chain Length property of the IK constraint to 2.
- Create a Copy Rotation constraint on the last bone in the chain (green bone in Figure 25.5), using the IK control as the target.

In the third and last stage, we will set up a control which will allow the animator to twist the chain. If I use the arm example again, the arm would always rotate so that the elbow points at this new control, which we will call the pole control (sphere-shaped bone in Figure 25.5). To set up the pole, follow these steps:

- Create a new bone, oriented to match world axes.
- Position it directly behind the chain and move it in the direction the chain is bending in, e.g. in front of the knee or behind the elbow. This location has to be precisely set to avoid any misalignment.
- Give this bone a custom shape and a descriptive name.
- Clear its parent or parent it to the world control.
- Assign it as the Pole Target in the IK constraint created in the previous stage.

Pole Target Placement

As mentioned, the pole target's location has to be set precisely and instead of guessing if the location is correct, I will show a technique for easy placement. One precondition is that you have already properly oriented the bones in the IK chain, as we will use their orientation to find the direction in which to move the pole target.

Follow these steps to place a pole target bone (Figure 25.6):

- Select one of the IK chain bones. Sometimes selecting them both works too.
- Enable the move gizmo and change the *Transform Orientation* to *Normal*.
- Click on the+button in the *Transform Orientation* menu to store this gizmo orientation. A new orientation called "Bone" should show up at the bottom of the list.
- Snap the 3D cursor to the middle of the IK chain (in an arm this would be the elbow or the knee in a leg)
- Create the pivot target bone, or snap an existing bone to the 3D cursor.

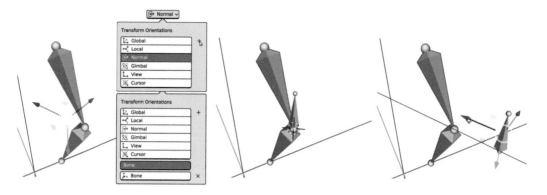

FIGURE 25.6 Precise pole target creation using snapping and normal transform orientation.

- Move the bone to be in front of the IK chain's bending direction using the corresponding axis on the move gizmo.
- Delete the custom orientation from the Transform orientation menu.

Blending

Instead of choosing between IK or FK, we can add both and let the animator choose which one they want to use.

The technique for creating an IK/FK blending setup is quite simple. We will attach the intermediate bones to a new set of bones which will be constrained to both IK and FK setups. Then we will use a custom property to control the influence of those constraints and make this new set of bones follow either IK or FK bones.

I will show the setup on an arm rig. We will need three copies of the deformation or intermediate arm bones. I like to change the bone thickness for all the chains so they are not laying exactly on top of each other. And I move them to three different bone layers. Rig the first chain into an FK setup, and the second one into an IK setup, as shown in previous sections.

The third chain will be the blend chain. Before we go further, make sure that all bones in this chain (except the first one) are connected to their parents. By doing this, the blending will look better as the bones will not move linearly, but stay on the tail of their parent and move on an arc.

Using Copy Transforms constraints, constrain each of the blend chain bones to the matching bone in the IK chain. Then repeat the process and constrain them to the FK chain. Each of the blend chain bones should now have two Copy Transforms constraints, the first one copying the IK chain bone and the second one the FK chain bone. By adjusting the influence of the second constraint, the blend chain will slide between following the IK or the FK chain.

To connect the blend chain with the intermediate bones, constrain each of the intermediate bones to the corresponding blend chain bone using Copy Transforms constraints (Figure 25.7).

Since we don't want the animators to change the IK/FK behavior by adjusting the constraints, we need to create an easy to locate and use custom property:

- Pick which bone will host the properties for this setup.
- To it, add a custom property of type Float. Set the *Min* value to 0.0 and *Max* to 1.0.
- Rename the property to something like "[name] IK/FK". Replace "[name]" with the name of the part that is being blended, e.g. "Arm L IK/FK".
- Right click on the custom property and choose *Copy as New Driver*.

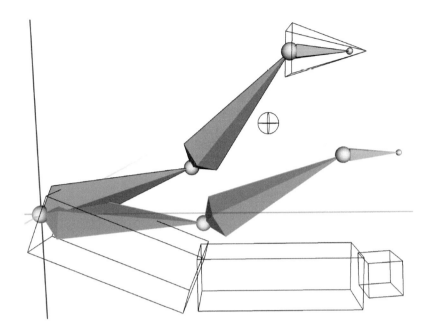

FIGURE 25.7 IK/FK blending setup with the blend value set to 0.5.

- Locate the second Copy Transforms constraint on the first bone of the blend chain. Right click on its *Influence* property and select *Paste Driver.*
- Repeat the "Paste Driver" step for every bone in the blend chain.

If done correctly, by adjusting the custom property, the blend chain will slide between the two setups. This value can also be keyframed so that the behavior can be switched at any point in the animation. We can create blending setups on any types of rigs, not just IK and FK. This will work as long as the setups contain bones that are exact duplicates of each other.

Tweak Chain

Animation is not always about believable body mechanics. There is often the need to "break" the character and create unrealistic poses that enhance the animation. Some of the previously shown setups prevent this kind of posing or make it hard to achieve, so we need an additional setup that can provide this type of control.

This is where the tweak chain, also called broken chain, comes into play. We can nest it under the setups previously shown. That way the animator can use things like IK to create the motion and further modify it without being constrained by the capabilities of the IK rig.

To rig a chain of bones with a tweak chain setup, follow these steps:

- Create a control bone at the head of every bone in the chain.
- Add an additional control bone at the tail of the last bone in the chain.
- Parent every bone to the control bone located at its head.
- Add a Damped Track constraint to every bone in the chain, use the control that is at its tail as the target.

I show the final setup in Figure 25.8. As you can see there, each control can be freely moved and rotated and the rigged bones will always point to the following control. I usually nest this setup under other setups. For example, in an IK/FK arm rig, we would have the IK bones, FK bones and the blend bones. Under the blend bones, we can add a tweak chain and parent each of the tweak controls to the corresponding blend chain bone. I would parent the intermediate bones to the tweak chain. That way, the tweak controls will follow the rest of the rig, blend between IK and FK and still be freely transformable.

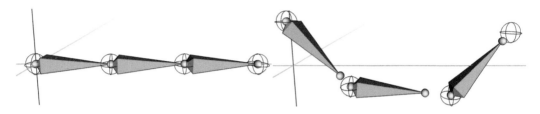

FIGURE 25.8 Tweak chain example.

26

Body Rig

Rules

At this point, we have the deformation bones and weights exist. We continue with the approach of working on the central body parts, like the spine or neck, and one side of the limbs. But before we start, I want to go over some general rules that apply to the entire body rigging process.

We are Rigging the "INT" Bones

Once the intermediate set of bones is in place, and the "DEF-" bones are connected to them using Copy Location and Rotation constraints, we will move all the deformation bones to one bone layer and disable its visibility. Unless you need to paint weights, you can forget about deformation bones as they are rigged and ready.

We can freely manipulate the intermediate bones (parenting, constraints, drivers) without worrying about keeping the rig game engine friendly. The only rule for "INT-" bones you have to keep in mind is that they must maintain the same position and rotation as the deformation bones. We can change their lengths.

Parent to "INT-" Bone

You might rig an arm, for example, and wonder where to parent the mechanism or control bones. The answer, in most cases, is to the intermediate bone of the shoulder. This rule of parenting to the last "INT-" bone of the above can apply to everything that doesn't have a clear parent.

This rule has one exception, which are IK bones or anything else that is not expected to move with the elements above it. If unsure about what to do with them, try parenting them to the world control.

Parent IK to World Control

The first control we will add to the rig will be the world control. Its purpose is to transform the entire character. We want IK bones to follow it so that it is easy to transform the entire character with only one control. Meaning that all IK bones should be parented to the world control.

Disable Deform on Non-Deform Bones

This is crucial for a smooth exporting process and avoiding any potential issues with bone weights, so make sure that all bones except those in the deformation skeleton have their *Deform* property disabled.

Duplicate

In any situation where you need new bones that are oriented the same as existing bones, make the new ones by duplicating those bones they are supposed to match. The duplicated bone will have the same properties as the original bone, and it will have the same constraints as the original. So clean up anything that needs cleaning up. Like deleting the constraints and disabling *Deform*.

DOI: 10.1201/9781003263166-26

Name Your Bones

I won't tell you how to name every single bone because it is better that you use names that are meaningful to you. Use a naming convention that you like and your best judgment to decide how to name bones. Make sure the names are descriptive so that you, or anyone else, can get a hint on the bone's purpose by looking at the name.

The Deformation Skeleton

Deformation bones must be in a separate skeleton hierarchy, meaning they are all parented to each other with the top bones parented to the root bone. They should not have any non-deformation bones as their children. We are doing this to ensure that exporting the rig will be easy as Blender will filter all non-deformation bones on export and bake animation to deformation bones correctly.

If bones are connected to their parents, they can't be moved, and we might encounter some issues later where a deformation bone is not properly following the intermediate bone because it is connected. In Edit mode, press **Alt + P** and select *Disconnect Bone*. The deformation bones are now disconnected, but still parented, to their parents. They are ready to be rigged. I like to place all deformation bones on the last bone layer, layer 31.

The Intermediate Skeleton

This intermediate set can be freely rigged with no constraints to how they are parented, constrained, or transformed in Pose mode. In Edit mode, they must keep the same transformation as their deform bone counterpart. If you need to make a change on either an intermediate or deformation bone, match their transforms after you make the changes.

This intermediate set of bones can be created by duplicating deformation bones. By duplicating them and not changing their rest pose, we know that they will always be perfectly aligned with the deformation bones. To create the duplicates, follow these steps:

- Select all deformation bones and press **Shift + D** to duplicate them.
- The duplicated bones automatically enter move mode which should be canceled using **Right Click** or **Escape**.
- With the duplicates still selected, press **M** and move them to a different bone layer, for example bone layer 15.
- If the bones disappeared, it means the selected bone layer is not visible. While holding **Shift**, click on the layer in the *Armature Properties* to make it visible. You can now enable or disable the visibility of the deformation and intermediate layers as needed.
- Disable *Deform* for all the duplicates. The fastest way to do it for all of them at once is to hold **Alt** and click on the *Deform* toggle in the *Bone Properties* panel. Changing a property while holding **Alt** applies the change to all selected objects.
- Press **Ctrl + Alt + S** and drag the mouse to make the bones slightly thicker than the deformation bones. This change won't be visible unless we set the armature to the *B-Bone* display mode, which I recommend you use at this stage.
- Change their prefix from "DEF-" to "INT-". To do this, while the intermediate bones are selected, press **Ctrl + F2** to start the batch renaming tool. Change the mode to *Bones* and set *Find/Replace* to "DEF-" and "INT-"
- Then repeat the process with *Find* set to ".001", and *Replace* left empty. This will delete the numbering suffix that was added when bones were duplicated.
- Parent the top bone in the intermediate hierarchy to the armature. Do not parent it to the root bone.

FIGURE 26.1 Finished intermediate skeleton creation stage and examples of constraints used to connect each deformation bone to its respective intermediate bone.

Finally, constrain every deformation bone to its intermediate bone using Copy Location and Copy Rotation constraints. We can leave all constraint properties at the default value. This can't be done for all bones at once and you have to do it manually for each bone. But it doesn't take long when using the **Ctrl+Shift+C** shortcut to add constraints with target. Here are the steps you need to make for every deformation bone (Figure 26.1):

- Select the "INT-" bone.
- Add the corresponding "DEF-" bone to the selection and make sure it is active.
- Press **Ctrl+Shift+C** and select Copy Location.
- Press **Ctrl+Shift+C** and select Copy Rotation.
- Clear the selection and repeat the process for every deformation bone.

World

The world control is a bone that everything else, except the root and deformation bones, will be parented to. We need it so that animators can transform the entire character by moving and rotating only one control. It is also useful for cycles that are animated in place, to test them for foot sliding.

The expected behavior for this control is that the entire character transforms with it as if it was its child. To make this control bone, follow these steps:

- Add a bone at world zero. You can first press Shift+C to reset the cursor to world zero to make sure the bone will be created there.
- Rotate it so that its axes are matching with the world axes. To be more specific: make sure you are in Edit mode, set *Transform Pivot Point* to *Individual Origins*, *Transform Orientations* to *Local* and, with the bone selected, press **R**, **X**, type in -90 and press **Return**.
- Give the bone a custom shape.

Also apply the rules we discussed earlier. Meaning disable Deform on this bone and give it a proper name like "world". And that is already it for the world control. It is just a single bone with a custom shape. See Figure 26.2.

FIGURE 26.2　The world control.

Root Control

The root control can be created by following these steps:

- Duplicate the root bone.
- Parent the duplicate to the world control.
- Constrain the original root to the root control using a Copy Transforms constraint.
- Give the root control a custom shape, rename it to something like "root_ctrl" and disable its *Deform* property.

In Figure 26.3, you can see a finished root bone and the bone hierarchy we have at this stage of the process. The expected behavior for a root control is that it transforms with the world control and can be freely moved on its own without the rest of the rig following it.

Body Control

If you analyze videos of someone performing acrobatics, you notice that the body is pivoting around a point in the belly button area. We will add control for this and refer to it as the body control.

The setup process is like how the world control was created. As a matter of fact, we can start the process by duplicating the world control and making a few adjustments. Like so:

- Select the world control and duplicate it using **Shift + D**.
- Make sure *Transform Orientations* is set to *Global*.
- Adjust the duplicate's position so that it is at around the height of the character's belly button, and the depth is around the center of the abdomen. Use only translations in Y and Z axes to ensure the bone stays in the center of the character.
- Rename the bone to something like "body" and make a unique custom shape for it.
- Parent it to the world control.

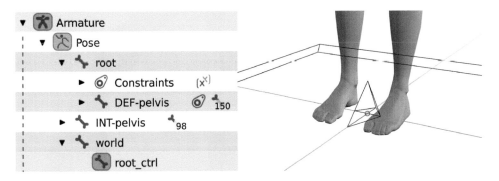

FIGURE 26.3 Finished root rig and the bone hierarchy at this stage.

Movable Pivot

The actual center of gravity constantly shifts based on the entire body's pose, so the body control might not be enough for handling all animation cases. We can fix this by adding a body rotation pivot which can be positioned by the animator as desired. We will call it the COG.

The idea behind this setup is that it can be moved freely without affecting the character's position, but if rotated, the character will rotate around it. I can give you a use case example. Imagine a character hanging on a tree branch and swinging. Meaning the entire character should rotate around the branch, which would require a lot of work if we were to animate each control individually. Instead, the COG can be placed on the branch and when rotated, the entire character will rotate around the branch.

We only need two new bones and a single constraint:

- Duplicate the body control twice and leave the duplicates where they are.
- Rename one duplicate to "COG" and the other one to something like "MCH-COG_inverse_loc".
- Parent the MCH bone to the COG bone.
- Parent the COG to the body control.
- Constrain the MCH bone to the COG using a Copy Location constraint.
- Adjust the following settings on the constraint:
 - Enable *Inverse* on X, Y and Z.
 - Set both *Target* and *Owner Space* to *Local Space*.
- MCH bone inherited the custom shape on duplication, remove it.
- Give the COG control a unique-looking custom shape.

Try moving and rotating the COG now. You should notice that the MCH bone is not moving when COG is moved, but it rotates with it. This works because of the combination of parenting and the constraint. The MCH bone will inherit all transformations from the COG but the constraint negates the movement so the MCH bone will stay where it is.

Remember the tips from the "Dealing with visual clutter" section. While creating the rig, adjust bone lengths, thicknesses, and layer assignments to make selecting, hiding, and showing the bones easier. Separating controls and MCH bones into different layers can help manage visual clutter, as shown in Figure 26.4.

Torso

Torso, or spine, rigs are where most riggers do things differently and have a preferred setup. I like to keep things simple. What I learned from observing human motion and years of animating is that all that I need for the spine is a pelvis and a chest control. Everything between those is just a smooth curve.

FIGURE 26.4 Finished body and COG controls.

FIGURE 26.5 Pelvis control (blue) and the intermediate pelvis bone (gray), with and without the custom bone shape.

Pelvis

We will start the setup by creating the pelvis control. We want to be placed at the top of the pelvis deformation bone because hips swing from this point and not from the bottom of the pelvis. Create the pelvis control by following these steps (Figure 26.5):

- Duplicate the intermediate pelvis bone to create the pelvis control bone.
- Move the control bone to the tail of the original bone.
- Disable its *Local Location* property.
- Parent the intermediate pelvis bone to the pelvis control.
- Parent the pelvis control to the MCH-COG_inverse_loc bone.
- Create a custom shape for the pelvis control and rename it to something like "pelvis".

Chest

To make the chest control, we will execute similar steps (Figure 26.6):

- Duplicate the intermediate chest bone to create the chest control bone. Do not change its position, it should be aligned with the intermediate chest bone's position.
- Disable its *Local Location* property.
- Parent the intermediate chest bone to the chest control.

FIGURE 26.6 Chest control (blue) and the chest intermediate bones (gray).

- Parent the chest control to the MCH-COG_inverse_loc bone.
- Create a custom shape for the chest control and rename it to something like "chest".

Abdomen

Last part of the torso is the abdomen area, which should work as a smooth transition between chest and pelvis. And what gives us a smooth curve-like shape, a B-Bone. We will use a base B-Bone setup to connect the pelvis and chest and then attach the two abdomen bones to it.

The base B-Bone setup can be made like so:

- Duplicate one of the intermediate abdomen bones. We will refer to the duplicate as "B-Bone".
- Place the head of the B-Bone at the same position as the head of the first abdomen bone.
- Position its tail at the same position as the tail of the last abdomen bone.
- Parent the B-Bone to the pelvis control bone.
- Constrain it to the chest control using a Stretch To constraint.
- Adjust the following B-Bone properties:
 - Set *Segments* to 10.
 - Change both *Start* and *End Handle* type to *Tangent*.
 - Assign the pelvis control as the *Start Handle Custom* target.
 - Assign the chest control as the *End Handle Custom* target.

What happens next depends on how many bones there are in the abdomen area. If there are over two, I would suggest extending the base B-Bone setup with a layered B-Bone chain setup. I have only two bones in my character, so I don't need an entire layered B-Bone setup and can save some computing power by not adding the additional two B-Bones required for it. But we need the middle control bone and will create it a similar way I showed this in the Layered B-Bones setup.

Which would go like this:

- Snap the 3D cursor to the head of the second abdomen bone. Or a bone closest to the middle of the B-Bone.
- Add a new bone and name it "abdomen".
- Align the abdomen bone's rotation with the B-Bone. Do this by selecting both, and making the B-Bone the active bone. Then press **Ctrl + Alt + A**.
- Duplicate the abdomen bone and rename the duplicate to something like "MCH-abdomen_bbone_follower"

- Select the abdomen bone and change its *Inherit Scale property* to *Aligned*.
- Constrain the MCH bone to the B-Bone using a Copy Transforms constraint and adjust the constraint like this:
 - Enable *Follow B-Bone*.
 - Adjust the *Head/Tail* property until the MCH bone's head is as close as possible to the head of the abdomen bone.
- With only the MCH bone selected, press **Ctrl + A** and select *Apply Selected as Rest Pose*.
- Parent the MCH bone to the pelvis control.
- Parent the abdomen control to the MCH bone.
- Disable *Deform* on both new bones and create a custom shape for the abdomen control.

We have the pelvis and chest controls, a B-Bone connecting the two, and an additional control at the middle of the B-Bone. The last thing left to do is to attach the intermediate abdomen bones to the entire setup. The goal with these two bones is to keep them always aligned with the B-Bone and the abdomen control and to have them inherit the twist from both the pelvis and the chest. Since there is no option to have a Copy Rotation constraint copy the rotation along a B-Bone, we will have to get creative with this setup. Here are the steps for attaching the intermediate abdomen bones to the rest of the spine rig (Figure 26.7):

- Constrain the first abdomen bone to the B-Bone using a Copy Transforms constraint and adjust the constraint:
 - Enable *Follow B-Bone*.
 - Set *Head/Tail* to 0.25.
- This takes care of the twist, but the bone has moved and we don't want that. Bring it back to the original position by constraining it to the pelvis control using a Copy Location constraint.
- The bone should always aim at the abdomen control, so constrain it to the abdomen control using a Damped Track constraint.
- Constrain the second abdomen bone to the B-Bone using a Copy Transforms constraint and use the following settings:
 - Enable *Follow B-Bone*.
 - Set *Head/Tail* to 0.75.

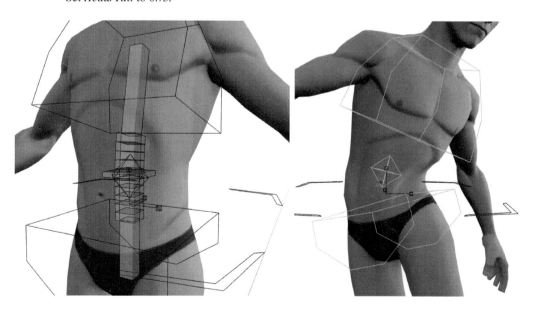

FIGURE 26.7 All torso rig bones and the finished product.

- Constrain it to the abdomen control using a Copy Location constraint.
- Constrain it to the chest control using a Damped Track constraint.

One last thing before we move on. Create a new bone that is aligned with the world. Place it at the head of INT-chest and parent it to it. Rename this bone to "MCH-rotation_reference_chest". We will use this bone as a rotation copy target for the arms, and head later.

Head and Neck

The neck and head setup is almost the same as the torso. So if you already have a good understanding of the techniques used there, you should be able to create a neck and head rig.

I will stop mentioning that the bones need to have their *Deform* property disabled since they are not meant for deformation. But keep that in mind and continue disabling it for every non-deformation bone.

Control Bones

We will start this setup by creating both the neck and head controls and the bones we will later use to create rotation isolation for these controls. Here are the steps for creating these bones:

- Duplicate the first intermediate neck bone and the intermediate head bone. These will serve as the control bones, so name them accordingly and create custom shapes for them. See Figure 26.8. I colored the two mentioned bones blue.
- Add three additional bones, oriented to the world.
- Place the first two at the head of the neck control bone.
- Place the third one at the head of the head control. These are the red bones in Figure 26.8. Name them something like "MCH-rotation_isolation_neck", "MCH-rotation_reference_neck" and "MCH-rotation_isolation_head".
- Parent them as shown in Figure 26.8.
- Disable *Local Location* on the head control. I could do the same on the neck control, but I choose to leave it enabled so that the move axes are aligned with the angle of the neck.

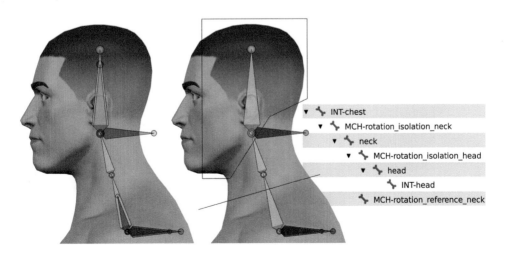

FIGURE 26.8 Neck and head control bones (blue) and their respective rotation isolation bones (red). The parent-child relationship of these bones is shown in the top right corner.

Neck Setup

To set up the intermediate neck bones, we will make a setup similar to the one used for the abdomen bones. The major difference in this setup is that the start of the neck should not rotate with the neck control (Figure 26.9).

Here are the steps for setting up the neck bones:

- Create a B-Bone that spans from the head of the first intermediate neck bone to the tail of the last intermediate neck bone.
- Set *Segments* to 10, the *End Handle* to *Tangent* and assign the head control as the end handle target.
- Leave the *Start Handle* empty and at *Automatic*.
- In Edit mode, change the B-Bone:
 - Set *Ease Out* to 0.5.
 - Depending on the B-Bone's orientation, adjust the *Curve Out X* or *Z* to align the B-Bone to the two neck bones as close as possible.
- Make the B-Bone follower and neck middle control as shown in the abdomen rig guide (two new bones around the middle of the neck, the first one constrained to the B-Bone using Copy Transforms and the second parented to the first one).
- Parent the B-Bone follower and the B-Bone to the MCH-neck_rotation_isolation bone.
- Parent the first intermediate neck bone to MCH-neck_rotation_isolation.
- Constrain it to the B-Bone using Copy Transforms. Enable *Follow B-Bone* in the constraint settings and set *Head/Tail* to 0.25.
- Constrain it to the MCH-neck_rotation_isolation bone with a Copy Location constraint, and to the neck middle control using Damped Track.
- Parent the second intermediate neck bone to the neck middle control.
- Constrain it to the B-Bone with Copy Transforms. Enable *Follow B-Bone* and set *Head/Tail* to 0.5. A smaller *Head/Tail* value, as compared to what we used in the spine, provides a more realistic twisting in the neck.
- Constrain the second neck bone to the neck middle control using a Copy Location constraint. Constrain it to the head control using a Damped Track constraint.

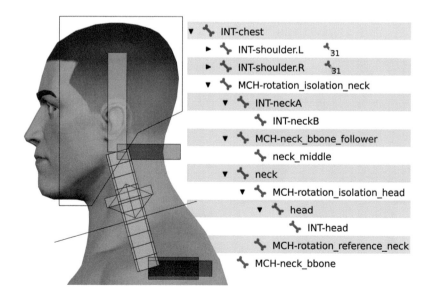

FIGURE 26.9 All neck bones required for creating the neck middle control and for connecting the intermediate neck bones to the setup.

Rotation Isolation

The chest, neck and head are forming one FK chain. This is not ideal as a lot of counter-rotating will be required to animate the head. We will create rotation isolation setups for both the neck and head so that the animator can specify how much they should rotate with the controls above them.

We have to decide which bone will host the custom properties that will control the rotation setup. I will use the world control and add five custom properties to it. See Figure 26.10 for property names. We should set all of them up like so:

- *Type* Float.
- *Min* value 0.0.
- *Max* value 1.0.
- *Library Override* enabled.

Next, we will create constraints on the MCH-rotation_isolation_neck bone. Constrain this bone using Copy Rotation constraints to these bones and in this order:

- World control.
- MCH-COG_inverse_loc bone.
- MCH-rotation_reference_chest.

We will repeat the same process with the MCH-rotation_isolation_head bone. Again, use Copy Rotation constraints and constrain it to these bones and in this order:

- World control.
- MCH-COG_inverse_loc bone.
- MCH-rotation_reference_chest.
- MCH-rotation_reference_neck.

The custom properties need to be connected to the constraints so that the animators can use them to adjust the influence of the constraints. Here is how to do this:

- Select the control that hosts the custom properties made earlier.
- Right click on the "Neck follow body" property and choose *Copy as New Driver*.
- Select the MCH-rotation_isolation_neck bone.

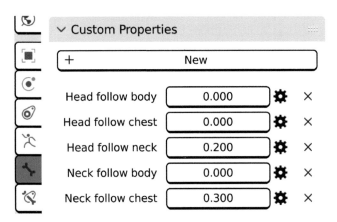

FIGURE 26.10 Custom properties required for the neck and head rotation isolation setup.

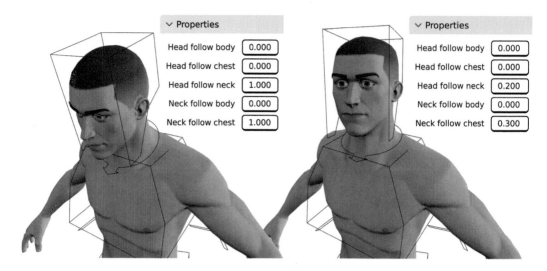

FIGURE 26.11 The finished neck and head isolation setup. By adjusting the values, the animator can define how much rotation should the neck and head inherit.

- Right click on the *Influence* value of the Copy Rotation constraint that has the MCH-COG_ inverse_loc bone as the target and select *Paste Driver*.
- Repeat the same steps and this time copy "Neck follow chest" as the driver and paste it on the *Influence* of the constraint that has "MCH-rotation_reference_chest" as the target.

The same needs to be done with the constraints on the MCH-rotation_isolation_head bone. The process is the same as above so I will just list which properties need to be copied and which constraint to paste it to (Figure 26.11):

- "Head follow body" to MCH-COG_inverse_loc bone.
- "Head follow chest" to MCH-rotation_reference_chest bone.
- "Head follow neck" to MCH-rotation_reference_neck.

Shoulder

A single control made by duplicating the INT-shoulder.L bone is enough. Name the control "shoulder.L" and parent INT-shoulder.L under it. Don't forget to give it a custom shape.

We will need a world oriented bone that we can use as the rotation reference target for the arm's rotation isolation. So make an additional bone that is aligned with the world axes. Parent it to INT-shoulder.L and position it at the head of that bone. Rename it to something like "MCH-rotation_refer-ence_shoulder.L" (Figure 26.12).

Arm and Hand

Arm animation is complex, so we need as much flexibility in the rig as possible. That is why we will layer many setups on top of each other to create the arm rig.

FK Arm

The first level of arm control will be an IK/FK blend setup. Let us begin by creating an FK arm rig. Make it by duplicating the upper arm, lower arm and hand INT bones. Use these to create an FK rig.

FIGURE 26.12 The shoulder rig.

The FK setup needs a rotation isolation setup to optionally disconnect its rotation from the rest of the rig. Create the setup by following these steps (Figure 26.13):

- Add a new world aligned bone and position it at the head of the upper arm bone.
- Rename this bone to "MCH-rotation_isolation_arm.L".
- Parent it to the INT-shoulder.L bone.
- Parent the upper arm FK bone to the rotation isolation bone you just created.
- Create custom properties on the world control and name them:
 - "Arm L follow body"
 - "Arm L follow chest"
 - "Arm L follow shoulder". Use the same settings as those described in the head and neck rotation isolation setup.
- Constrain the "MCH-rotation_isolation_arm.L" using Copy Rotation constraints to these bones:
 - World control.
 - MCH-COG_inverse_loc bone.
 - MCH-rotation_reference_chest.
 - MCH-rotation_reference_shoulder.L.
- Connect the custom properties to the constraints using driver Copy/Paste, the same way as I described it in the head and neck rotation isolation setup. Here are which properties to connect to which constraints:
 - "Arm L follow body" drives constraint with MCH-COG_inverse_loc target.
 - "Arm L follow chest" drives constraint with MCH-rotation_reference_chest target.
 - "Arm L follow shoulder" drives constraint with MCH-rotation_reference_shoulder.L target.

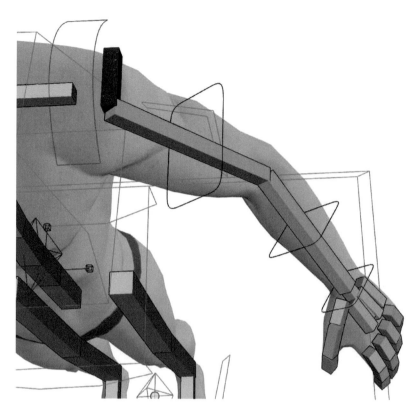

FIGURE 26.13 The FK part of the arm rig (blue rounded squares) and its rotation isolation bone (red).

IK Arm

Move the FK bones to a different layer and hide it so it is not in the way. Then duplicate the arm inter-mediate bones again and create an IK setup. Parent both the hand and elbow pole controls to the world control (Figure 26.14).

Arm IK/FK Blend

The arm intermediate bones need to be duplicated a third time to create the blend chain. Enable *Connected* on the lower arm and hand blend bones so they move in an arc as they blend between the IK and FK bones. Once you create the blend setup, parent the upper arm, lower arm, and hand intermediate bones to their respective blend chain bones (Figure 26.15).

Twist and Bend Setup

On top of the blend chain, create two layered B-Bone setups. One along the upper arm and the other one along the lower arm. Apply these notes to the setup:

- For the upper arm B-Bone setup, parent the start handle to the shoulder and the end handle to the lower arm blend bone.
- Both of its handles should receive custom bone shapes and we will use them as control bones.
- On the lower arm B-Bone chain, parent the start handle to the end handle of the upper arm B-Bone chain. This way we can adjust the elbow position using only one handle bone.
- The end handle of the lower arm chain needs to be parented to the hand blend bone we will use it as a control bone.

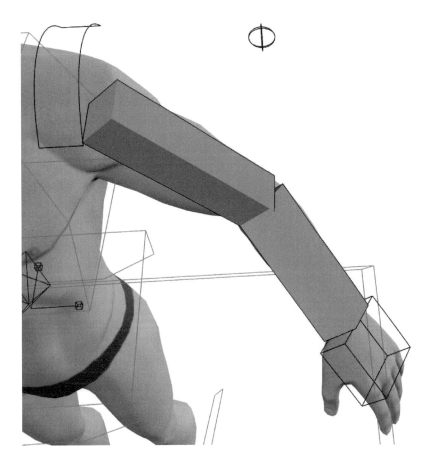

FIGURE 26.14 The IK controls and mechanism bones.

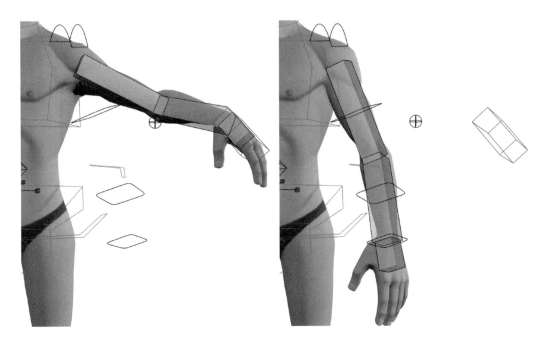

FIGURE 26.15 The finished IK/FK blend setup, with the blend value at 0.0 (left) and 1.0 (right).

Adjust the *Ease In/Out* values in Edit mode to make sure B-Bones are not bending9+ when the arm rotates. For the main B-Bones, change both Ease values to 0.0. For the layered B-Bones, the first bone needs to have *Ease In* at 0.0 and *Ease Out* at 1.0. On the second bone will have the opposite, *Ease In* at 1.0 and *Ease out* at 0.0. Do the same for both the upper arm and lower arm layered B-Bone setups.

If done correctly, what should happen when you transform the IK or FK arm controls is that the B-Bones always stay straight but they should twist with the arm. And when the tweak bones that are at the middle of the layered B-Bone setups are transformed, the arm should be deforming as a curve.

Now we can finally attach the intermediate twist bones to the entire setup. Do this for every twist bone in the upper and lower arm:

- Constrain the twist bone to the layered B-Bone closest to it.
- In the constraint settings, enable Follow B-Bone and adjust Head/Tail so that the bone moves back to its original location.
- Add a Damped Track constraint to the twist bone with the next twist bone as the target. With the last twist bone, the end handle will be the target.

Arm Rig Summary

Figure 26.16 shows the arm rig layers in an order of dependency. The top rig layer are the IK and FK control rigs, which don't have dependencies on the rest of the arm. Next is the blend chain, which completely depends on the IK/FK setups and always follows them. The upper arm, lower arm and hand intermediate bones are parented to the blend chain. As well as the B-Bone handles, which are made into controls. The handles transform the B-Bones, which then transform the intermediate twist bones.

There is quite a lot to keep track in the arm. My advice is to stay organized at all times during the process. As soon as you create new bones, give them proper names, adjust their thickness and, if possible, length. Group them using armature layers.

After you duplicate the intermediate bones, move the duplicates to different armature layers and hide all the layers you don't need. Once you are done with IK, hide the layer that contains the IK bones and repeat the process for the FK rig. Then create the blend chain on a third layer, and once that is done, you can forget about the IK and FK layers for a bit and focus on creating the B-Bone setups. Once those are ready, hide the blend chain and work on constraining the twist bones to the B-Bones.

It might seem complex when doing it for the first as there is a lot to keep track of. If you are struggling with this setup, try making simpler rigs first. Maybe just an IK arm without nothing else. Then an FK arm and continue adding more layers of complexity until you get to something similar to what I have shown here.

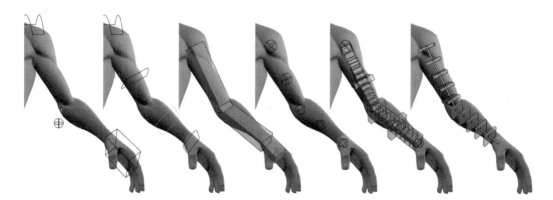

FIGURE 26.16 All arm rig components. From left to right: IK controls, FK controls, the blend chain, tweak controls, the layered B-bones, twist bones (intermediate and deformation).

Hand

The main hand transformation is being handled by the IK and FK rigs we made earlier. What is left are the metacarpal bones, fingers and thumb. Let's start with the metacarpals first.

Metacarpals

We will make a control that allows quick posing of all metacarpal bones at once and a control for each of them for those who prefer individual control.

To make the individual controls, simply duplicate the intermediate metacarpal bones and parent the intermediates to the duplicates. The duplicates need to also be named properly and receive custom shapes.

In most cases, the metacarpal bones rotate together. To see this, make a fist with your hand and look at the back of the hand. Now clench and unclench the fist. You will notice how the pinky and ring finger metacarpals move together, with the pinky rotating about double as much as the index. We can automate this behavior using a couple of Copy Rotation constraints. Like this:

- Duplicate the pinky metacarpal control bone. We will call this control "metacarpals" for simplicity.
- Move it away from the hand so it sits right at the side of it.
- Give it a custom shape.
- Add Copy Rotation constraints to the pinky, index, and middle finger metacarpal bones with the metacarpals control as the target. Adjust the constraints like so:
 - Set the Mix mode to Add.
 - Set both Target and Owner space to Local Space.
 - Adjust the Influence of the constraint on the ring and middle finger constraints to your liking. I set mind to 0.5 for the middle finger and 0.2 for the index finger.

Fingers and Thumb

The last part of the arm and hand rig is the thumb and fingers. Add a single control to each of the digits by duplicating the intermediate bones and parenting them to the duplicates (Figure 26.17).

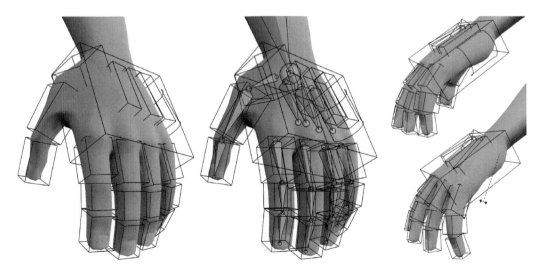

FIGURE 26.17 The finished hand bones rig.

Leg

FK Leg

I make the FK leg rig the same way as the arm FK rig, which is a simple FK chain with rotation isolation. To create the FK controls, duplicate all intermediate leg bones, including the toes, and create custom shapes for the duplicates.

For FK leg rotation isolation, we need a world oriented rotation target that is parented to the hips. Just like the one we made earlier for the chest. And of course we need the bone that will copy its rotation. To create the FK leg rotation isolation setup, follow these steps (Figure 26.18):

- Add a new world oriented bone, move it to the head of the intermediate hips bone and name it "MCH-rotation_reference_hips". Parent it to the intermediate hips bone.
- Add a new world oriented bone, move it to the head of the upper leg bone, name it "MCH-rotation_isolation_leg.L".
- Parent the top upper leg FK bone to the MCH-rotation_isolation_leg.L bone.
- Following the usual rotation isolation creation process, make custom properties and constraints between MCH-rotation_isolation_leg.L and these bones:
 - world (does not need a custom property, just the constraint).
 - MCH-COG_inverse_loc.
 - MCH-rotation_reference_hips.

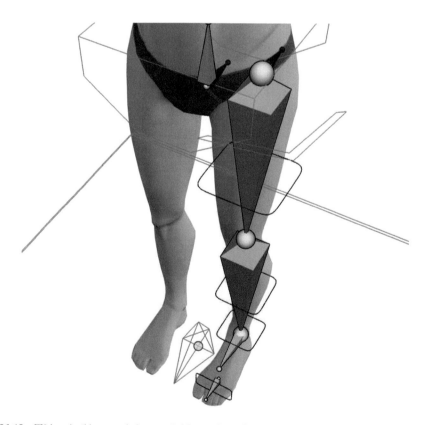

FIGURE 26.18 FK leg rig (blue rounded squares), hip rotation reference and FK rotation isolation bones (red), and the intermediate bones (gray).

IK Leg

There is something we need to take into consideration for the IK target. When you make the IK leg rig, don't use the IK foot control as the IK constraint target. Instead duplicate it, parent the duplicate to the control and use the duplicate as the IK target. This is required for the inverse foot setup, as it needs control over the IK target so the foot control and IK target can't be the same bone. I will refer to this IK target bone as "MCH-foot_IK.L" later in the inverse foot setup. See Figure 26.19.

Leg IK/FK Blend

When I was explaining how to set up a blending chain, I mentioned that all bones, except the first blend bone, need to be connected to their parent so that they move on an arc and not in a straight line. This would break the toes because the head of the toe bone is not in the same position as the tail of its parent.

It is easy to fix this by adding an extra bone above the blend toe bone and placing its tail at the location of the blend toe bone's head. Parent the toe bone to this new bone and set it as Connected. We should parent the additional bone to the foot blend bone. Nothing else needs to be done with this extra bone. It is just there so we can set the toe bone to be connected to it. We make the rest of the blend setup as described in the "Rig building blocks‖ chapter. See Figure 26.20.

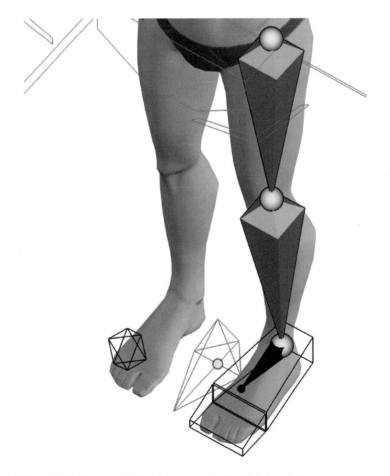

FIGURE 26.19 IK leg rig. The IK target (red bone) is parented to the IK foot control.

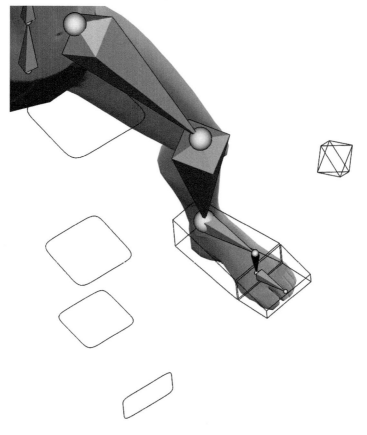

FIGURE 26.20 Leg blend chain.

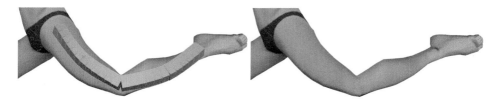

FIGURE 26.21 The layered B-Bone chains used in the leg rig.

Twist and Bend Setup

I rig the twist bones using two layered B-Bone setups. I create the first one across the upper leg with its start handle parented to the intermediate hip bone and the end handle to the intermediate lower leg bone. The second B-Bone setup spans across the lower leg. I parent its start handle to the end handle of the first B-Bone setup and hide it. I parent the end handle to the intermediate foot bone.

We constrain the twist bones to the secondary B-Bones using Copy Transforms constraints, and each of them has a Damped Track constraint with the following twist bone as the target. The last twist bone uses the lower leg B-Bone's end handle as the Damped Track target. This setup is the same as the one we did for the arm twist bones (Figure 26.21).

Inverse Foot

We commonly add the inverse foot setup to leg rigs. It extends the IK leg rig and helps with animating feet when they are on the ground and easily maintains ground contact. For example, in a character walk

animation, without an inverse foot rig, the animator would have to add many keyframes to keep the foot stable on the ground as it is pushing the leg up. But with the inverse foot rig, an additional control can rotate the ankle up while the front part of the foot stays in place. When the foot is lifted, the transition between using the inverse foot to using the regular foot controls can be messy, but it is a compromise that most animators are used to making.

Adding the Bones

The inverse foot setup requires nine additional bones. Create the bones and name, parent and transform them, as shown in Figure 26.22. The three bones that don't have a number next to them are those from the IK setup. Namely, the IK foot, toe and the additional bone we created as the leg IK target. All the new bones are world oriented.

This is what the goal is with placing each of the new bones:

1. Position it at the bottom of the foot, around one third of the foot's length. It will serve as the twist control.
2. A duplicate of the previous bone. They should be positioned and oriented exactly the same.
3. Place it at the inner edge of the foot.
4. Place it at the outer edge of the foot. This and the previous bone will tilt the foot to the side.
5. Put it at the heel of the foot. Will rotate the foot around the heel.
6. Needs to be at the tip of the toes. Will roll the foot from the toes.
7. Snap it to the head of the intermediate toe bone. Rolls the foot at the ball of the foot.
8. Does not have to be precise, just place it above the foot, close to the front. This bone will control the heel, ball and toe roll.
9. Also, does not need precision, put it slightly behind the foot. It will control the foot tilt.

I encourage you to rotate each of the inverse foot MCH bones to see what they are doing. The parenting hierarchy is the main reason this setup will work as it should. We could leave the setup as is and make each of the bones into control bones with one specific function, but this would be tedious to animate and keep track of. Instead, we will connect all of them to "foot_twist.L", "foot_roll.L" and "foot_bank.L". A single rotation axis on each of those controls will transform all the other inverse foot bones.

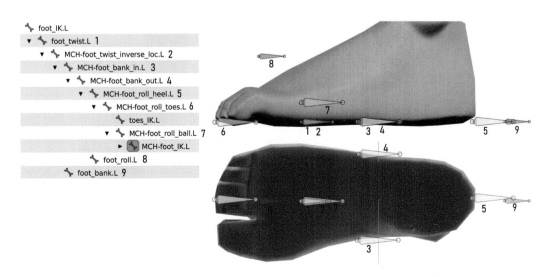

FIGURE 26.22 Inverse foot bones.

Twist

The first control we will set up is "foot_twist.L", which I will refer to as just "twist". Its purpose is to provide the means to rotate the foot from different spots. If someone is standing on their toes and twists their foot, this is the control an animator would use to animate that instead of the foot IK control, which would rotate the foot from the ankle's position. Instead of that, this control can be positioned at the front of the foot and used to twist the foot from there. The setup is very similar to the one we created for the body inverse foot control.

To set up the twist control, do the following (Figure 26.23):

- Add a Copy Location constraint to "MCH-foot_twist_inverse_loc.L".
 - Set the *Owner* and *Target* space to *Local Space*.
 - Enable *Inverse* on X, Y and Z.
- Create a custom shape for "foot_twist.L"
- Change its rotation mode to XYZ.
- Lock all of its transformation channels besides Location Y and Rotation Z.

Bank

This control will allow the animator to rotate the foot from side to side. We can easily create the setup by using Transformation constraints and setting them up so that when the control rotates from 0 to 90 in Y the outer bank bone does the same. And we repeat it with the inner bone but from 0 to -90. Set *Owner* and *Target* space to *Local Space* for both constraints.

Here are the steps for creating the setup (Figure 26.24):

- Constrain the "MCH-foot_bank_out.L" bone to the "foot_bank.L" bone using a Transformation constraint.
 - Change the constraint's *Owner* and *Target* spaces to *Local Space*.
 - Set *Map From* to *Rotation*.
 - Set *Y Min* to 0.
 - Set *Y Max* to 90.
 - Change *Map To* to *Rotation*.

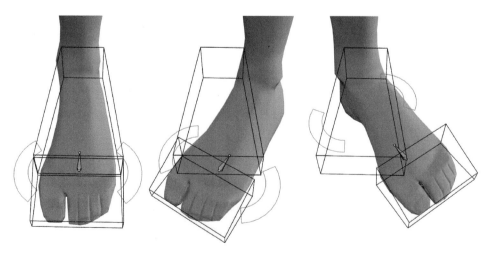

FIGURE 26.23　The inverse foot twist control.

- Set *Y Min* to 0.
- Set *Y Max* to 90.
- Repeat the process for "MCH-foot_bank_in.L" and set *Min* and *Max* values to -90 and 0, respectively.

Roll

I have intentionally saved the most fun ones for the end, the rolls. To further make the animator's life easier, a single control will control those. The behavior we want to achieve is that which can be observed in a foot during a walk. When the foot lands, the heel touches the ground first and becomes the point around which the foot rotates until it fully lands on the ground. Then the foot rotates from the ball, and at a certain angle, it rotates from the tip of the toes. The ball rotation is reversed as the foot flattens again. You can see this illustrated in Figure 26.25.

In order to make this as flexible as possible, we should give the animator the option to define at which angle will the foot stop rolling from the ball and start rolling at the toes. For that, create a custom property on a bone. I will create it on the world control as I have done so with all the other custom properties. Here are all the steps for creating the property correctly:

- Add a custom property on a control of choice.
- Name the property "Leg L Roll Angle".
- Set *Type* to *Float*.
- *Default* to 30.0.
- *Min* to 0.0.
- *Max* to 90.0.
- Enable *Is Library Overrideable*.

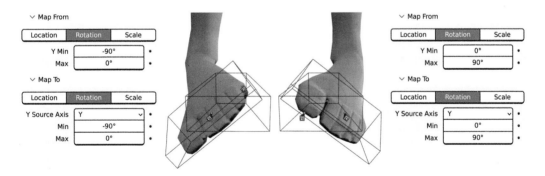

FIGURE 26.24 Foot bank behavior and the constraint map values.

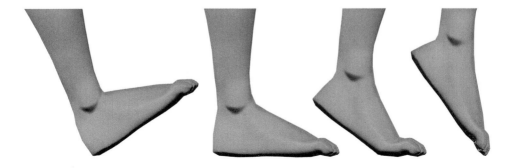

FIGURE 26.25 Foot roll motion example.

The control bone that we will use for the rest of the setup is "foot_roll.L". Create a custom shape for it. Let us begin the rest of the setup by connecting it with the heel roll. Do the following:

- Add a Transformation constraint to the "MCH-foot_roll_heel.L" bone with "foot_roll.L" as the target.
 - Set the *Target* and *Owner* space properties to *Local Space*.
 - Set *Map From* to *Rotation*.
 - Set *X Min* to -90.
 - Leave *X Max* at 0.0.

That is it for the heel. We will handle the rest of the setup using three Transformation constraints and drivers. First constraint will rotate "MCH-foot_roll_ball.L" from 0.0 to the angle defined by the custom property we made earlier. When it reaches that angle, a second constraint on this bone will start rotating it back to zero so that the foot becomes flat again. In the meantime, the third transformation constraint will start rotating the "MCH-foot_roll_toes.L" bone.

The "MCH-foot_roll_ball.L" bone requires two Transformation constraints and four drivers. Three drivers are identical, and the fourth is the same except for having a different Expression. See Figure 26.26. Here is the step-by-step process for creating this setup:

- Constrain the "MCH-foot_roll_ball.L" bone to "foot_roll.L" using a Transformation constraint.
 - Set the *Target* and *Owner* space to *Local Space*.
 - Change both *Map From* and *Map To* to *Rotation*.
- Right click on the "Leg L Roll Angle" custom property and select *Copy as New Driver*.
- Go back to the constraint and right click on the *X Max* value and select *Paste Driver*.
- Right click on the same property again and choose *Edit Driver*.
 - Change the driver *Type* to *Scripted Expression*.
 - In the *Expression* field type "radians(Foot_L_roll_angle)" and leave the driver editor.
- The driver is the same for the *Map To X Max* value, so right click on the first *X Max* property and choose *Copy Driver*.

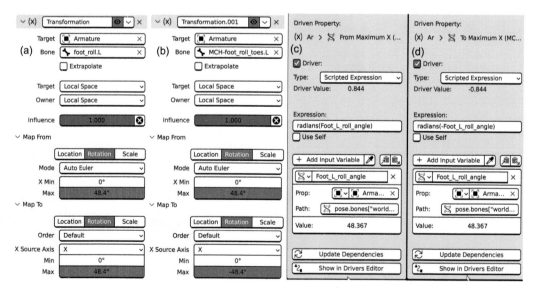

FIGURE 26.26 The constraints and drivers used to create the ball roll behavior.

- Paste it on the *Map To*'s *X Max* property by right clicking and selecting *Paste Driver*.
- The first constraint is finished (Figure 26.26a and c). To create the second one, hover the mouse over the first constraint and press **Shift + D** to duplicate it.
- Adjust the duplicate constraint like so:
 - Change the target *Bone* to "MCH-foot_roll_toes.L".
 - Right click on the *X Max* value in the *Map From* section and *select Paste Driver*.
 - Right click on the *X Max* value in the *Map To* section and select *Paste Driver*.
- The *Map To* driver needs to be adjusted slightly. Right click on the property and select *Edit Driver*.
- Change its expression to "radians(-Foot_L_roll_angle)" (Figure 26.26b–d).

The last piece of the whole inverse foot puzzle is the toe roll. We will again use a Transformation constraint to set it up (Figure 26.27a). This bone should start rotating only when the control bone reaches a rotation value defined by the custom property. Meaning we have to connect the custom property to the constraint's *X Min* value using a driver. The driver is the same as the one used in the ball roll setup so you can copy/paste it from there (Figure 26.27b). For the *X Max* value, we will use a similar driver which just adds +90.0 to the value defined by the custom property (Figure 26.26c). Copy and paste the driver from the X Min property and change the Expression to "radians(Foot_L_roll_angle_90)". Set the *Map To*'s *X Min* and *X Max* values to 0.0 and 90.0 and the inverse foot is done.

As you might have noticed, we are converting the custom property to radians in all the driver expressions. This has to be done because even though the constraints display angles in degrees, this is just for easier readability and they are actually radians and require the driver to provide the value in radians.

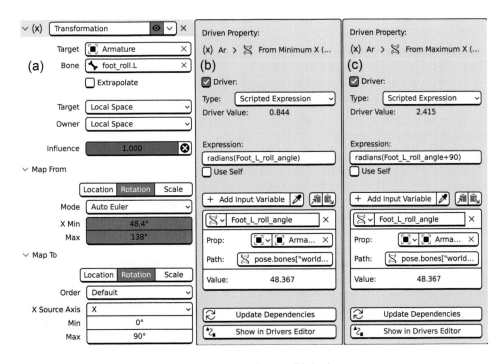

FIGURE 26.27 The constraints and drivers used to create the toe roll behavior.

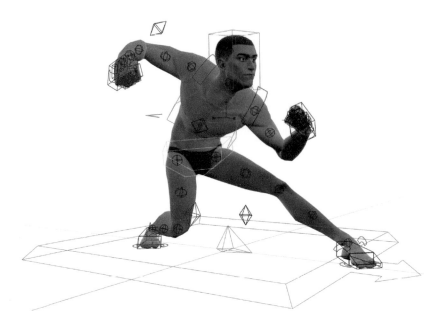

FIGURE 26.28 The finished and posed body rig.

Symmetrize

The body rig is done at this point and can be transferred to the right side. We will do this in a few steps. First of those involves creating the bones and constraints using Symmetrize. Follow these steps:

- Make all bone layers visible.
- In Edit mode press **Alt+H** to make sure no bones are hidden.
- Select all bones on the character's left side.
- Execute the *Symmetrize* operator, which can be found by pressing **W** to display the *Armature Context Menu*.
- Change the operator's *Direction* value to *+X to -X*. This is done in the small window that shows up in the bottom left corner of the 3D view.
- Press **Ctrl+Z** to undo the *Symmetrize*.
- Execute the *Symmetrize* again. This is a safety measure as *Symmetrize* can produce errors when executed with the *Direction* value set to *-X to +X* by default.

Test the newly created controls and check if anything is not behaving as expected. For example, a limb is bending in the wrong direction, the constraints are the usual suspects and might need to be tweaked. For example, a different Pole Angle value might be needed in IK constraints, or axis values in tracking constraints might need to have the positive and negative direction swapped.

 The drivers do not get mirrored and have to be created manually. I usually do this by copy/pasting drivers from the left side and adjusting them so they use the correct variables, or I make them from scratch. Of course, the drivers which are controlled using custom properties require the custom properties to be made first. Make those and connect them to drivers. And with that, the entire body rig should be fully functional (Figure 26.28).

27

Correctives

DOI: 10.1201/9781003263166-27

Introduction

If pushing weights, bone placement, and topology to their limits still doesn't yield good results in areas like shoulders, elbows, and hips, additional "corrective" bones can be added if the budget permits.

Corrective bones are transformed based on a certain input parameter. This can be something like a change in a bone's transformation, or the angular difference between two bones. This input is processed either directly by a constraint or using a driver which controls a bone's transformation channel or the influence of a constraint.

To ensure consistent function in the game engine, we can either bake animation to all deformation bones, including correctives or set up correctives in the engine using an angle or pose reader to make them usable with non-keyframed animation such as ragdoll physics.

Angle Reader

The idea behind this setup is that we will measure how much the rotation between two bones changes and use that value to transform a bone using one or multiple Transformation constraints. Since a bone's rotation caused by its parent does not count as local rotation, I often find it easier to add a new bone and parent it in a way I know will give the correct results.

To create the setup, identify the two bones you want to measure the angle change between (see Figure 27.1 for reference). In the arm rig, these two bones would be the upper arm's last twist bone and the lower arm's first twist bone. Then follow these steps:

- Duplicate the bone that is lower in the hierarchy out of the two.
- Rename the duplicate to something like "MCH-angle_reader_part.side". Replace "part" with the name of the body part the angle is being read for and "side" with the actual side identifier (e.g. "MCH-angle_reader_elbow.L".
- Parent the duplicate to the other bone that is part of the angle reader. Not the one that was duplicated, the other one (see Figure 27.1). The red bone is the MCH bone and it is a child of the blue bone.
- Constrain the duplicate using a Copy Rotation constraint to the bone the duplicate was created from. If any of the two bones now rotate, this will apply to the MCH bone as local rotation.

Elbow and Knee Correctives

For elbows, or knees, we add two corrective bones, one for the outer side and one for the inside, and parent them to the first deformation bone of that segment, typically the first lower arm twist bone in my rigs. Using the method shown earlier, create an angle reader which will be used to drive the transformation of these two bones.

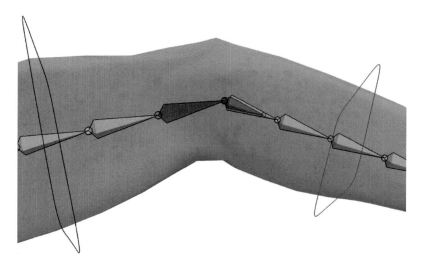

FIGURE 27.1 Angle bone (red). Blue bone is its parent, and it is constrained to the bone it is laying inside of.

FIGURE 27.2 Example of elbow and knee corrective bone placement.

Elbow Bones

I choose not to add intermediate bones for correctives. Since the corrective bones don't have any child bones, there is not much that can go wrong as long as they stay parented to other deformation bones (Figure 27.2).

Corrective Bone Weights

Sharp weight transitions are unnecessary in areas where correctives prevent volume loss. I recommend you smooth the transitions between existing weights first, then add weights to the corrective bone, assigning a maximum weight of 0.3–0.5 for a balanced transformation with other deformation bones (Figure 27.3).

Bringing it Together

With the corrective bones in place and the angle reader created, we can finally connect the two using Transformation constraints. This is how I approach this:

- Add a Transformation constraint to the outer elbow corrective, with the angle reader as the target.
- Change both spaces to *Local Space*.

- Set *Map From* to *Rotation* and *Map To* to *Location*.
- In the *Map From* section, change the *Max X* (or whichever axis the angle reader is rotating when the elbow bends) value to 90. This means that when the angle reader reaches a rotation of 90, the corrective will be at its *Max* value.
- Set *Mode* to *Swing and Y Twist*, or whichever is the best fit for your rig. If you are unsure, once the *Map To* values are set, experiment with different modes and see which gives the most consistent results.
- Now rotate the elbow by about 90 degrees. This will trigger the Transformation constraint and allow us to see what is happening with the correctives.
- In the *Map To* section, change the *X, Y* and *Z Source Axis* to *X*. Yours might be a different axis depending on the lower arm bone orientations.
- Start adjusting the *Max* values on different axes and watch what it does with the elbow. Adjust it until the elbow is pulled out to counter the volume loss and creates an appealing elbow shape.
- Continue changing the rotation of the lower arm and tweaking the constraint until you are happy with the result.

Repeat the same process for the inner elbow corrective. If you want to additionally use the corrective bone's rotation and scale, simply duplicate the constraint and change the Map To mode to Rotation or Scale (see Figure 27.4 for reference). Notice how corrective bones have to move quite a lot as they have little influence over the mesh.

When the angle reader is rotating in the negative direction, the constraint might not work if we set the target angle in the *Max X* property. To fix this, swap all the *Min* and *Max* values in both *To* and *From* sections.

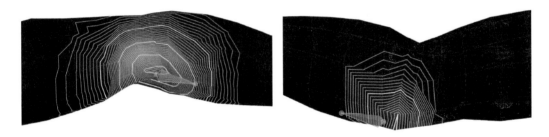

FIGURE 27.3 Example of weighting of corrective bones.

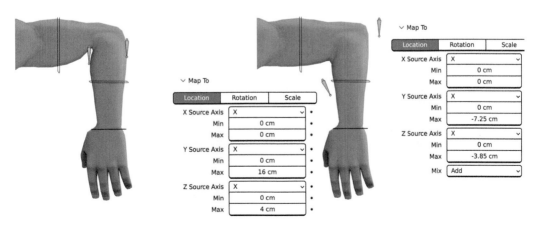

FIGURE 27.4 Elbow corrective bones and an example of how their transformation constraints might look.

FIGURE 27.5 Comparison of the shoulder area with corrective bones (character's left side) and without (his right side).

Shoulder and Hip Correctives

If you have any resources for adding deformation bones, shoulders is where I would put them. Ideally, five additional bones can be added for optimal correction, with four placed above, below, in front, and behind the upper arm joint to correct motion in all directions. The fifth bone goes between the shoulder and neck to simulate muscle compression and upward push (see Figure 27.5 for an example). I left the character's right side without correctives so you can compare the look between corrected and not corrected.

In the example shown in Figure 27.5, the upper arm is being corrected with the help of an angle reader that is parented to the shoulder and copies the rotation of the upper arm's first twist bone. The corrective that is close to the neck is using a different angle reader, which is parented to the chest and copies the rotation of the shoulder bone.

Hips are like the shoulder area, meaning you would want to correct four sides instead of just front and back.

28

Facial Rigs

Introduction

We will look at two types of approaches to facial rigging, FACS and what I call "freeform". Both can provide great results and the one that is best for your project depends on different factors like what the game engine is better at optimizing and what else needs to be shown on screen at the same time, and of course which technique is more suitable for the style of character and animation.

Types of Facial Rigs

FACS

FACS (Facial Action Coding System) breaks facial movements into AUs (contractions or relaxations of muscles), which are turned into poses or shape keys for animators to use. This systemic approach is good for real-time tracking and retargeting, but limited to predefined shapes. If there is no shape that makes the entire eye larger, which there usually isn't because it is not what human eyes do, then the animator can't do that kind of animation. This means this is not ideal for stylized and exaggerated styles of animation.

We can use bones instead of shape keys to create this rig, giving the option to transform bones freely on top of the motion created by actions. Though the poses might not be as good due to the limit of bones and influences we can use. To make a bone-based setup, add bones to different parts of the face, create each AU by posing and key framing bones in actions, and set up Action constraints to trigger these AU actions. This is my preferred method for creating simple facial rigs (Figure 28.1).

Freeform

This setup aims to provide animators with complete freedom to shape the face, rather than replicating realistic muscle contractions. Therefore, there is no concept of predefined facial expressions. This rig is ideal for stylized characters that require more flexibility in posing and animation. However, it requires more artistic knowledge to achieve polished and appealing results.

This rig type includes deformation bones placed on facial features that can be rigged using various techniques such as attaching them to B-Bone chains, using Action constraints, or using single controls and constraints (Figure 28.2).

Standard ARKit Shapes

AR apps and auto facial tracking have made action units a popular choice for facial rig creation. The standardized set of AR shapes is called ARKit shapes.

The ARKit set of shapes comprises 52 shape keys and they cover most of the broader facial expression with a bit more emphasis on the mouth. The full list of ARKit shapes, as well as visual examples, can be

DOI: 10.1201/9781003263166-28

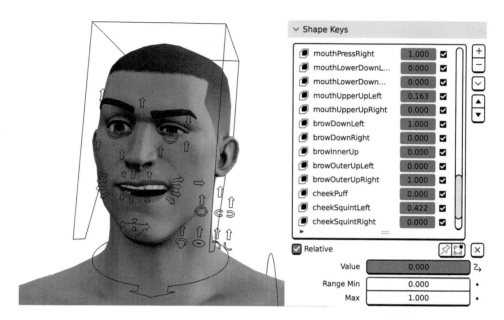

FIGURE 28.1 FACS-based rig, created using shape keys and animated via bones and driver connections.

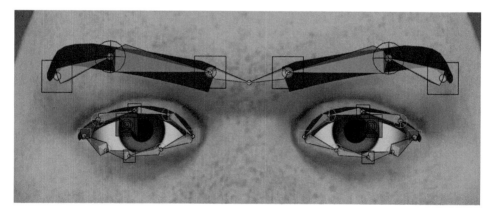

FIGURE 28.2 Example of facial rigging using bones.

found in Apple's official developer documentation. Here is the address that will take you there, as well as an address to an unofficial page, which provides a slightly better overview of the shapes:

- https://developer.apple.com/documentation/arkit/arfaceanchor/blendshapelocation
- https://arkit-face-blendshapes.com/

To create an ARKit-based rig, model the necessary shape keys and animate them by adjusting their Value property. Use bones and drivers to connect the shape key values to the rest of the rig.

Shape Creation Using Audio2Face

Nvidia's Omniverse has Audio2Face, which automates creating ARKit shape keys without requiring much FACS knowledge or character modeling. We can download a custom Blender build through Omniverse that has an add-on to prepare the mesh, export and import the finished one back into Blender.

FIGURE 28.3 Nvidia Omniverse's Audio2Face tool.

A video guide for how to use the add-on and process the mesh in Audio2Face can be seen here: https://youtu.be/PzOK46eKcaw.

Depending on your situation, the tools mentioned here can be free or might require a subscription. Refer to Nvidia's license agreement to find out which license type is required for your project (Figure 28.3).

Shape Key Transfer

Facial meshes often have separate pieces for features such as eyebrows and eyelashes. To simplify creating shape keys for these additional pieces, the shapes can first be created on the face mesh and then transferred over.

The shape-transferring process happens in two stages. Before the first stage can start, we must separate the additional meshes into their own object. Do this by selecting the mesh faces you would like to separate and press **P** to bring up the *Separate* menu. From this menu choose *Selection*.

The first stage involves "binding" the additional meshes to the face mesh so that they follow its motion. Make sure all Shape Keys have their *Value* set to 0.0. Add a Surface Deform modifier to the object that contains the separated mesh and set the head mesh as the target. Then press the *Bind* button.

In the second stage, we will transfer the shape keys to the additional meshes by saving the results of the Surface Deform modifier as shape keys. This functionality is built into modifiers and exists on many other ones besides Surface Deform. Here is a step-by-step explanation of how to create the shape keys from the modifier:

- Select the head mesh.
- Choose a shape key that you want to transfer and set its *Value* to 1.0.
- Select the object which contains the additional meshes.
- In the modifier stack, click on the chevron icon in the Surface Deform modifier's header and choose the *Save as Shape Key* option. The *Apply as Shape Key* option has the same effect but

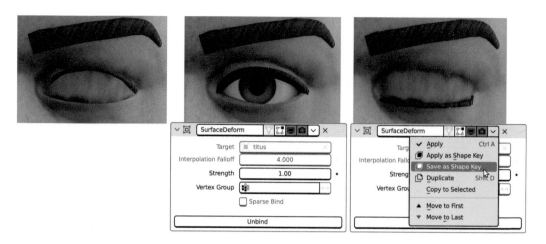

FIGURE 28.4 Shape key transferring process using the surface deform modifier.

it additionally deletes the modifier. In our case, we want to reuse it for multiple shapes so we don't want to delete it yet.

- Switch to the *Mesh Properties* tab and find a new shape key that was created from the previous operation.
- Name this shape key exactly the same as how the same shape key on the head is named.
- Set the *Value* of this shape key to 0.0 on both objects.
- Repeat the same process for all shape keys that affect the additional meshes. If a shape key is deforming a different area of the head it can be skipped.
- Once all shape keys are created, delete the modifier.

The additional meshes can be joined back together with the head mesh. If all shape keys on the additional mesh have the same names as those on the head, they will be merged automatically. The joining of multiple mesh objects into one is done by selecting all of them and pressing **Ctrl+J**. One of them has to be set as the active object. All other objects will be joined into the active one (Figure 28.4).

Connecting Shapes to Bones

I usually do this by driving the shape key Values using positions of control bones. Parent these bones to the head control.

Direct Connection

To map a bone's transformation channel to a shape key's value, right-click on the channel and choose "Copy as New Driver." Paste the driver on the shape key's Value property by right-clicking and selecting "Paste Driver (Figure 28.5).

Inverted Connection

Let me start this one by giving an example. Let us say that we want to use one bone to control the eye blink and eye wide shapes. When the bone moves from 0.0 to 1.0 in the Z channel, we want the eye-wide shape's value to go from 0.0 to 1.0 as well. This can be achieved by using a direct connection as previously explained.

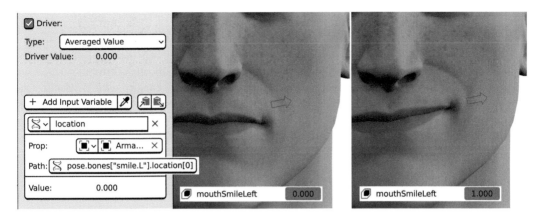

FIGURE 28.5 Bone to shape key value connection via drivers.

To create a seamless transition between eye wide and blink, we want to connect the Z channel's value so that when it goes in the other direction, namely from 0.0 to -1.0, the blink shape key's value goes from 0.0 to 1.0. Meaning we need to invert the connection. To create this, follow these steps:

- Create a direct connection between the two properties by using driver copy and paste.
- After the driver is pasted, right-click on the value and choose *Edit Driver*.
- Change the driver's *Type* to *Expression*.
- The *Expression* field should already be pre-filled with the input variable's name. If it is not, write it in the *Expression* field.
- To negate the value, add a minus in front of the variable name in the expression field. The final expression should look something like "-location".

Adjusted Motion Range

Depending on the character's size and the unit scale, it can happen that the bone needs to be moved far until the shape value goes to 1.0. The opposite is also possible, i.e. transforming the bone only slightly makes the shape reach the max *Value* of 1.0. We can adjust this relationship by changing the driver's expression.

To adjust the relationship between properties, set the driver to Expression type and multiply the variable by a value larger than 1.0 for a stronger reaction, or smaller than 1.0 for a weaker one. For instance, if the expression is "location * 0.5", the bone has to move twice as much for full effect. A value of "location * 2" doubles the sensitivity of the shape key to the input variable's changes.

Shape Combo

To automate the activation of a shape key based on the activation of other shape keys, we can use a Minimum Value type driver. A common example is the mouth closed shape key, which is activated only when the jaw open shape key is also activated, countering the motions of the lips.

The setup requires two driver input variables. You can create the driver with the first variable by using the Copy as New Driver and Paste Driver technique. Once the driver is created, edit it to add the second variable. Set the driver type to Minimum Value. The driver will output var1 or var2 depending on which of them is smaller. That way the mouth closed is activated only as much as the jaw opens.

Eye Rotation

Instead of using shape keys, eyeball rotation can be controlled using bones and Damped Track constraints, a common approach in facial rigging that allows animators to easily set the eyes' target location.

For the eyes to rotate, a bone needs to be placed at its center. The technique used is selecting the eyeball mesh and snapping the cursor to it, then adding or snapping a bone to that location. Parent the eyeball bones to the head bone, weight paint them and name the bone DEF-eye.L. The right side is automatically named DEF-eye.R when the rig is symmetrized (Figure 28.6).

Follow these steps to create the eye rig:

- Duplicate the eye bones to create intermediate bones.
- Parent the intermediates to the intermediate head bone.
- Constrain the eye deformation bones to their respective intermediate bones using Copy Rotation and Copy Location constraints.
- Duplicate the intermediate bones to create the control bones.
- Move the control bones forward to be about 1m away from the character.
- Add an additional bone directly in between the two eye controls.
- Parent the individual eye controls to this new main eye control.
- Parent the main eye control to the world control.
- Add a Damped Track constraint to the left eye intermediate bone with the left eye control bone as the target.
- Do the same for the right eye intermediate bone.

The eyes should now always point at the eye controls, which can be freely moved to any desired location.

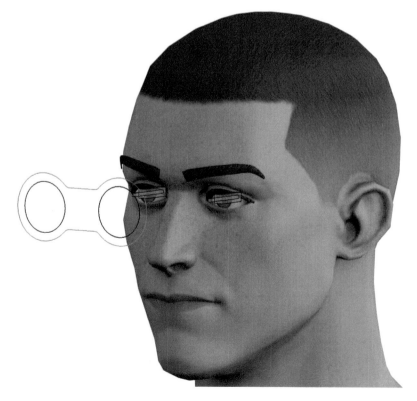

FIGURE 28.6 Damped track constraint-based eye rig.

Facial shape key sets usually come with shapes made for different eyelid rotations. For example, the eyeLookDownLeft shape which should activate when the left eye rotates downwards. To set it up:

- Make a driver on the shape's Value.
- Add a Transformation Channel type variable to it. Assign the armature as the Object and the correct eye intermediate bone as the Bone.
- Set the Type to the rotation channel that is used to rotate the bone down, Mode to one of the Swing and axis Twist types and space to Local Space.
- The value might need to be scaled in the Expression to make the shape react more or less to the input rotation.

29

Cloth and Hair

Introduction

The approach to rigging cloth and hair may require different solutions depending on how they will be animated in the engine. If they are going to be fully simulated, then bones might not be needed at all. Another approach is to use physics simulation, but on the bones themselves and not on the mesh. You could even blend between keyframed animation and physics simulation.

Bone Distribution

Rotating evenly spaced bones will not create interesting looking shapes, instead, it will look mechanical and even. It is better to create bones so that their lengths resemble a Fibonacci sequence (see Figure 29.1) for an example and notice how much more energy and motion the example with uneven bone lengths has.

Example Setup

In Figure 29.2 you can see an example of how I would approach a cloth, and hair, rig. It consists of four layers of bones. The first layer comprises the blue bones that have a boxy custom shape applied to them. This is a simple FK chain made by parenting each bone to the one above it. The second layer are the red bones with spherical custom shapes. These are rigged into a tweak chain setup. I created them

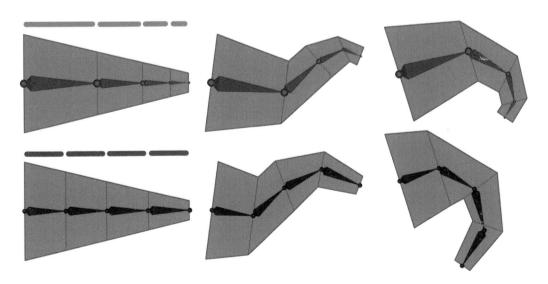

FIGURE 29.1 Comparison of even bone lengths versus a Fibonacci sequence.

DOI: 10.1201/9781003263166-29

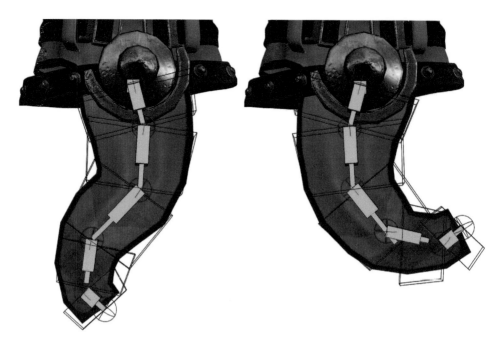

FIGURE 29.2 Rigged cloth example.

by duplicating the FK chain, then I parented each of them to the one they were duplicated from and lastly I added a Damped Track to each of them with the next tweak control as the target.

The last two bone chains are the intermediate and deformation bones. Intermediates were parented to their respective tweak bone and the deformation bones are constrained to the intermediates using Copy Rotation and Copy Location.

I have also created a rotation isolation setup at the top of the rig so that parameters can control how much rotation should the cloth inherit from the hips.

30

Space Switches

Introduction

What if the animator wants to do something like place a hand on the hip and attach them to move together? Parenting the hand to the hip requires changes to the rig and does not make sense for other animations. So we need to change the behavior without changing parenting.

Space switch rigs provide the animator with a custom parameter which seemingly changes which bone a control is parented to. The actual parenting does not change, only the control's behavior.

I recommend adding this setup to all IK controls and their pole controls, as well as the root and the eye target controls. It will also be required for prop controls so that they can be attached to hands or other parts of the body.

Space Switch Setup

Custom Property

For space switching, an Integer type custom property works best, as we can make the setup in such a way that each value represents a different parent. For example, 0 could mean an arm should behave as if parented to the shoulder, 1 to the head, 2 to the chest and so on.

Create the property either on the control bone that is being constrained or on any other bone where you might have created other custom properties. I will use the world control as I have been doing for all custom properties. Add the property and set it up like so:

- Set Type to Integer.
- Property name should describe what the property does. For an arm IK control, I would name the property "Arm L IK parent".
- Set Min to 0 and Max to the total number of fake parents minus 1.
- Enable Library Override.
- In the Description field write which parent each number represents. For example, for the arm I would write something like "0 Shoulder, 1 Head, 2 Chest, 3 Hips, 4 COG, 5 World".

If you hover the mouse over the property, you should see a pop-up window which will display the description which was added to the custom property (see Figure 30.1).

Armature Constraint

It is important to un-parent the control bone that is going to receive a space switch setup so do that first. If it has a parent bone, then it will receive double transformation. One from the constraint and one from the actual parent. To clear a bone's parent, in Edit mode, press **Alt + P** and choose the *Clear Parent* option.

The Armature constraint works similar to how the armature modifier works on a mesh. We can add different bones to the constraint as targets, and the owner will inherit the transformation from each of the bones based on how much influence is assigned to them.

DOI: 10.1201/9781003263166-30

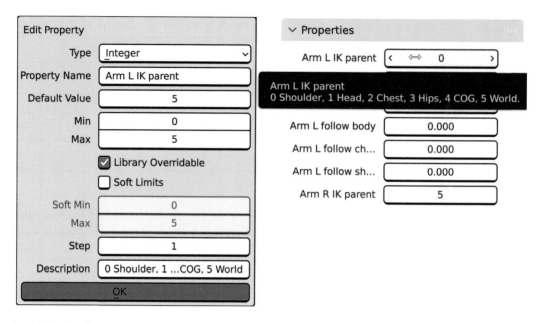

FIGURE 30.1 Custom property made for a space-switching setup.

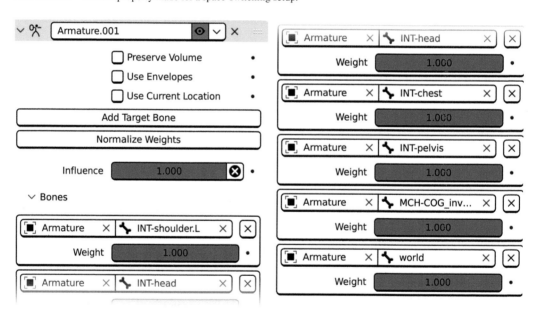

FIGURE 30.2 Arm IK control space switch constraint setup example.

Add an Armature constraint to the bone that is being set up for space switching. Then Press the Add Target Bone button as many times as the number of fake parents. In the Bones list, assign the active armature as the first target for all items. Add the fake parent bones as the bone targets. Add these in the same order as how you listed them in the custom property description so the two will match (see Figure 30.2 for reference).

Drivers

The only thing left to do is to connect the custom property to the constraint so that we can use it for parent selection. To do this, follow these steps:

- Right-click on the custom property and select **Copy as New Driver**.
- Navigate to the constraint, right-click on the **Weight** value of the first item in the **Bones** list and choose **Paste Driver**.
- Right-click on the same value again and select **Edit Driver**.
- In the driver edit pop-up window:
 - Change the driver type to **Expression**.
 - In the **Expression** field, next to the automatically added variable name, add "==0". The expression should look similar to "Arm_L_IK_parent == 0", where "Arm_L_IK_parent" is the variable name.

Once the first driver is created, the rest can be made by pasting it to the other targets and adjusting the integer value in the expression:

- Right-click on the property a third time and select **Copy Driver**.
- Move to the second item in the list and right-click on its **Weight** property. Select *Paste Driver*.
- Edit this driver and change the *Expression* to "Arm_L_IK_parent=1".
- Repeat the process for each other *Weight* values and continue incrementing the number in the expression by 1.

Test by changing the custom property's value and transforming different controls to see if the control follows the correct parent (Figure 30.3).

Copy Global Transform Add-On

The problem with space switching is that changing the parent can cause the control's transformation to change. The Copy Global Transform add-on can return the control to where it was before the parent was changed. Enable the add-on from the Preferences window. It will appear in the 3D view's N panel under the Animation tab.

Switching the parent during an animation would go like this:

- Select the control that is getting its space switched and make sure it is active.
- In the Global Transform panel, click on Copy. This will store its current transformation.
- Change the space switch property to the new value. The control might jump to a different transformation.
- Select the control again and in Global Transform, click Paste. The control should jump back to its original transformation.

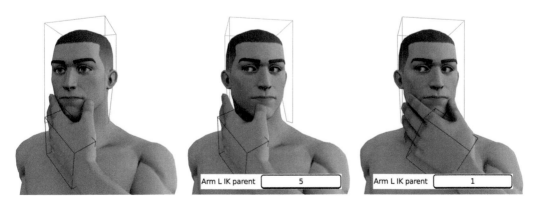

FIGURE 30.3 Rotating the head control with the IK hand parent set to the world (middle) and to the head (right).

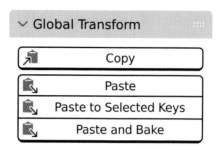

FIGURE 30.4 Copy global transform add-on interface.

The add-on can also be used in other areas to, for example, copy and paste the transformation between IK and FK controls (Figure 30.4).

31

Props

Introduction

A common requirement for game rigs are attachment points for weapons or accessories. In Blender, these sockets would be bones and by animating them, instead of animating each prop directly, we have a system that allows us to reuse animation. For example, imagine working on a game where the character can use 50 different broadswords that all have the same attack animations. If we put all the sword animations on prop bones, we can parent any of the swords to them and get the animation for free.

Prop Bones

The Nnema character has two morning star weapons, so I will add two prop bones. I will parent them to the root because they need to be exported to the game engine (Figure 31.1).

The full process for adding prop bones goes like this:

- In Edit mode, create two new bones and orient them so they match world axes.
- Parent both to the root bone.
- Even though they will not deform the mesh, leave their *Deform* property enabled to prevent them from being deleted on export.
- You can leave the bones at the world origin or move them to the character's palms.
- Duplicate the bones and make control bones out of the duplicates. Constrain the prop bones to the control bones using Copy Transformation constraints.
- Clear the parent on the control bones.
- Create space switches on both controls so that they can be attached to the hands, world and any other bones the props should be able to attach to.

How to Animate Props

Link the prop mesh into the animation file and constrain it to the prop bone using a Copy Transformation constraint. Then create the animation using the rig and its prop control bones. Once the animation is finished, you can delete the prop or hide it for later use.

DOI: 10.1201/9781003263166-31

FIGURE 31.1 Prop bones being used to animate weapons.

32

Rig Finalizing

The rig is technically finished, but there are a few things we can do to make it more user-friendly. It is the last 10% which will make quite a difference in how happy your animators, and you, will be once they start animating it.

Selection Sets

Selection sets allow us to create a list of bone groups which can be selected from a pop-up window. This helps the animators quickly select multiple bones.

The add-ons interface can be found in the Armature Properties and is available only in Pose mode. To create a set and assign bones to it, follow these steps:

- Press the + button to add a new set.
- Double click on the set that was added to the list to rename it to something descriptive.
- Select the bones you wish to add to the set.
- Make sure the set is selected in the *Selection Sets* list and press the *Assign* button.

The sets can be selected using the *Select* button in this part of the UI but a faster way to get access to selection sets is to use the Shift+Alt+W shortcut in the 3D view. This will bring up a pop-up menu which lists the sets (see Figure 32.1).

Rotation Order

No one animates characters using Quaternions so the minimum you can do is change this to a Euler option for all controls. There is no rule that we can apply to all controls and, depending on the scenario, different Euler modes work better. This setting is only relevant for animation and animators can change it freely (Figure 32.2).

How Modes Affect Animation

Look at Figure 32.3. There is no difference between the two lowered arm poses, but the rotation axes look completely different. The most important thing to note is that the relationship between the mesh and the axes changes. Where the Y-axis points down the arm in the default position, once the arm is lowered, this might not be the case depending on the rotation order. So, the animator might expect that the Y-axis always twists the upper arm, but if the Y-axis is not the first value in the rotation order, then this will not always be true.

Use your best judgment to set the initial rotation order value to something that makes sense and let the animators change the value prior to starting an animation.

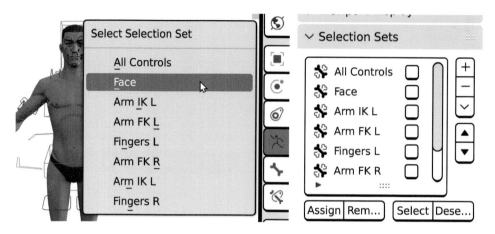

FIGURE 32.1 Selection sets user interface.

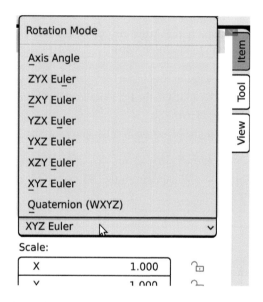

FIGURE 32.2 We can access the rotation order from the Item panel in the 3D view's side (N) panel.

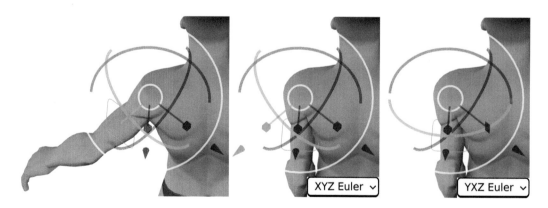

FIGURE 32.3 A look at how the relationship between the mesh and a control rotation axes changes based on the rotation order.

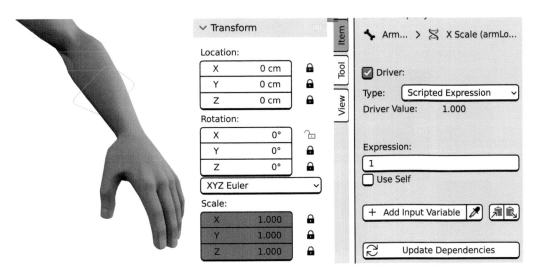

FIGURE 32.4 Channel locking on a lower arm FK control. The value of the Scale properties is locked to a single value via drivers.

Channel Lock and Limit

We should lock the scale channels on all controls, as I did not make the rig with scaling in mind. If you are building a different type of rig which requires scaling, leave those unlocked.

As the knee and elbow are hinge joints, i.e. they can only rotate on one axis, it makes sense to lock the other two axes. You might also want to lock the location channels on all FK controls if they are meant to only be rotated. To lock a transformation channel, simply click on the lock icon next to its value. To apply this on all selected objects, press and hold **Alt** and then click on the button.

We can still make changes by adjusting the property values. If you want to lock it so that it can't be changed this way, simply add a driver to the property with no variables and set type to Expression. In the Expression field write the value that you want this property to always be at. To keep default values, the expression would be "0.0" for location and rotation and "1.0" for scale channels.

A third method for limiting the transformation channels is by using Limit Location, Limit Rotation and Limit Scale constraints. Enable *Affect Transform* in the constraint settings and set the *Owner* property to *Local Space* (Figure 32.4).

Visibility Layers

Animators can use armature layers to change the visibility of groups of bones. Layers need to be populated with controls as part of the rigging process using the usual layer assigning methods. A not so ideal part of this approach is that there is no option to label the layers so that the animator knows which layer contains what. The only way to achieve this is to use add-ons or custom UI scripts.

You should also consider enabling protection on all armature layers that don't contain controls bones. This is done in the *Armature Properties*, *Skeleton* tab (Figure 32.5).

Colors

We can visually separate controls using bone group coloring. You can see an example in Figure 32.6. This is just one example of how to use color to group bones by location and functionality (Figure 32.6).

FIGURE 32.5 Custom user armature layers user interface created using a Python script.

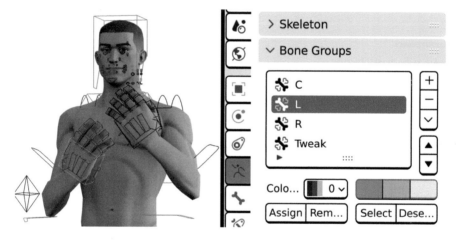

FIGURE 32.6 Control color scheme example.

Scene Cleanup

Tidy up the file. Make sure all control bones are visible, all other layers are disabled, and everything has their transformation channels zeroed out. Remove any objects from the scene which might not be required anymore, like reference images, cameras, etc.

Make sure that the rig and the character's geometry are all in one collection labeled with the character's name. Only the essentials need to be in it (armature and character mesh) (Figure 32.7).

Pose Library

There are two good reasons it is worth building a pose library for game animation: time saving and animation consistency. Animators can create and share poses like an idle pose that all other animations can blend in and out of, or poses for sections (e.g. hand poses).

FIGURE 32.7 Cleaned up rig file with all controls visible and in default pose. We link the rig and mesh to a collection named with the character's name.

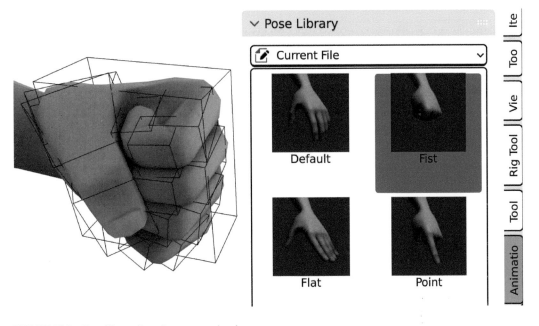

FIGURE 32.8 Pose library featuring common hand poses.

Blender has a built-in add-on called Pose Library that enables us to create and manage poses. A complete breakdown of how to use the add-on is out of scope for this book but a thorough guide can be found in Blender's official documentation, here (Figure 32.8): https://docs.blender.org/manual/en/latest/animation/armatures/posing/editing/pose_library.html

33

Animation

The goal of this chapter is to provide a "how to" guide for using rigs for animation, and to make you familiar with some animation-related concepts and tools that are worth knowing.

Linking and Library Overrides

Consider the rig file and animation files to be two separate entities. Connect the rig to animation files through linking. What is crucial here is that a linked rig is not a duplicate of the original, it just points to it in the rig file. So any updates made to the rig file will automatically be available in the animation files.

To link a rig and create an animation file, follow these steps:

- In Blender, click on *File > New* to create a blank file.
- Click on *File* again and select *Link*.
- In the file browser, navigate to the file that contains the rig and double-click on it. The file will open like a regular folder and give you access to the file contents.
- Double-click on the *Collection* folder to open it.
- Double-click on the collection which contains the rig and the mesh. This is why it was important to create this collection during rig finalization.

The character should now appear in the file, but the rig can't be used yet. To access pose mode and animate the rig, make sure the linked object is active and in the 3D view menu click on *Object > Library Override > Make*. The rig is now ready for animation.

Relative Versus Absolute Paths

A relative path is a file path that is based on the location of the current file. Meaning it is not making the file path based on where the file is on the hard drive (i.e. absolute path) but based on how to get there from the current file.

If absolute paths are used, linked rigs or textures that are linked in the character's material might fail to load. To make sure all the external assets are using relative paths, use the *Make Paths Relative* operator, which can be found in the 3D view menu by going to *File > External Data > Make Paths Relative*. Save the file after executing this operator.

Forcing a Linked Object to Update

It can sometimes happen that a linked rig is not able to automatically sync with changes made to the rig file. We have two operators that tell Blender to make a full update (Figure 33.1):

- In an Outliner view, change the *Display Mode* to *Library Overrides*.
- Change this mode from *Properties* to *Hierarchies*. The hierarchy should display collections now.
- Right-click on the collection which contains the rig and in the menu select *Library Override > Troubleshoot > Resync*.
- If this does not get the job done, then try the *Resync Enforce* option.

DOI: 10.1201/9781003263166-33

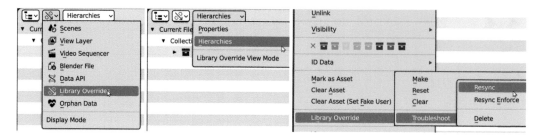

FIGURE 33.1 Location of the resync operators.

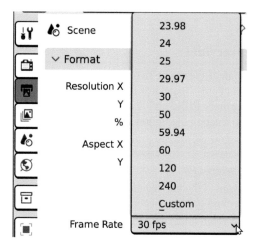

FIGURE 33.2 Frame rate settings location.

If this still does not update the rig to its latest state, you might have to delete the entire rig collection and link it again. There is an additional step you need to do to make sure no name clashing happens because of leftover data. Follow these steps to do a clean re-link:

- From the outliner, right-click on the collection which contains the rig and select *Delete Hierarchy*.
- From the main menu select *File > Clean Up > Recursive Unused Data-Blocks*.
- Link the rig collection and make it into a library override.

Actions will not be lost if the rig is deleted but they will get removed if they do not have *Fake User* enabled and *Recursive Unused Data-Blocks* clean up is triggered.

Framerate

The scene frame rate can be set from the Output Properties editor. Either select a preset or Custom which will display additional fields where a frame rate number can be typed in (Figure 33.2).

Keyframes and Keying Sets

When a keyframe is inserted (**I** key is the shortcut), the list of keying sets will show up. A keying set is a collection of properties that would be keyed. We can choose a default set that should be used and avoid seeing the list. This is done in the Timeline view by pressing on the *Keying* button. I recommend using *Whole Character (Selected Bones Only)* as the *Active Keying Set* option. It will key all available channels on selected bones (Figure 33.3).

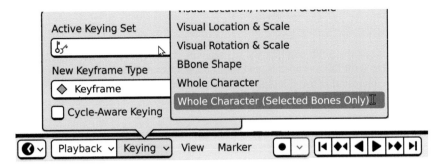

FIGURE 33.3 Default keying set setting location.

Actions

Since Blender automatically deletes data objects which do not have any users, always enable *Fake User* (shield icon next to the action name) for all actions that you wish to be saved in the file. If you don't, and the action is not linked to the rig, Blender will delete it and there is no way to get it back.

When changing the active action on a rig, any property that does not have keyframes will keep the value it was at before the action was changed. This can produce unexpected behavior and I recommend you key all properties at the start of each action to make sure you are not getting data from other actions (Figure 33.4).

In-Between Tools

Blender comes with an array of so-called "tweening" tools. We can use them to quickly create in-betweens, blend, relax and push poses. I recommend assigning shortcuts for these tools as they can speed up the animation process.

Once one of these tools is engaged, we adjust the value by moving the mouse cursor left/right. Additional modifiers can be applied to the tool using keyboard inputs. The options are shown in the info bar at the bottom of the Blender window. Some modifier examples are **E** for enabling overshoot or **Shift** for precision mode (Figure 33.5).

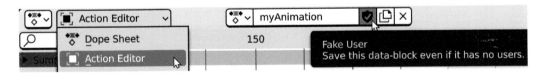

FIGURE 33.4 Getting access to the action editor through the dope sheet and the fake user button.

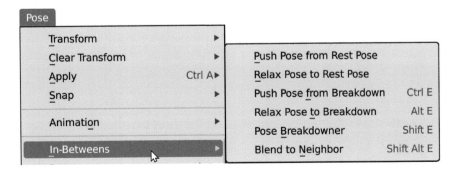

FIGURE 33.5 In-between tools.

NLA

The Non-Linear Animation editor can be used to create layered animation. A proper detailed guide for how to go about using it for this purpose is out of the scope for this book, but I encourage you to explore it further if you are interested in using layered animation techniques.

Discontinuity (Euler) Filter

Anyone animating characters will inevitably encounter gimbal issues. These are hard to resolve manually and luckily we don't have to as there is an operator that can do it for us. First, select all animation curves which you want to process with the filter, then in the Graph Editor's menu click on *Key > Discontinuity (Euler) Filter.*

Preview Rendering

To create animation preview videos, first adjust the settings found in the Output Properties panel. The most important settings are *Resolution*, and from the *Output* menu the file path, *File Format* and *Container*. Set the file path to where you want the video to be saved. A popular option for *File Format* and *Container* is a combination of *FFmpeg Video* and *QuickTime*. The *Render > View Animation* option will render the current 3D view (Figure 33.6).

FIGURE 33.6 Preview render settings and operator location.

Rotation Order and Mode

You can choose the best mode rotation mode for every control in each action. I recommend setting and keying the rotation order on the first frame of each action. If no key is present, the action will use the mode that was active in the previously used action.

If you enable the Rigify add-on, operators for changing rotation modes on existing animation will become available. We can find these in the 3D view menu while in Pose mode. Open the *Pose* menu and find the *Convert Rotation Modes* operator (Figure 33.7).

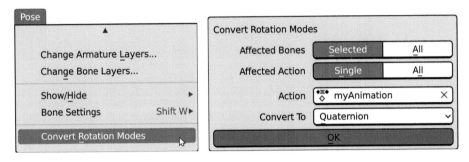

FIGURE 33.7 Rotation mode conversion using the rigify add-ons convert rotation modes operator.

34

Export

Skeleton and Mesh

We export the skeleton and mesh to an FBX file, which can be imported into most game engines. Another valid format is gLTF 2. Pick the one that works best with the game engine you are using.

Before exporting, make sure that the character's armature is selected as well as all of the meshes that are part of the character. Everything else should be deselected. Once those are selected, click on the *File* menu and choose *Export > FBX (.fbx)*. Navigate to the desired export location and set a name for the exported file. Then adjust these settings in the side panel (press **N** or click on the cogwheel button in the top right corner if settings are not visible):

- Enable *Selected Objects*.
- Set *Smoothing* to *Edge*.
- Enable *Only Deform Bones*.
- Disable *Add Leaf Bones*.
- Disable *Bake Animation*.

Since we set the rig up with deformation and prop bones in a clean bone hierarchy under the root bone, all the other bones will be automatically deleted. And with *Selected Objects* enabled, we make sure that only the character mesh and the armature get exported.

To store settings into a preset, set the correct settings, press the + button in the top right corner of export settings and you will always get a clean and correct export.

Animation

There are several combinations of export settings and scene setups that you should know about to be able to define which animations get exported.

The export settings for animations are almost exactly the same as those in Figure 34.1. The major difference is that you don't need to include the mesh, only select the armature. Then enable Bake Animation and adjust the animation settings based on what you want to export. Skeleton with meshes, and animation files are assembled together in the game engine.

All Actions

To export all actions, use the export settings from Figure 34.1 and additionally enable Bake Animation. Leave the options under Bake Animation at default, as shown in Figure 34.2a.

If any of the curves are not compatible with the armature, the action will not be exported. This can easily happen if you are reusing actions and the characters have differently named bones. You can still reuse actions but look at the list of curves in the graph editor and remove any that have a red line under their name.

DOI: 10.1201/9781003263166-34

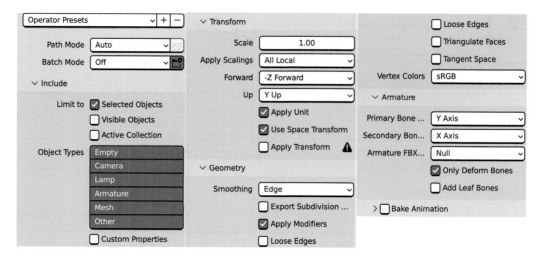

FIGURE 34.1 Rig and mesh export settings.

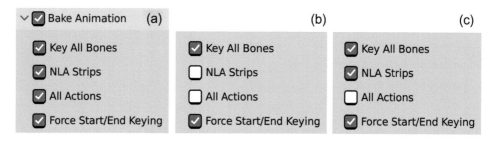

FIGURE 34.2 Animation export settings for different scenarios. All actions (a), active action only (b), actions from NLA editor (c).

Single Action

A single action can be exported by assigning it to the armature and in the export settings, enable *Bake Animation*, disable both *NLA Strips* and *All Actions* toggles (see Figure 34.2b).

We assign actions to objects through the Action Editor. To get to the Action Editor, change a view to be a Dope Sheet editor. Then in the Dope Sheet view, change the mode to Action Editor.

Selection of Actions

We can't simply select actions and export the selection, this has to be done through the NLA editor. To achieve this, first make a view that is set to be a NLA Editor.

Look at Figure 34.3. It has four tracks (horizontal rows) in total. The three gray tracks are those which will be exported. I created those by hovering the mouse over the left area of the editor and by pressing **Shift+A**. This adds a new row but does not assign an action to it. To assign the action, first click on the newly added track to make sure it is active, then move the cursor over to the right so that it hovers over the area with the grid divisions. Then press **Shift+A** again. This will show a pop-up window that contains a list of all actions in the file. Choose the one you want to export, and it will be added to the track.

Note that you can exclude tracks from export by disabling the checkbox next to their names. In the export settings, make sure *NLA Strips* is enabled and *All Actions* is disabled, as shown in Figure 34.2c.

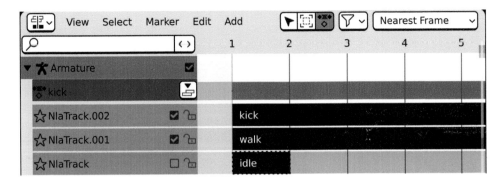

FIGURE 34.3 Exporting a selection of actions through the NLA editor.

Conclusion

Congratulations on getting to this place. It takes a lot of effort and dedication to learn a new skill. So tap yourself on the back and take a moment to enjoy this achievement.

Thank you for reading my book. I hope you enjoyed learning about rigging, and I look forward to seeing what you create with your new skills. Have fun rigging and animating.

Index

For Product Safety Concerns and Information please contact our
EU representative GPSR@taylorandfrancis.com Taylor & Francis
Verlag GmbH, Kaufingerstraße 24, 80331 München, Germany